2. D

20TH-CENTURY DREAMS

20TH-CENTURY DREAMS

NIK COHN AND GUY PEELLAERT

ALFRED A. KNOPF NEW YORK 1999

This Is a Borzoi Book
Published by Alfred A. Knopf

Text copyright © 1999 by Nik Cohn
Illustrations copyright © 1999 by Guy Peellaert

All rights reserved under International and Pan-American
Copyright Conventions. Published in the United States by
Alfred A. Knopf, a division of Random House, Inc.,
New York, and simultaneously in Canada by
Random House of Canada Limited, Toronto.
Distributed by Random House, Inc., New York.

www.randomhouse.com

Knopf, Borzoi Books, and the colophon are registered
trademarks of Random House, Inc.

Library of Congress Cataloging-in-Publication Data
Cohn, Nik.
20th-century dreams / Nik Cohn, Guy Peellaert. — 1st ed.
 p. cm.
Includes index.
ISBN 0-375-70708-5 (alk. paper)
I. Peellaert, Guy. II. Title.
PR6053.038T94 1999
823'.914—dc21 99-30626 CIP

This book is a work of fiction. The references to and
illustrations of real people are used solely for satirical
and humorous purposes.

Manufactured in Great Britain
First Edition

FOR PIERRE LESCURE

G. P.

TO PAT O'SULLIVAN; AND ALWAYS, TO MICHAELA

N. C.

Claudine, be blessed.

Special thanks to Laurie Bex, a pro, a critic, a moral support.
There must be a trap somewhere.

Orson, your father was immersed in these images when you
were between fifteen and nineteen. They're yours, too.

Thank you, Elizabeth.

Thanks to: Robert Delpire, Sabine Eisner, Christian Fechner,
Claire Lampérière, Hans-Peter Litscher, Mayumi Matsuo,
Christian Naitslimane/Presse Sports, Zabo Nora, Albert
Raymond/Keystone-Paris, Carol Reid, Laetitia Sala, Agnès
Sire, and the police departments of Carmel-by-the Sea,
Little Rock, and Miami.

Acknowledgment for Nabokov: Homage to Philip
Halsman/Magnum

G. P.

20TH-CENTURY DREAMS

It was John Lennon who introduced us.

I was loafing away an afternoon in the back room of Max's Kansas City, sometime in the early spring of 1971, when Lennon came plundering in with Andy Warhol and Candy Darling, Warhol's drag-queen superstar. Lennon was in a sulfurous mood, but this was nothing unusual. Our paths had crossed a few times in London in the sixties, back when the Beatles were still the Fab Four, and even then he could be a nasty proposition. "Fucking Nik Cohn. Calls himself a writer," he'd taunted me once. "He couldn't write himself out of a wrong."

Perhaps the strain of playing modern-day Jesus was eating at his nerves and he felt the need to kick over the traces. At any rate, he'd done a bolt from Yoko and the rest of the Give Peace a Chance crowd, and reverted to Liverpool corner-boy mode, itching for confrontation. In this mood, the deep self-loathing that was always in him, working against his yearning for sanctity, would turn itself outward and seek out surrogate victims. Squinting down the long rail of his nose, he looked like a predatory bird scavenging for roadkill. He lobbed a spitball into my Jack Daniel's and made Candy Darling cry by calling her "boy," then zoned in on an androgynous youth in black leather, sharing a coffee with Patti Smith. "Who the fuck are you?" Lennon asked.

"Robert Mapplethorpe."

"Lovely name for a lovely girl." The Merseyside drawl was laid on with a trowel, the weak eyes tight with malice, but the youth's look of dumb adoration never wavered, even when Lennon reached across

the table and knocked the coffee cup into his lap. "Who's an arse licker then?" Lennon demanded.

"I am," Mapplethorpe replied.

Warhol was ecstatic. The prospect of a public dogfight brought a faint flush to those raddled, wax-museum cheeks, and he reached for his Polaroid. Mapplethorpe's own excitement, meanwhile, was intensified by Candy Darling, who kept dabbing at the spreading coffee stain with a lace hankie. "You poor wet lamb," she murmured. Lennon, however, had lost interest. "This place is a poxhole," he pronounced. "A filthy khazi."

"Gee," said Warhol, "what's a khazi?"

"A toilet to let." He threw his glass at the neon installation in the corner, which sputtered and hissed. "I can't stop here, I might drop dead of boredom," Lennon said, and stormed off toward the door. "I'm off to see the Wizard."

"Who's the Wizard?" I ventured to ask.

"Max Vail," said Warhol, shocked by my ignorance. "What other wizard is there?"

I knew the name, of course. Everybody did. In New York at that time, Max Vail was an inescapable presence. Hardly a day seemed to pass without some new item in the tabloids—Vail at a premiere or charity gala, Vail advising a scandal-racked politico, Vail consoling a lovelorn star. In photographs he would appear, smiling but shadowy, behind the shoulder of Muhammad Ali or Rudolf Nureyev or Elizabeth Taylor. He was so omnipresent, in fact, that it became a standard gag to study his latest snapshot, as he lurked a step behind Mick Jagger, say,

or Aristotle Onassis, and ask, "Who's that with Max Vail?"

There were mysteries here. How had Max Vail contrived to make himself ubiquitous, while remaining completely elusive? Where did he come from? What was his history? And how did he manage to pay his bills? Nobody could furnish any hard facts. Even my friend Gail, celebrated for her black book, drew a blank. "I don't think people know him," she told me with a shrug. "He knows people."

The chance of a meeting was not to be missed. Ignoring Lennon's glare, I squeezed into the back of his waiting limo, and the whole disordered pack of us took a ride uptown.

Max Vail, it turned out, occupied a penthouse suite at the Carlyle Hotel. The door was answered by Habib, a North African manservant, clad in full-length Arab robes, with a splayed nose and knotted eyebrows, the honor badges of an ex-prizefighter. He let us in grudgingly, mumbling under his breath. "Habib a wonderful time?" Lennon asked. The manservant was not amused.

My first sensation, walking into the reception room, was that I'd slipped underwater. All was dimness and hush, refracted light. Moiré silk was offset by velvet plush, velvet by Chinese screens. The walls and furnishings, beneath a high vaulted ceiling, were in various tones of pearl gray, and the artworks—a silvery Sargent portrait of a lady in a ball gown, a Degas gouache, an early Braque—seemed to have been selected to match. Even Rumi, the Persian cat who sat preening in his master's lap, was color coordinated.

Vail himself cut an unimposing figure. He was a neatly made man of indeterminate age—I guessed mid-fifties, though he later turned out to be past seventy. His skin was unmottled, his silver hair still thick, his dark suit clearly Savile Row. Discreet silk tie, Piaget watch, an almost subliminal whiff of Eau Sauvage—the overall package suggested a merchant banker, or perhaps a diplomat. The only hints of personal expression were his shoes, which were a deep chocolate brown, handcrafted and polished to a high

sheen that made me think of racehorses. While seated, he liked to fondle them, alternately cupping one sole, then the other, as if weighing them in the balance.

In isolation, he gave an impression of absolute repose. But the moment he came into contact with Lennon, it was as though he'd entered a force field. Every muscle and nerve end was galvanized, and his whole being radiated attention.

He seemed to function as a human Geiger counter, minutely responsive to stardom in all its gradations. The buzz that Lennon caused lost some of its intensity when he moved on to Warhol, and more when he came to Candy Darling. Then he reached me. "How do you do?" he said earnestly, putting the emphasis on the last two words, as if asking a real and pressing question. Before I could respond, however, my moment had already passed. In that split second, I had been weighed; my value set. "So you write," Max said, and mentioned the title of my last book. "I read the reviews," he confided. He smiled neutrally, then passed on to Mapplethorpe. "How do *you do*?" he inquired. "So you take pictures." I was crushed.

Ill-assorted as we were, Max seemed to take us in perfect stride. "Let's have tea," he suggested, at which Habib, scowling, brought us Gibsons. "You are at home here," Max told us, his accent not quite American, though I could not place it anywhere else. His neat hands, I noticed, were freshly manicured.

For Lennon, being told he was at home was an open invitation to rampage, and he started to roam the apartment, with the rest of us at his heels. We rattled down a long corridor into a gleaming stainless-steel kitchen, where Candy Darling began to empty out her handbag. Cocaine and amphetamines appeared, bottles of vodka and Jack Daniel's, a razor blade, a mirror. Lennon pounced. Three drinks, a double line of coke and assorted pills disappeared in seconds. "Hooray for Hollywood," Candy cried, but there was none for me, and I drifted back to Max.

He was sitting as we'd left him, serenity unruffled, listening with deep attention to a high-pitched whis-

per that seemed to issue from the depths of the velvet curtains. At second blink, I realized that this stemmed from Truman Capote.

He was almost entirely swallowed up by an oversized camel-hair coat, a wide-brimmed fedora and shades. The effect was of an ancient infant dolled up in fancy dress. Waving his little hands in front of his chin, he appeared on the verge of tears. "If there's one thing I can't abide, it's a man who bites." Before he could elaborate, Lennon came roaring back. "My God, the Tiny Terror! I didn't notice you there," he started in. "I could have trod on you." He lifted up his open-toed sandals, inspecting the soles for smears. "Never mind," he said blandly. "What's a little shit between friends?"

Capote had no defense. He tried a pout, but Lennon wasn't playing. "Don't mess with the messer," he warned, then made a grab for Capote's trousers. "Is it true you're tiny in every way?" he demanded, starting to yank. "I've heard that null's the void."

Locked in grotesque embrace, they reeled back and forth across the room, while Warhol started snapping away with his Polaroid, Candy Darling thought about screaming and Mapplethorpe looked as if he'd just glimpsed paradise. Only Max seemed unconcerned. He took the precaution of tucking his feet in their hand-stitched shoes under his chair, but his neutral smile never wavered. "John," he said simply, "you look weary."

And everything stopped.

Though he had spoken quietly, without haste, the effect on Lennon was like a stun gun. All rage and menace seemed to drain from him, and he let go of Capote's waistband. "You're right, Max. Hole in one," he said, putting up his hands in mock surrender. "I'm weary unto death."

It was as if the rest of us had vanished. "They're all using me," Lennon said. "I give and give, and they're just along to cop a free ride." He wiped his nose clean of coke with the back of his hand. "They're eating me alive," he said.

"Go home, John," Max suggested. "Try to get some rest." Lennon nodded, head bowed. "Rest," he said. "Yes." He let out his breath in a dying fall and hauled his carcass to the door. "Shine on," he pronounced from the threshold, and was gone.

The rest of us soon followed, Capote in a flurry of outraged feathers, Candy Darling with bulging handbag, Mapplethorpe walking on air. "You must send me one of your books," Max said as we shook hands, but I knew he didn't mean it. Though we had exchanged no more than a few words, I felt I'd failed. "Until we meet again," he said in parting.

No dismissal could have seemed more final.

Years went by. Max continued to haunt the gossip columns—at play with John Travolta, in conference with Richard Nixon or Idi Amin, greeting Solzhenitsyn, visiting Mao—but we did not meet again until the late seventies. One snowy morning around Christmas, my phone rang. "Have you seen Andy's show yet?" Max asked casually. Then he asked me to tea.

Nothing had changed in his reception room, which still felt like a drowned cathedral. Outside, the streets were choked by snowdrifts, but up here there were no seasons and no such thing as passing time. The moiré silks and velvets and wall hangings were the same muted shade of pearl gray, and a matching cat still sat preening in his master's lap. It wasn't the same Rumi I'd seen before, Max informed me, but the sixth in a line that stretched back to 1925.

Tea, as before, meant Gibsons, served with the same malign scowl from Habib. Even Max, though by now pushing eighty, looked essentially unaltered. There was perhaps a tightening around his eyes and a corresponding looseness at his throat. Otherwise, he was as immaculate as ever. His choice of shoe today, I noted, was midnight blue, with discreet cross-stitching along the cuff and just a hint of a lift in the vamp.

Conversation was desultory. Max offered no quick clues as to why he'd asked me here. First we had to catch up on John and Andy, dear Truman and the now departed Candy. Next we performed a ritual

waltz around a smorgasbord of places I'd never been and people I'd never met. Only when these rites had been observed in full did he start to edge toward the point, and even then Habib had to give a nudge. "Miss Dietrich phoned. She will be here within the hour," the manservant muttered gloomily. His glance made it clear that, for him, my fifteen minutes were already up. But Max decided to grant me a stay. "I have something to show you," he said.

Shooing Rumi from his lap, he led the way to the outer reaches of the apartment, which seemed immense. We passed what looked like an auction room, filled with a job lot of artworks of every period and persuasion; an oak-lined dining hall, very Scottish baronial; and a bedroom as neutral as his smile. Then we came to a heavy leather-padded door. "I call this my sanctum," Max said, producing a small brass key, and ushered me into a windowless cell, lined from floor to ceiling with ranks of file cabinets. Their gunmetal gray was institutional, not pearly, and the space they overlooked equally austere. A single reading light rested on a plain pine table. The floorboards were bare.

A library ladder on rollers leaned against one wall. Shinnying up it with an agility impressive for his years, Max extracted a slim leather-bound journal, chosen seemingly at random, and handed it down. It was labeled by month and year—September 1919— and fastened with blue ribbon.

The journal, at first glance, seemed a conventional scrapbook. There were newspaper cuttings about President Wilson touring America in support of the League of Nations, the death of Adelina Patti, the first postwar run of the Orient Express, the new flight altitude record of 34,610 feet set by Roland Rolffs in his Curtiss Wasp. Gabriele D'Annunzio had occupied the Adriatic port of Fiume and claimed it for Italy, and in Munich the rising star of the Workers' Party, one Adolf Hitler, made a speech. Also enclosed were a number of handwritten letters. One from Sarah Bernhardt, another from Isadora Duncan, and two more from Colette. Then came a selection of mementos—a beaming rectum doodled on a menu and signed by Tristan Tzara, a bandanna from Suzanne Lenglen, an onyx cigarette holder from Douglas Fairbanks. And a tiny line drawing by Cocteau of a lounging boy who just might have been Max himself.

Some comment was obviously expected, but I didn't know where to begin. "I have a history of sorts," said Max. This seemed to me, even by his standards of obliquity, an understatement. Max, on the other hand, found it too bold. "It might be fair to say that I have acquired, in the course of my life, a narrative," he amended. "It is not, I think, entirely without interest."

He had kept these journals, month by month, ever since he'd passed puberty. "A tool of memory," he called them. "My own humble form of jackdawism." Now, as he approached his ninth decade, he had begun to crave something more. A record; some form of permanence. Would I be interested in helping him write his autobiography?

"I'll need to think about it," I replied.

"Naturally." Max ushered me out of the cell and called for Habib to bring my overcoat. "Shall we say tomorrow at noon?" he murmured in parting.

At first, work went sluggishly. As time passed and we grew attuned to each other, it bogged down completely.

As a memoirist, Max possessed one crucial flaw: an absolute disinterest in his own inner workings. His gifts were entirely as a receptor, not a transmitter. He didn't live in himself, but through the people he knew, in the reflection of their glamour. I sensed that, when his last guest had gone home, he essentially ceased to exist.

He was also crippled by retroactive discretion. In session after session, he unfolded tales that held me spellbound, only to snatch them back. "Too close to the bone," he'd say, and nothing I could argue would change his mind.

For a would-be Boswell, this was a cruel frustra-

tion. Here was a man, I began to understand, who contained the secret history of the century. Unfortunately, he would grant me only covert glimpses. "We are not writing a scandal sheet," Max used to tell me sternly. Indeed we weren't. We were not writing at all.

Our work schedule was sporadic. When both of us were in town, we might meet once or twice a week, wrangle for a few hours, then retire in mutual frustration. The barren months stretched into a year, then another, and still we had not even finished the opening chapter.

As the second anniversary of this futility rolled around, I sat down one night and collated everything I'd manage to wring out of Max to date. It amounted to the barest outline.

Born Maxim Valesky in 1900, he had grown up in St. Petersburg. He was characteristically sparing with his early memories, but I gathered that most of his childhood had been spent on the streets, surviving from day to day. His real life, at least in his own eyes, didn't start until he turned fourteen and was taken up by Rasputin, who adopted him as a sort of mascot. When revolution loomed, this association turned against him, and he escaped from Russia, sneaking through the war zones to Vienna, and then to Zurich. Had he, at some point, been a Bolshevik spy? He wouldn't say. But certainly he was present when Lenin boarded the fateful train for Russia. Around the same time, he also met Freud and Mata Hari. And suddenly, though still scarcely more than a boy, he was everywhere. Befriended by Isadora Duncan, he toured with her and came to know the Zurich of the Dadaists, the Paris of Proust, the Venice of Diaghilev. Then it was on to New York, where he got to know Babe Ruth and John Barrymore, sat in at the Algonquin Round Table and, somewhere along the line, qualified as a lawyer. By the thirties, he had made America his center of operations, finally becoming a U.S. citizen in 1940.

With the passage of years, his sphere of influence had kept widening. Hitler and Picasso, Greta Garbo and Duke Ellington, Einstein and Hemingway—was there no milieu he hadn't penetrated, no secret he hadn't shared? As we plowed our way through his journals, a vast kaleidoscope unfolded: the illicit, the long buried, the almost unthinkable; plots and deceptions and dirty deals, fatal meetings, doomed loves. "I have witnessed the world," Max liked to say.

How he had managed all this remained a mystery. Always wary of the spotlight, he had rarely been written about at any length, let alone analyzed, though I did unearth one brief mention in Dorothy Parker's diaries. "Max Vail is nothing in particular," she wrote. "Not witty, not smart, not attractive. He simply knows what people want without being told, and how to provide it without being asked."

As to his personal life, the picture was even less defined. At first I thought he might be Jewish, but his acceptance by Hitler and D'Annunzio made that seem unlikely. He had never married, and he never spoke of any love affairs, past or present, hetero or homo. For a time I suspected a liaison with Habib— it seemed the only conceivable reason for putting up with that grim presence—but Habib, it turned out, had a wife and family in Brooklyn and took the subway home each night. In itself, of course, that proved nothing. Still, I couldn't picture them as a couple. More and more, watching Max at work, I felt that the only sexual gratification he required was osmotic—an almost subliminal fallout from brokering the loves and lusts of others.

That, in the end, is what he was—a glorified broker—though he himself would have spurned the term. "Facilitator" was the word he preferred. But, however fancy the label, the bottom line was the same. He made connections. Fixed things. And drew his own lifeblood from the results.

For this he had been richly rewarded. I was never sure where his money came from, but he gave the appearance of serious wealth—homes in London and Rome, an estate in Jamaica that he hardly ever visited and, of course, the Carlyle penthouse, with its room full of pictures: the Delacroix, the small Pieter de Hooch, the Matisse drawing, the Jackson Pollock,

the Rodchenko, the Max Ernst and perhaps a dozen others, none of which ever crossed over into the reception room. They weren't the right colors.

My attempts at background research always ended up in blind alleys. As a lawyer, Max didn't appear to have tried a case; as a financier, he'd left no record of wheeling and dealing. Various suggestions, ranging from CIA spook to Mob laundryman, were never supported by hard facts. Finally, no explanation was more plausible than his own. "I have been lucky in my friends," he said simply.

The range and number of these friends never ceased to stagger me, and neither did his stamina. I once made a log of his schedule for a typical day, late in 1983. Breakfast with a group of Chinese diplomats was followed by morning phone calls to Warren Beatty and Muhammad Ali, a hurried conference with a flustered and red-faced Nancy Reagan, a light lunch with Yasser Arafat, a further round of phone calls to Luciano Pavarotti, John McEnroe and Ava Gardner, tea with Leonard Bernstein, Gibsons with Norman Mailer, an early supper with Princess Diana, more phone calls, one act of *Cats,* another of a revived *Glass Menagerie,* a quick pit stop at Danceteria to catch Madonna, then new in town, and back home to the Carlyle for a last phone call to Jacqueline Kennedy Onassis. This was weeks before his eighty-fourth birthday.

Small wonder, then, that his autobiography foundered. Even if Max's approach had been less constipated, we would have been hard squeezed for time. As it was, our book never stood a chance. We continued to meet and bicker occasionally, well into the nineties. By then, the project was more than a dozen years old, and deader than the pharaohs. I kept trying to bury it for good, but Max wouldn't quite let go. It was his history, therefore his to shovel under.

The stalemate was resolved only when I chanced to speak of the book to a publisher, who made an offer. Instantly, Max slammed down the portcullis. "It's no use rushing things," he said. And he never mentioned the project again.

The liquidation of our partnership didn't mean an end to all contact. By now, I suppose, I'd become a part of the furnishings, if not on a par with Habib or the latest model of Rumi, perhaps comparable to Sargent's society lady.

Even so, my visits were never entirely free of tension. After twenty years, Habib still treated me as a gate-crasher. Every time that Max told him he could go, the old prizefighter would stiffen and flash me a look of purest poison, as if his dismissal was my fault. "That will be all," I felt, would be the words inscribed on his tombstone.

Max was approaching his century. Many of his older intimates, inevitably, had died or gone gaga; but they were replaced by a constant stream of newcomers. Hillary Clinton fell under his spell, and Salman Rushdie, and Johnny Depp. As Nelson Mandela descended in one elevator, Madonna would rise in the other.

Through all these comings and goings, morality in any form was strictly beside the point. Good and evil were concepts foreign to Max. The only mortal sin he recognized—the reason he loathed Paul McCartney, for instance, and Herbert von Karajan—was to be a star who refused to fall into his grasp.

By stardom he didn't mean merely success. The common run of movie idols and supermodels and pretty-boy pop singers was never a honey trap to him. What he craved was contact with inner heat: the divine fire.

To Max, this was imperishable. The magic he worshiped, being inbuilt, was beyond the reach of fashion or changing fortune. Orson Welles and Capote in ruins remained as potent to him as they'd ever been in triumph.

In the last year of his life, when it was known that he was ailing, the flow of visitors at last began to slacken. By any normal standards, his social round was still a whirl. Still, there were certain afternoons when I'd find him alone, unoccupied. The hunger in him then, deprived of fuel, was terrible to behold.

Finally, this hunger was all that was left. He suffered from no specific disease; he was simply wearing out. His skin seemed as translucent as a lamp shade, and his eyes were filming over. Nothing kept him going but his yearning for one more fix.

By 1999, he rarely went out. One night, however, Habib phoned to say that my presence was required. Mr. Vail wished to visit Life.

The club was packed sardine-tight. Propped at a corner table, still swathed in scarves and his fur coat, Max looked out across the dance floor and sipped his Gibson. "Watery," he judged it, with a small shrug of dismissal. Gorgeous young creatures in various states of undress came up to embrace him and gush. Max duly smiled on them, without ceasing to look bored. "There is nothing here for me," he said mournfully, and had already risen to leave when suddenly he froze. Something or someone had caught his eye across the floor.

Without hesitating, he set off through the crush. The dancers cleared a path for him, as slowly, leaning heavily on his cane, he moved toward his target. It was not one of the gorgeous creatures, but a short, square-built girl in combat boots and biker's jacket, with hair that looked cut with garden shears. "Might I ask your name, my dear?" Max asked.

"Christina," the girl replied. She looked battered, unwashed, but her eyes burned. She had the spark, yes; and Max, bowing low, kissed her hand. "Fata morgana," he muttered. Then he went away.

He didn't speak much on the drive uptown, just cradled his shoes in his palm, first the left shoe, then the right, stroking their pelts with the blunt of his thumb. When the moment came to drop me off, he summoned up a wintry smile and handed me a package. "Just a token," he said casually, quick to squelch any fuss, as the chauffeur closed the door.

Inside the package was a small brass key. "This may perhaps be of use to you," said the note it came wrapped in, hand-scrawled in Max's spidery fist. "Employ it as you see fit."

Three days later, he was dead.

His funeral, on a suitably pearl-gray day, was as discreet as Max himself: a nondenominational service, a cremation and a modest gathering in the Carlyle penthouse, too muffled to pass for a wake.

Some of the mourners, ranging from Michael Jordan to Mikhail Gorbachev, seemed startled by their company. Max had ordered his life like a Chinese puzzle, in a complex series of interlocking chambers. Without his controlling hand, the divisions crumbled, and Brooke Astor, for instance, suddenly found herself seated next to the Artist Formerly Known as Prince.

Afterward, lying awake, I relived that first afternoon with John Lennon and the rest. At one point, before Capote appeared, Lennon had insisted on playing a version of Truth or Dare, in which we all had to say what we really wanted in life. Lennon himself, to show us how, had gone first. "I want love, I want peace. I want a pair of big, hairy balls to bounce upon my knee like Daddy's baby boys."

Andy Warhol said, "Gee, I don't know."

Robert Mapplethorpe said, "I want to blow sky-high."

Candy Darling, putting her hands up to her mouth, said, "I want, I want, I just want to go Whee!"

And I said, "I just want."

But Max, whose want was fiercest of all, refused to play the game. "I do hope it doesn't rain," was all he said.

Come morning, I was back at the penthouse, the brass key in my vest pocket. Habib, instead of his habitual Arab dress, was wearing a spiffy dark suit. From the way it strained across the chest, it might have been one of Max's; but that was his right, since he'd been left the apartment in the will, plus any of its contents not otherwise bequeathed. The Sargent was gone, I saw, as was the Degas gouache. Other paintings and bibelots were in the process of being crated up, and Habib, now lord and master,

had moved his family in. Women in dark robes huddled in the kitchen, cooking up a tagine, while children raced wildly along the corridor. "Chop chop," said Habib, yawning in my face. "I must ask you to make this snappy."

"Ten minutes," I told him.

"Five."

When the brass key let me into Max's retreat, I found the table loaded down with nine cardboard boxes, each containing a handwritten manuscript. "The Journals of Max Vail," read the cover of the first.

My first reaction, remembering all those years I'd slogged away, trying to wheedle a book out of him, was hurt. "It's no good pushing," he'd told me. Then he'd sneaked off behind my back and written it himself. Nor had he just knocked it out. Each cardboard box held its own full-length book. Put together, they must weigh in at three thousand pages, maybe more.

I started to flip the pages.

All of them were blacked out.

Line after line, page upon page, had been carefully expunged with Magic Marker. The urge to secrecy, apparently, had proved the deepest and strongest of all Max's hungers, and his final act had been to obliterate himself.

Or not quite. Rising to leave, I gave the manuscript a good-bye riffle, and my eye fell on page 87. A few lines near the bottom appeared to have escaped the censor. An oversight? Or had Max, at the last, balked at leaving no trace? On closer inspection, I found other survivors. Eight lines on page 134, a paragraph on page 226, almost all of page 287. Then a single line on page 353, a block on page 488, the end of page 515 and the start of page 516. Scattered through nine volumes, these amnesties added up to precious little. Still, I bundled the cardboard boxes together and slung them into a Hefty bag. They might, at the least, yield a few anecdotes.

When I emerged from the sanctum, Habib was waiting in the hall. The suit buttons looked about to pop across his belly, the pants were at least two inches too short, his smile was full of rotted teeth, but his triumph was absolute. "That will be all," he said, and shut the door behind me.

THE JOURNALS OF
MAX VAIL

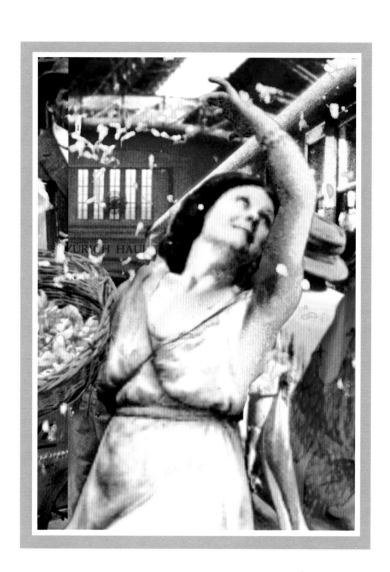

DOES HE THINK HE CAN HOLD BACK PROGRESS?

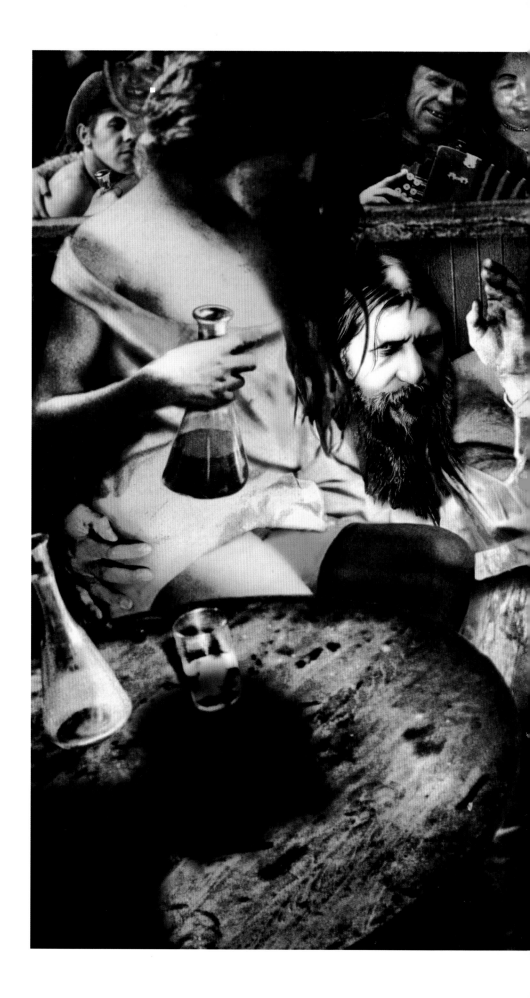

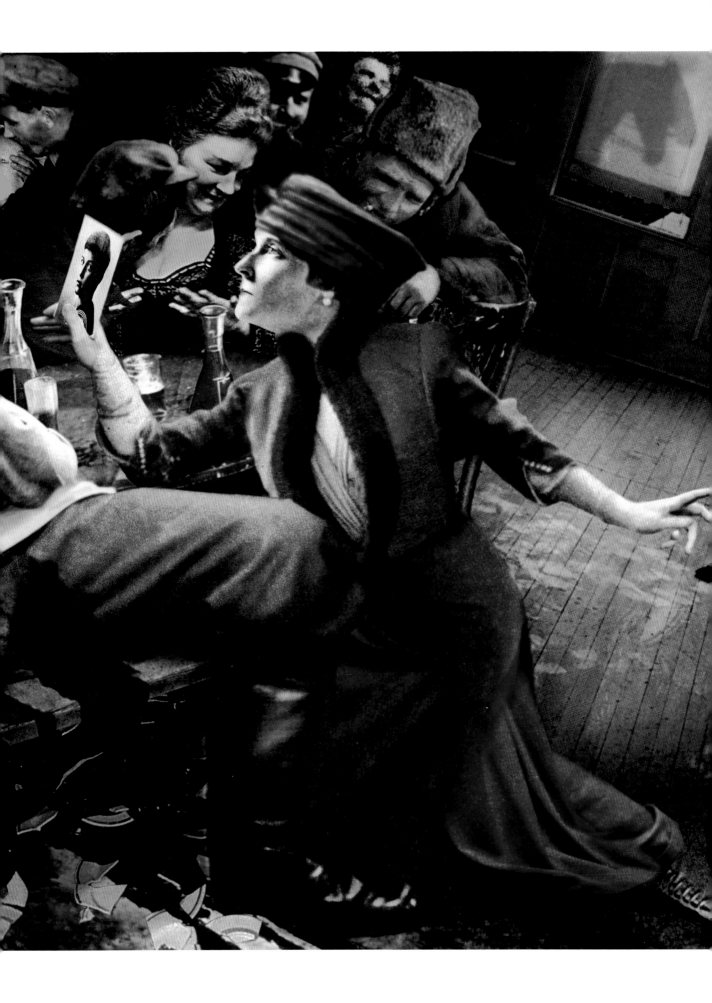

On the night of my tenth birthday, too cold to move another step, I lay down in a doorway and waited to die. The next thing I knew, Rasputin's rough beard was tickling my face. "You need a drink," he said. He dragged me into a low tavern and poured vodka into me. I remember his breath, like a foul-smelling blanket that choked me and made me feel faint. And the weeping woman who flung herself at his feet. "Come home, Little Father. Your children need you," she cried, but the monk merely called for more drink. Through the tavern door, I could see the coachman waiting in the snow. The night sky was full of flame.

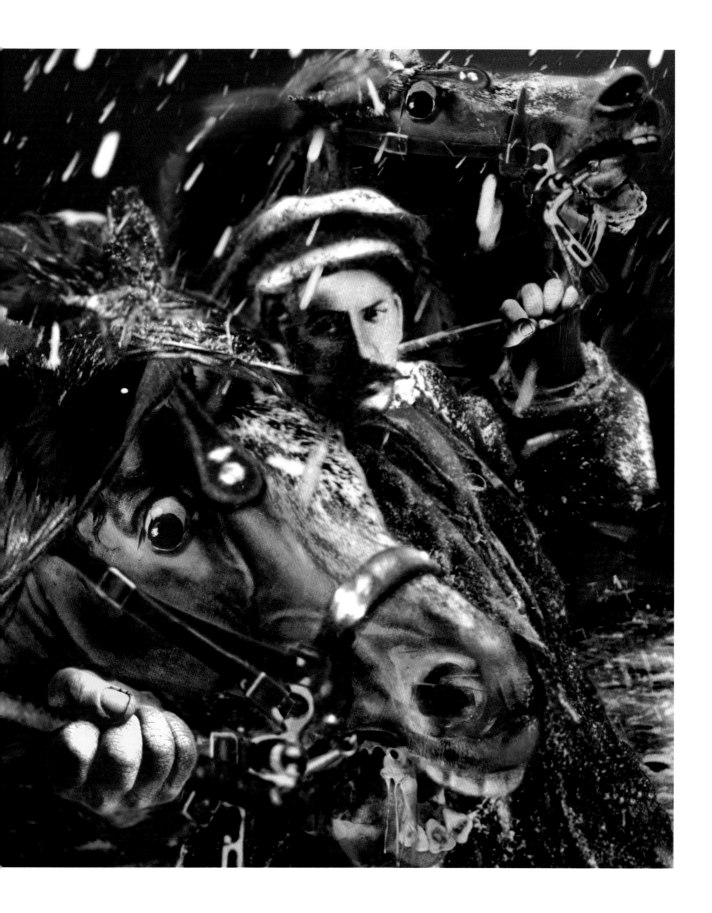

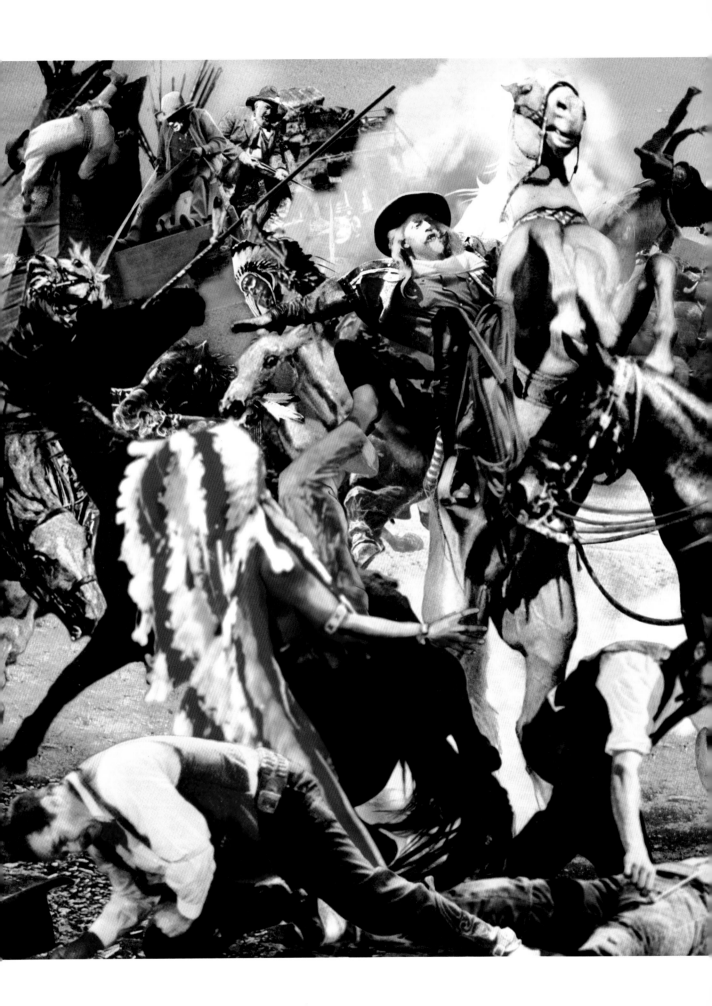

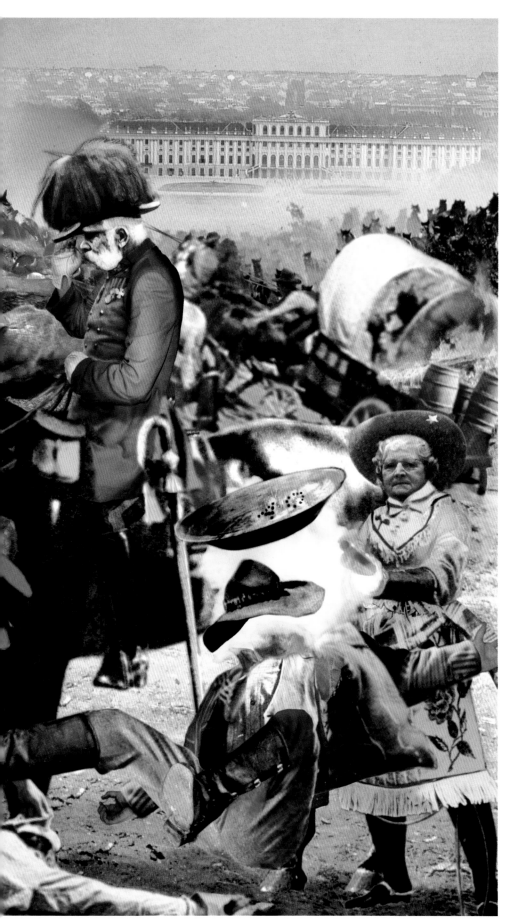

Mr. Cody was always a true gentleman. By the time I joined his troupe, his legs were crippled by rheumatism, his liver and kidneys shot, his heart failing, yet he comported himself like a king and expected to be treated as one. This the Emperor's flunkies failed to do. The Great Scout found himself housed in the stables, his Wild West Show derided as old-fashioned nonsense. As a result, his performance the next day was unusually ferocious. Once again, as in his prime, he roamed the range in glory—the noblest whiteskin of them all. But afterward, when presented to the Emperor, his anger quickly abated. They were simply two old-timers, after all. "Pleased to make your acquaintance," said Buffalo Bill, reaching for his hip flask. "Perhaps Your Majesty would care for a nip?"

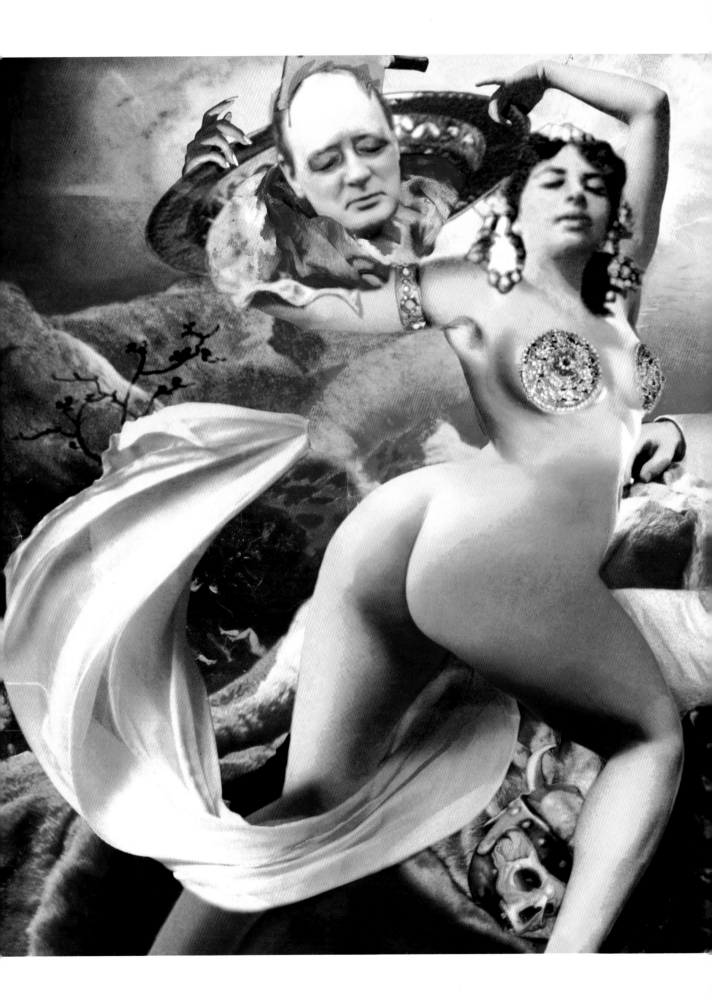

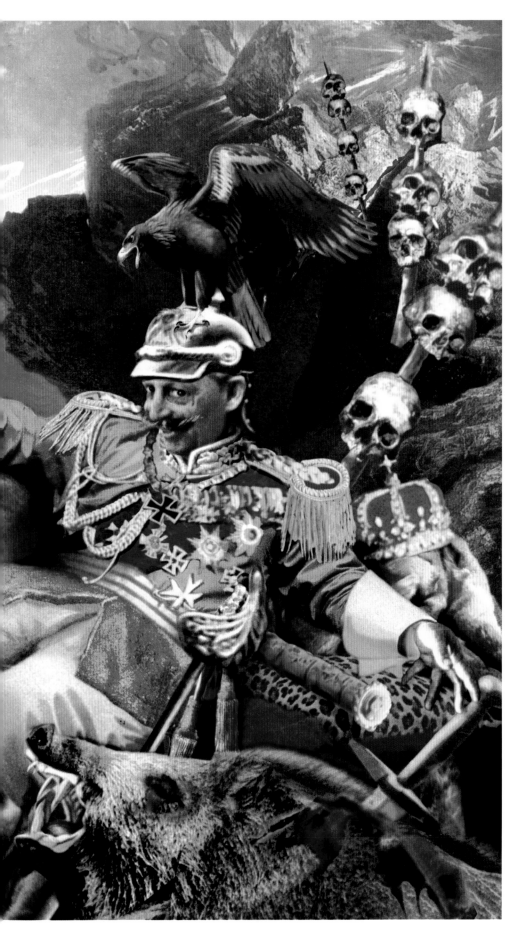

She couldn't blame the Kaiser; he had no way of knowing what he was missing. Each morning for two months she'd presented herself at the offices of his advisors and demanded an audience, but she was always turned away. The bureaucrats saw only a middle-aged woman of no account, run to fat, her flesh mottled from the blue dye she'd used on stage. Still, she refused to give up. "I have brought the Kaiser a gift," she said.

"What gift?"

"Joy."

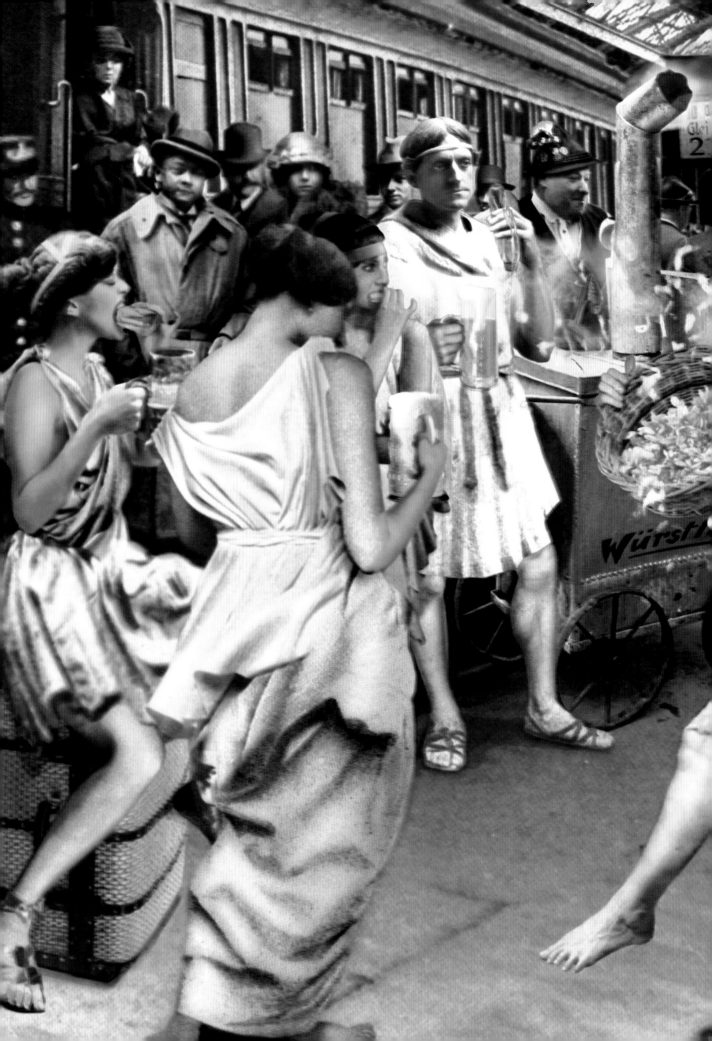

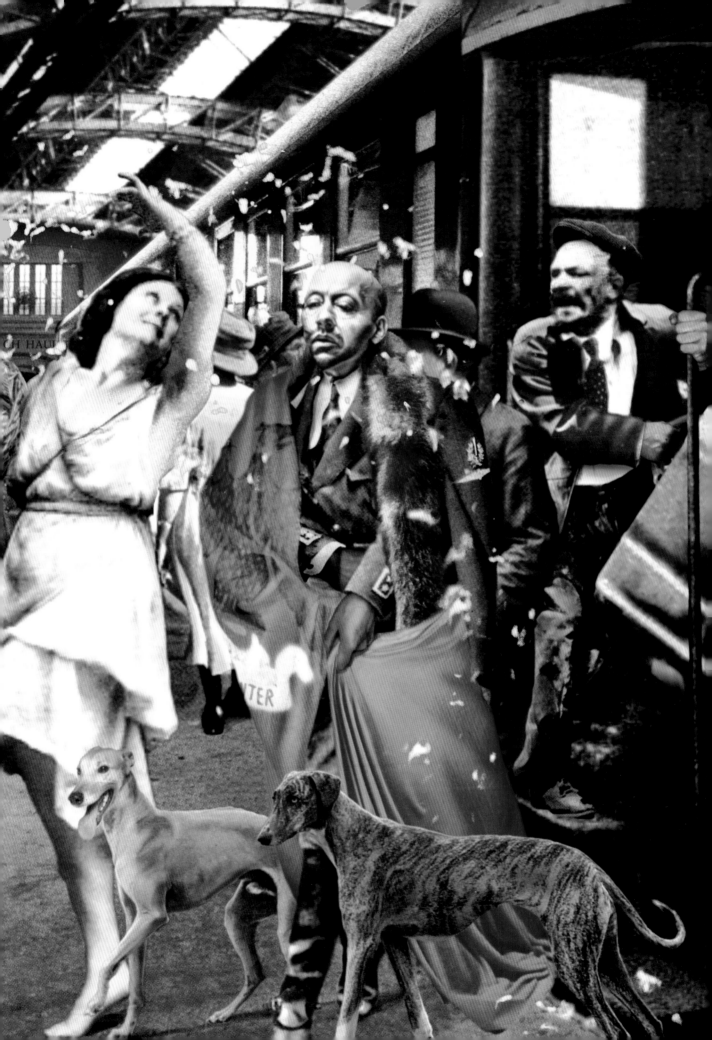

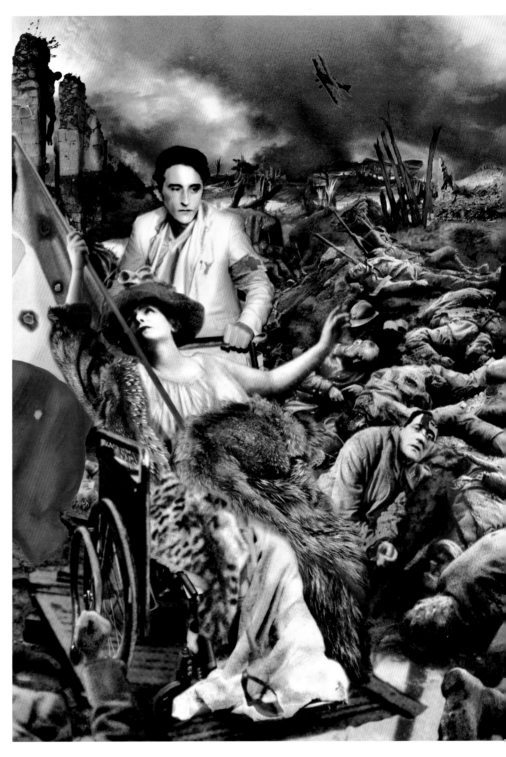

PRECEDING PAGES:

In all her years before the public, Madame Duncan had never been so humiliated. "God forgive you, for I can't," she said to the harassed railway officials, but they had their orders and could do nothing to help. The train that was to carry her from Zurich to St. Petersburg had been commandeered, nobody would tell her why, and the odious man who seemed to be in charge refused point-blank to allow her on board. "Philistine!" Isadora cried, but did not forget her dignity. She must not let her dancers see her despair, nor her adored D'Annunzio, who had traveled all this way to wish her bon voyage. With careless gaiety, she turned her back on the ignorant lout. "Silly little man," she scoffed. "Does he think he can hold back progress?"

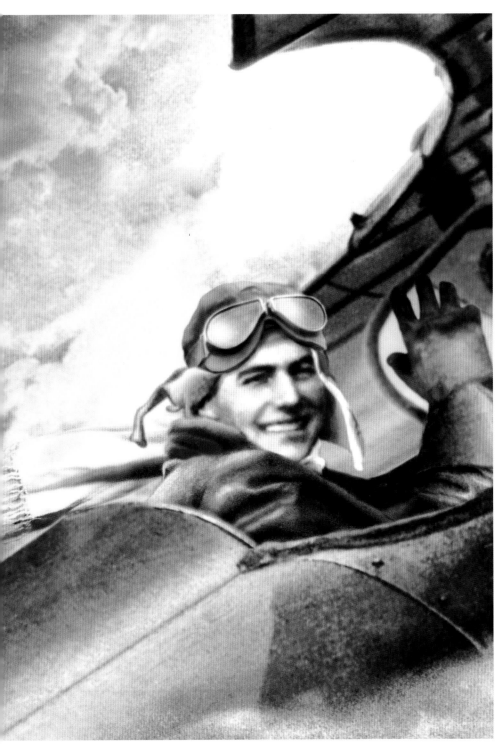

It was Bernhardt's finest hour. Though old and maimed, she dragged herself to the front for one last tour, performing in hospital waiting rooms, in decrepit barns or even in no-man's-land, among the dead and dying. Her every word was vibrant, delivered in a pounding rhythm that mounted like a battle charge. Even she could not compete, however, with the insolent young pup of an American airman who insisted on turning dipsy-doodles overhead. The more furiously Cocteau waved him off, the lower the airman flew, until the great tragedienne was rendered almost inaudible. *"Objet infortuné des vengeances célestes!"* I heard Sarah declaim, but the flyer, oblivious, just grinned. He seemed to think himself clever.

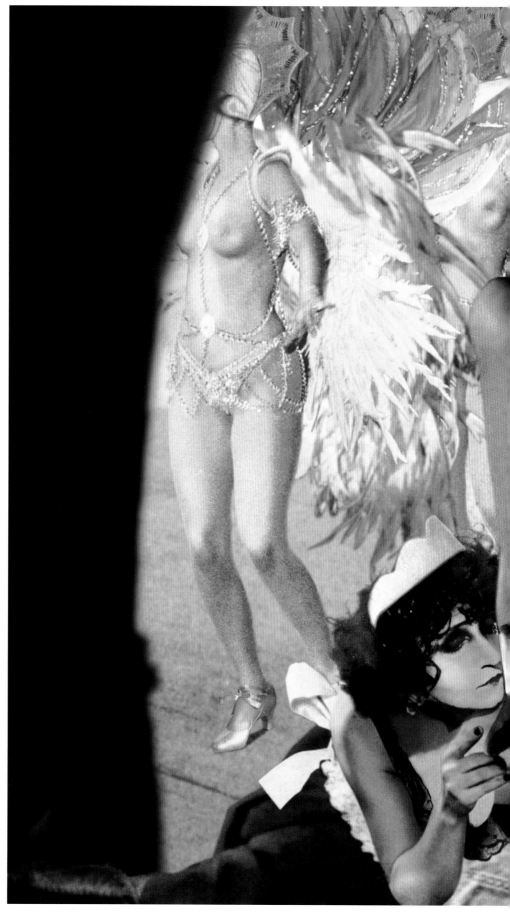

You don't stay at the top for sixty years with just a pair of fabulous legs. A born perfectionist, Mistinguett ruled those who served her with a steely will, and did not hesitate to discipline them if they fell short. Sometimes this led to misunderstandings, as in the case of the unworldly Irishman who wandered backstage one night, claiming to be researching a novel. "Would I be correct in supposing that you are, ahem, sisters of Sappho?" he asked.

"Monsieur!" Mistinguett was outraged. "We are artistes!"

"Oh," said Joyce, crestfallen. "Not literally clitoral, then?"

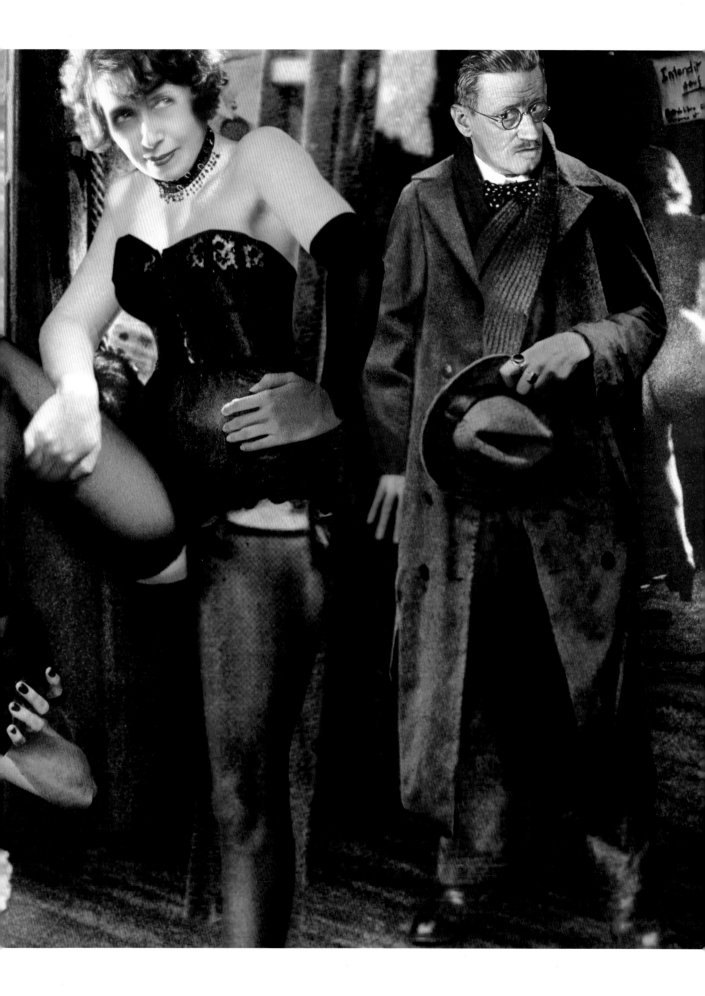

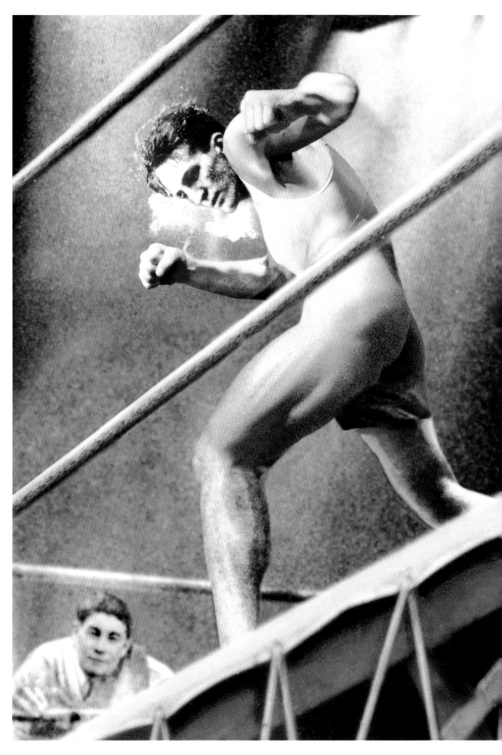

That last summer, Marcel would sometimes drag himself from his sickbed and request that I take him for a drive. One day I arranged for him to visit Carpentier's training camp near Versailles. "I am told he is named the Orchid Man," he mused, as the champion wheeled and shadowboxed above his head. "Strange name for a gladiator."

Only when his manager, Descamps, called "Time" was Carpentier free to talk. Marcel examined his face closely, as if searching for clues. "You remind me of my friend Agostinelli. He used to be my chauffeur," he said at last. "His black rubber cape, and the hooded helmet, which enclosed the fullness of his young, beardless face, made him resemble a pilgrim, or rather, a nun of speed." Though the pugilist made no reply, Marcel was not deterred. "May your boxing gloves, like the steering wheel of my young mechanic, remain the symbol of your talent," he continued, "not the prefiguration of your martyrdom." But the wily Descamps had heard enough. *"Eh, bien,"* he called out hastily. "Time."

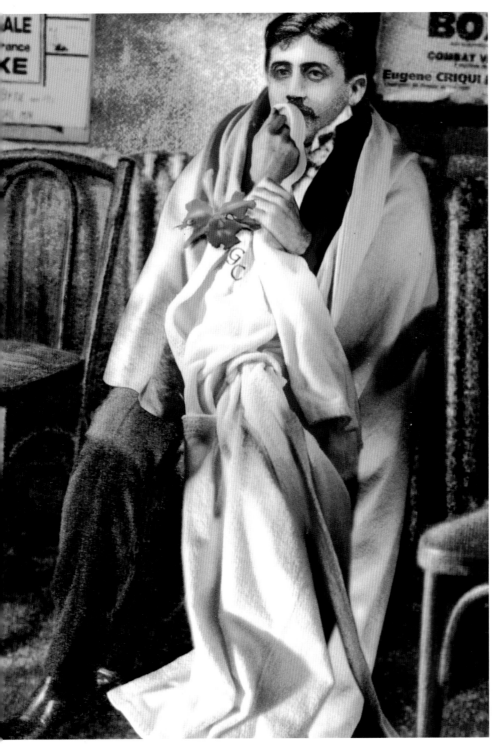

OVERLEAF:

I had never seen Rudy so angry. The morning's batch of American papers had included a cutting from the *Chicago Tribune*, headlined PINK POWDER PUFFS, calling him effeminate. As he raged through the lobby of the Negresco, his fury made the bellhops cower and little old ladies run shrieking for cover.

And now this! The final insult! A man who not only dared to copy his costume from *The Sheik*, but actually flaunted it in his face. It was time to draw a line in the sand. Descending on the wretched impostor, Rudy slapped him twice across the cheek. "Take your punishment like a man," he growled.

"Yes," said Lawrence. "Please."

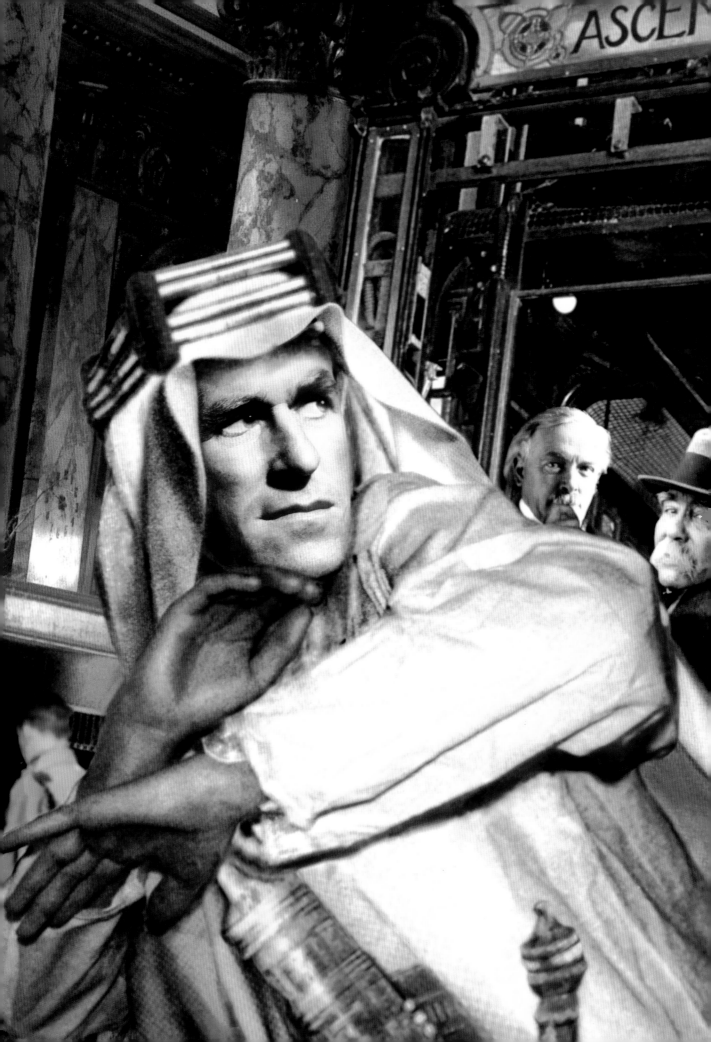

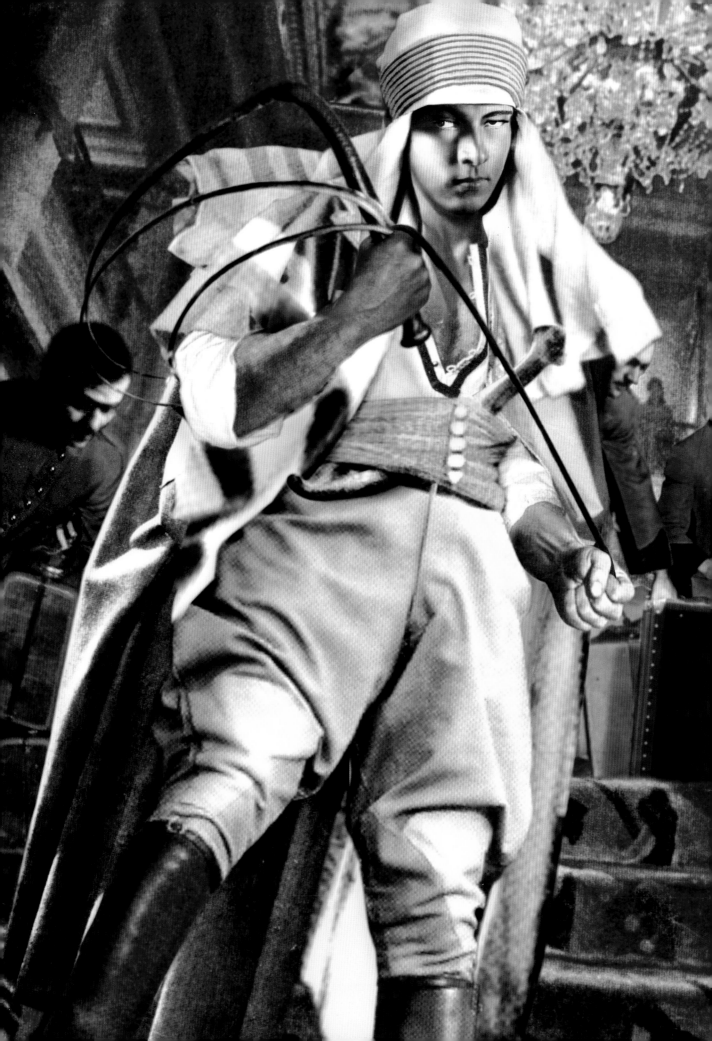

As Tzara walked from the Gare de l'Est, he was approached by a girl of the streets. "Have you got a light, *chéri*?" she asked roguishly.

"Dada is a virgin microbe," the poet replied. "The angel has white hips (umbrella virility)."

"Here, watch your mouth," said the girl.

"No more vigor! No more piss passages! No more enigmas."

At the streetwalker's scream, her protector leaped from the shadows and made a grab for Tzara's suitcase. "Roar roar roar roar roar roar," Tristan shouted, but the apache would not relax his grip. Slowly the case slipped away. "Dada is dead," the poet cried out. And the locks flew open.

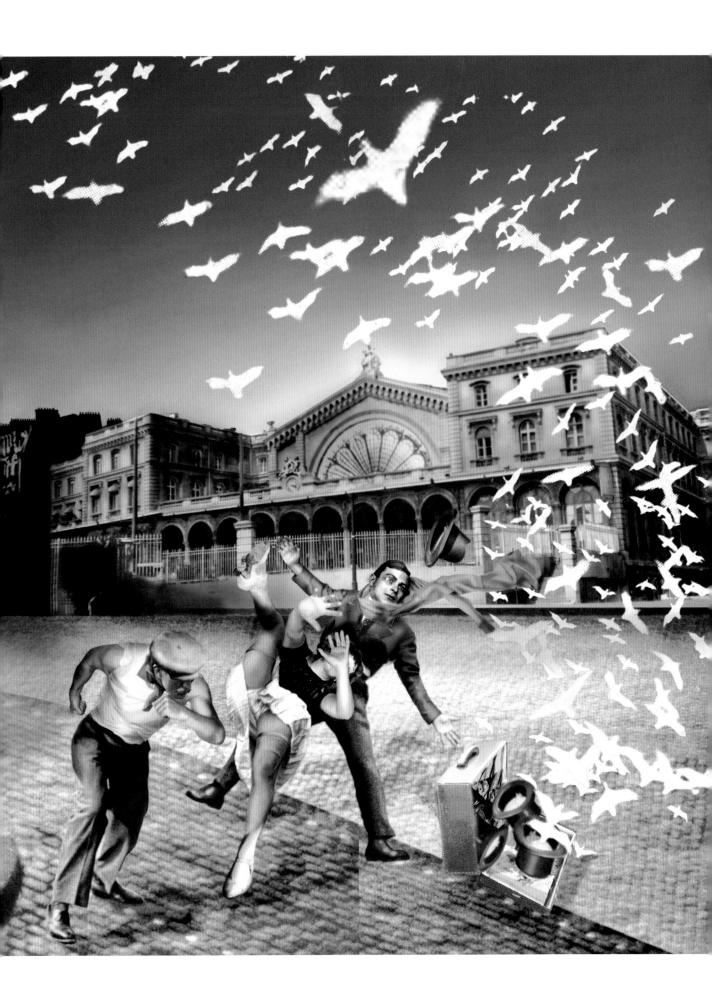

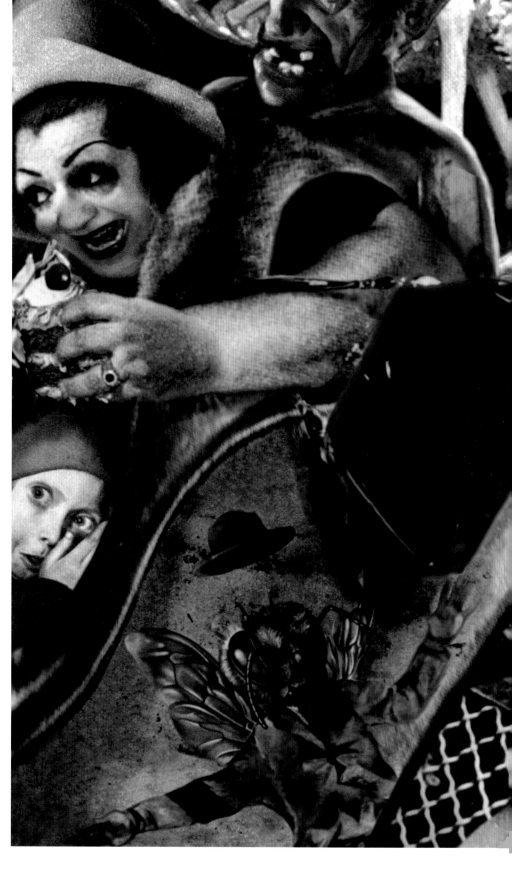

Only those who knew Franz best were aware of his sense of fun. One day in the sanatorium, not long before he died, he talked to me of the time that he went to the Prater with Milena, his love, and took her on all the rides. Their favorite was the Ghost Train. "It reminded me of school," he said, and was instantly transformed into an undernourished, saucer-eyed child. How his nurses laughed!

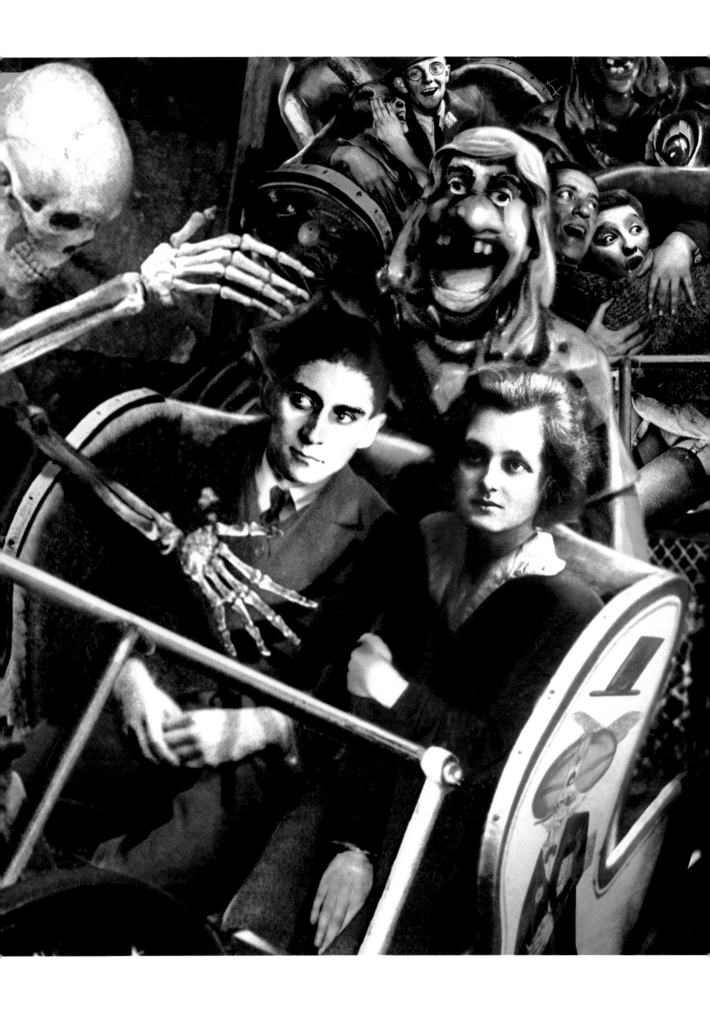

TAKE US TO THE REGULAR JOES . . .

Foxx

Gehrig

Ruth

Home Plate

$$m u_i \quad \left| im\left(\frac{1}{\sqrt{1-u^2}}-1\right) \text{Kin.Enrg.} \right.$$

$$\sqrt{1-u^2} \quad \sqrt{1-u^2} \quad \sqrt{1-v^2}$$

$$\text{Hyp.} \sum c_i = \sum$$

$$x = \frac{x' + u t'}{\sqrt{1-v^2}} \quad y = y' \quad z = z'$$

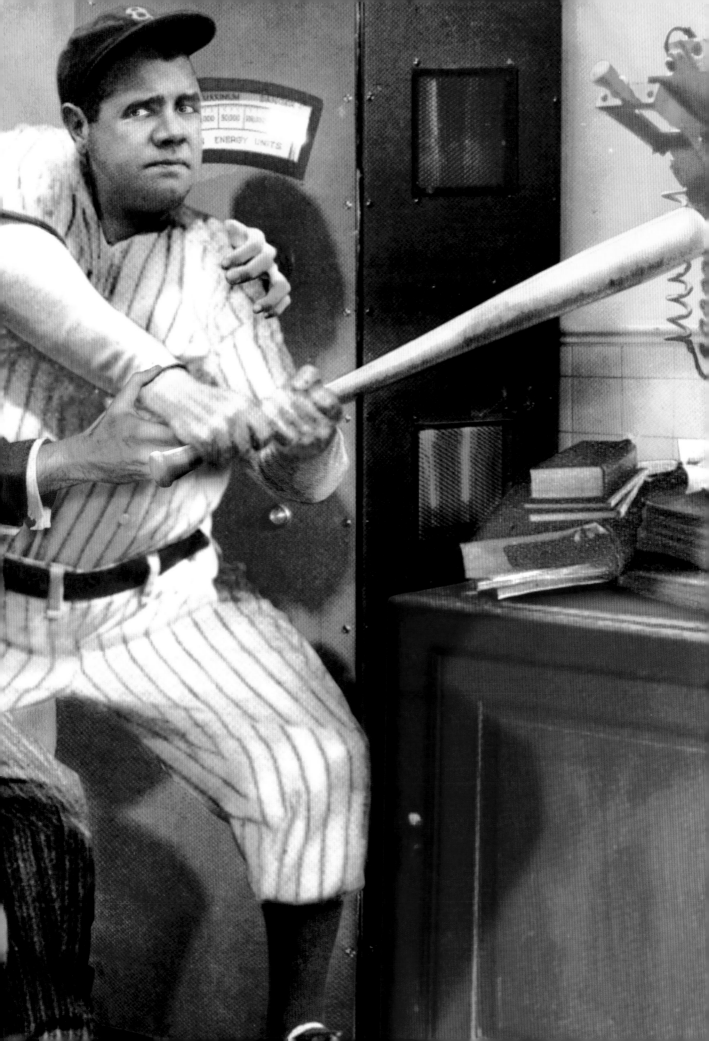

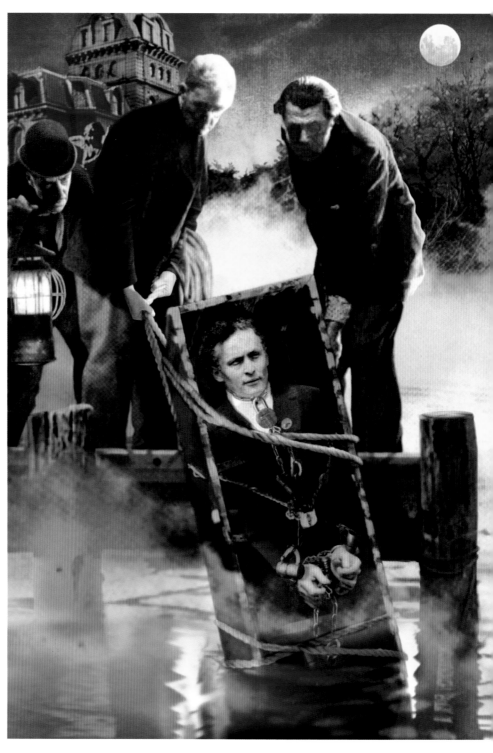

PRECEDING PAGES:

I dunno," said the Babe. "He don't look like no slugger to me." But he was in no position to argue. For the last two months, his home-run stroke had deserted him and the press had started to hint that he might be finished. All other remedies having failed, I took him to see my friend Albert. Although a Giants fan himself, the physicist was more than happy to help. "Mass and energy are equivalent," he explained. "The velocity of light is independent of the motion of its source."

"Come again?" said the Bambino.

"First see it. Then hit it." With a mighty swing of his bat, Einstein sent the ball rocketing through the lab window. By the time the sound of shattering glass had died away, Ruth was all smiles again. "Just one more question, Al," he said as we took our leave. "Can you do anything for the clap?"

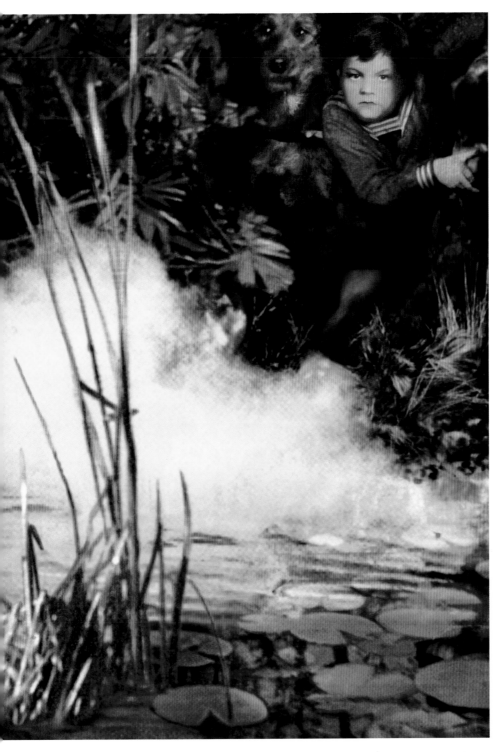

It was a season of signs and wonders. Orson's father had purchased a rambling, falling-down hotel in Grand Detour, popular with traveling showmen. A steady stream of mountebanks, snake-oil salesmen and illusionists passed through.

Then came this man who promised the greatest marvel of all—that he would drown himself, yet survive. The boy prepared to watch him die, but the magician proved as good as his word. The impossible, Orson realized, was simply a knack.

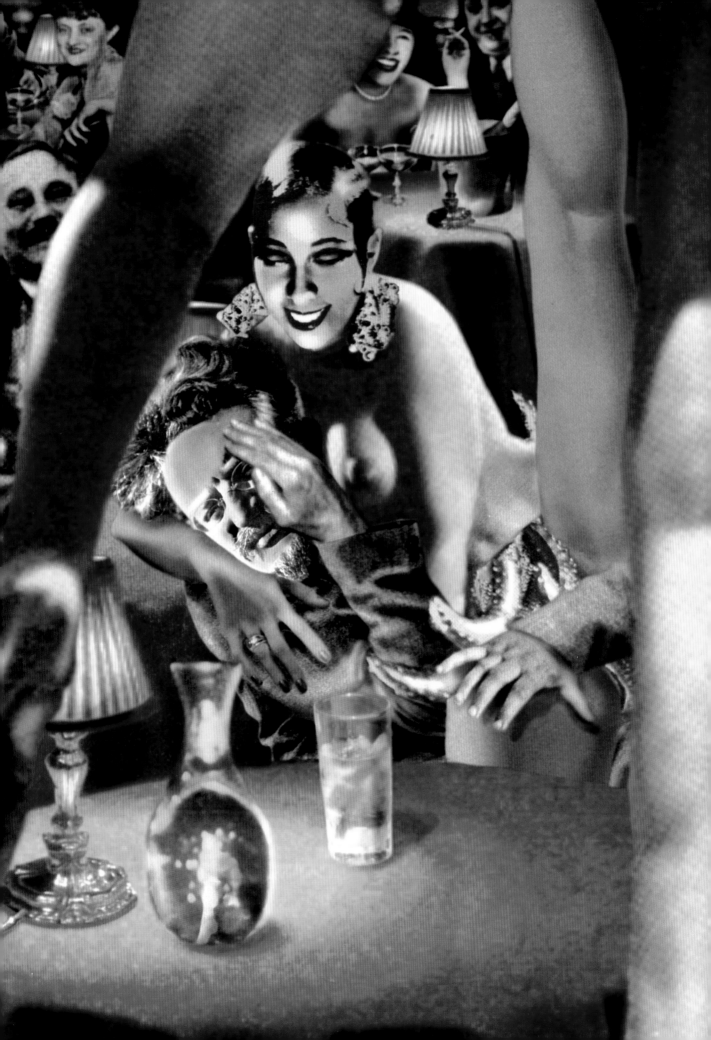

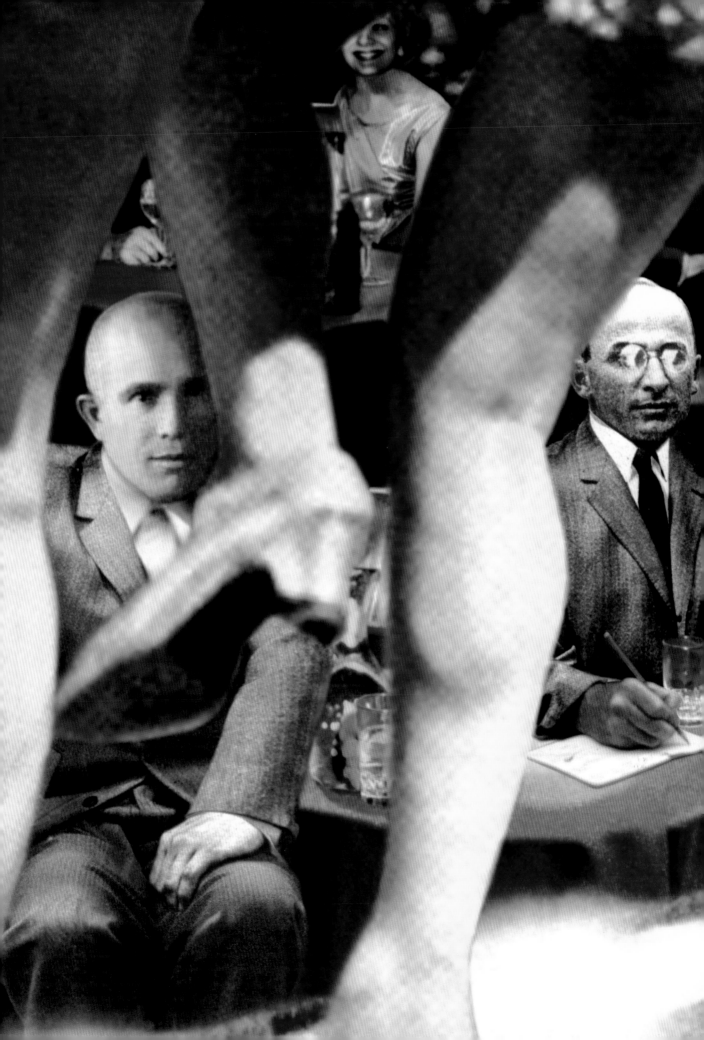

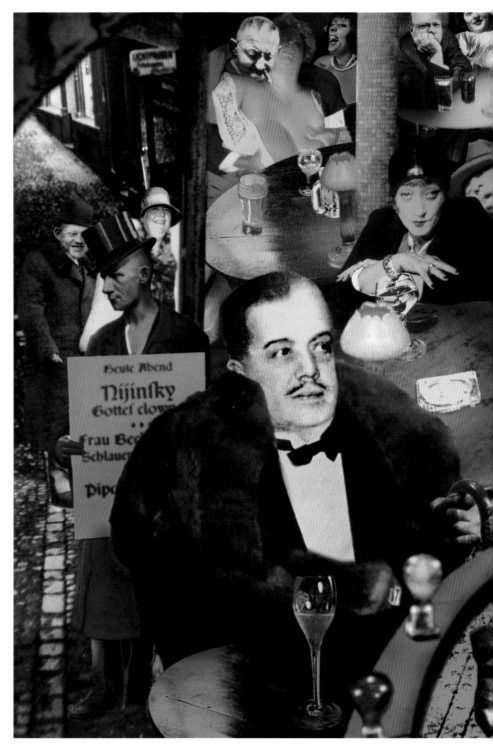

PRECEDING PAGES:

That morning Trotsky received the order recalling him to Moscow, and he knew that his goose was cooked. Having nothing left to lose, he spent his last evening at Chez Josephine. He was a great admirer of Miss Baker's art, but Khrushchev, that young thug, misunderstood as usual and treated her disgracefully. Mortified, Leon asked her back to his hotel, where they sat up talking till dawn. When he asked about her childhood, Josephine recalled a race riot in East St. Louis. "I'll never forget the screaming," she said. "A friend's face shot off, a pregnant woman cut open. I still see them running. I've been running ever since."

The following day, after Trotsky had left, Josephine discussed him with her friend Bricktop. "A strange man," she said. "He never once tried to get me into bed."

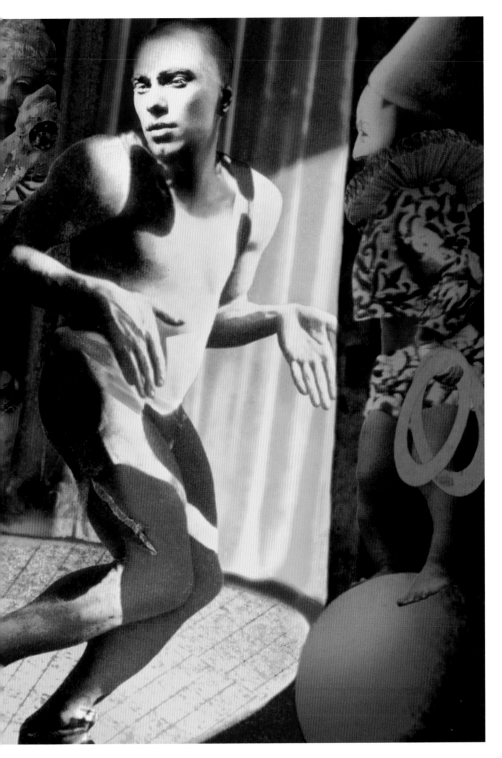

Diaghilev's rage was volcanic. First the breakfast tray went flying, then the samovar, then the Meissen shepherdesses. "It's a fraud. A dirty lie," Sergey shrieked.

We had thought that Nijinsky, hopelessly insane, was confined to a Swiss asylum, but the morning paper reported that he had dismissed his doctors and was appearing, for one performance only, at the Blue Angel.

"My poor Vaslav! The incomparable, the divine, reduced to a peep show for drunkards and whores." Diaghilev's black-rimmed panda's eyes were wet with tears, and he shivered inside his heavy overcoat. "I refuse to dignify such a travesty with my presence," he declared. But that night he showered the stage with bouquets. "Your genius is imperishable," he told the dancer later, and kissed him tenderly on the forehead.

Only on the drive back to the hotel did Diaghilev drop the pretense. "Midnight of a faun," he said.

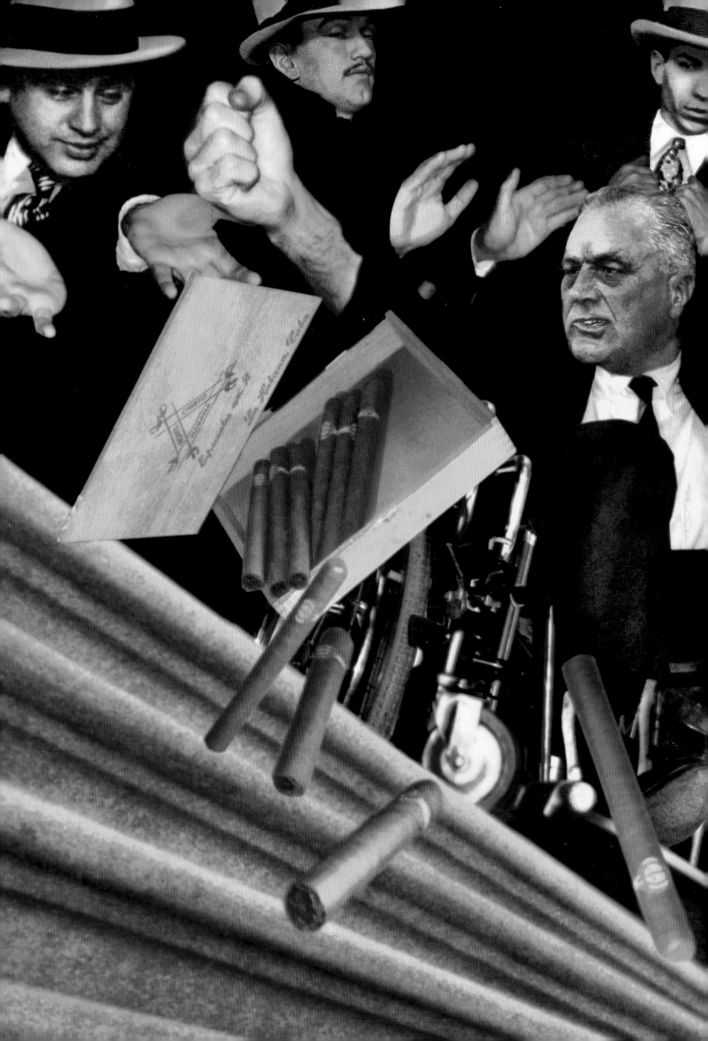

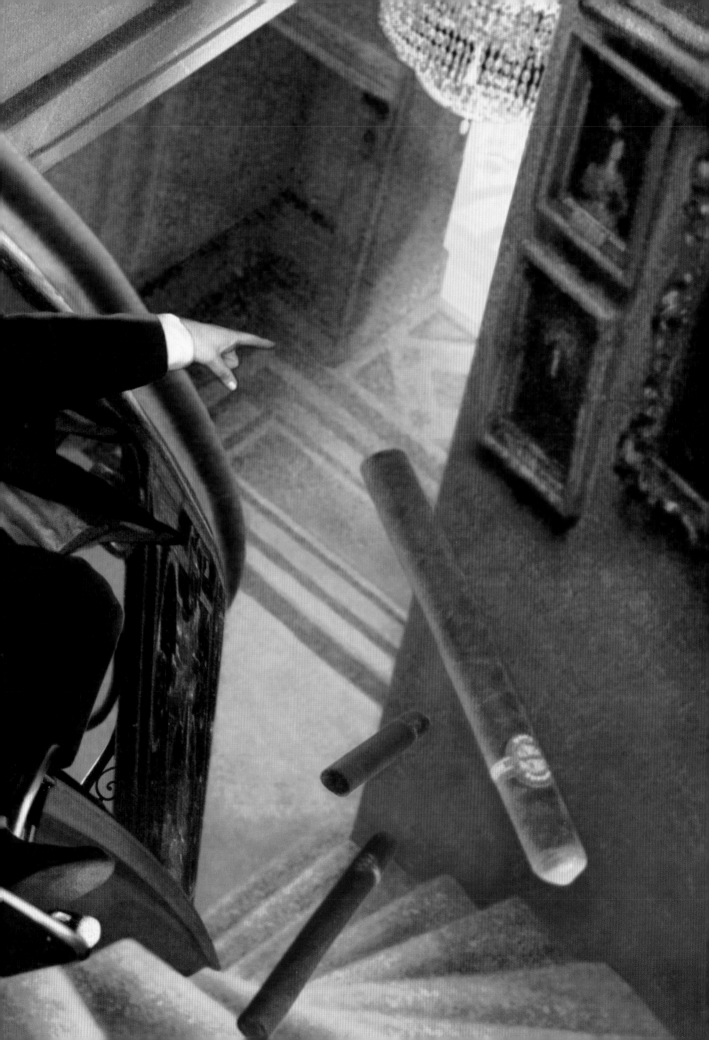

Capone always wore his heart on his sleeve. So long as you were his pal, he was happy to give you the world. But if he felt you'd let him down, he could turn quite petulant.

When F.D.R. made governor, Al was thrilled for him. He broke short his vacation in Havana and rushed to Roosevelt's side, armed with a box of the best Romeo y Julietas. "You and me," he said, "we speak the same language. We're both patriots, and we're both in the freedom game. If we stick together, the sky's the limit." The governor, however, turned out to be a prude. "I don't do business with hoodlums," he huffed, a remark that cut Capone to the quick. In a trice, the cigars and soft smiles were forgotten. "If there's one thing I can't stand," Al remarked, "it's a man whose hat's got away from his head."

Shakespeare, said Doug, was a crashing bore. Fairbanks wished he'd never let Mary talk him into filming *The Taming of the Shrew*—a lot of tiresome palaver—when he could have been shooting tigers in India or chasing crocodiles up the Amazon. The trouble with the Bard was that he never knew when to shut up. Nor, come to that, did Mary's new friends. Some of the windbags she invited to Pickfair these days were simply beyond the pale.

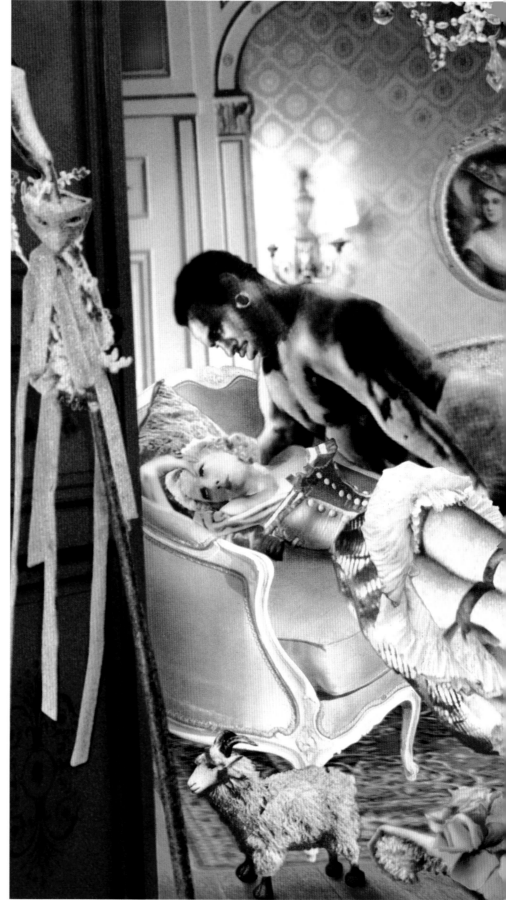

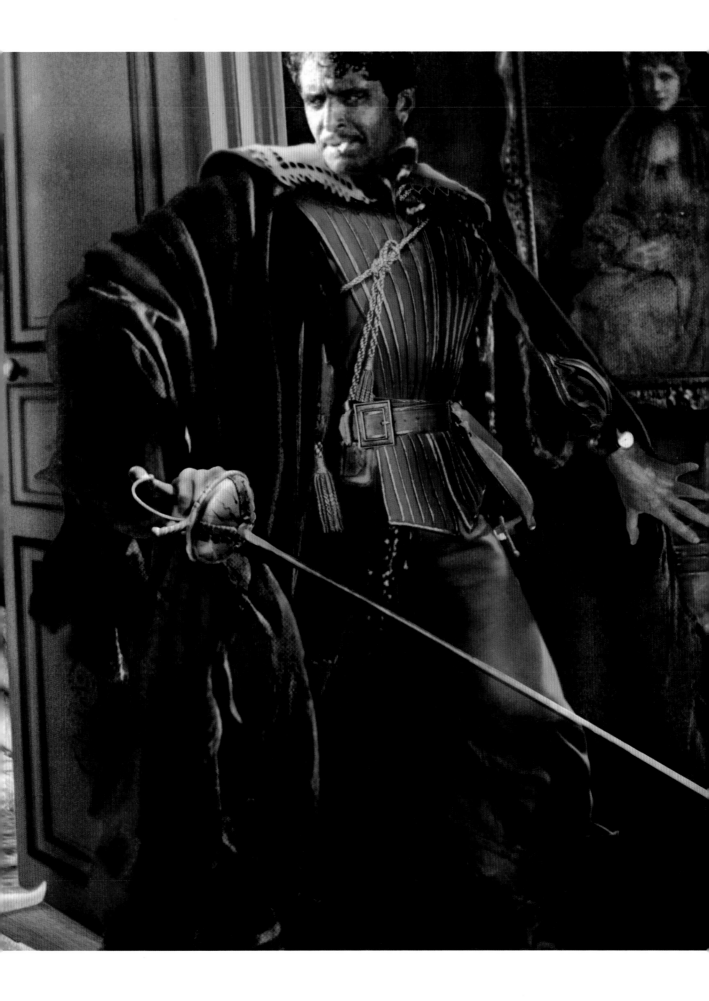

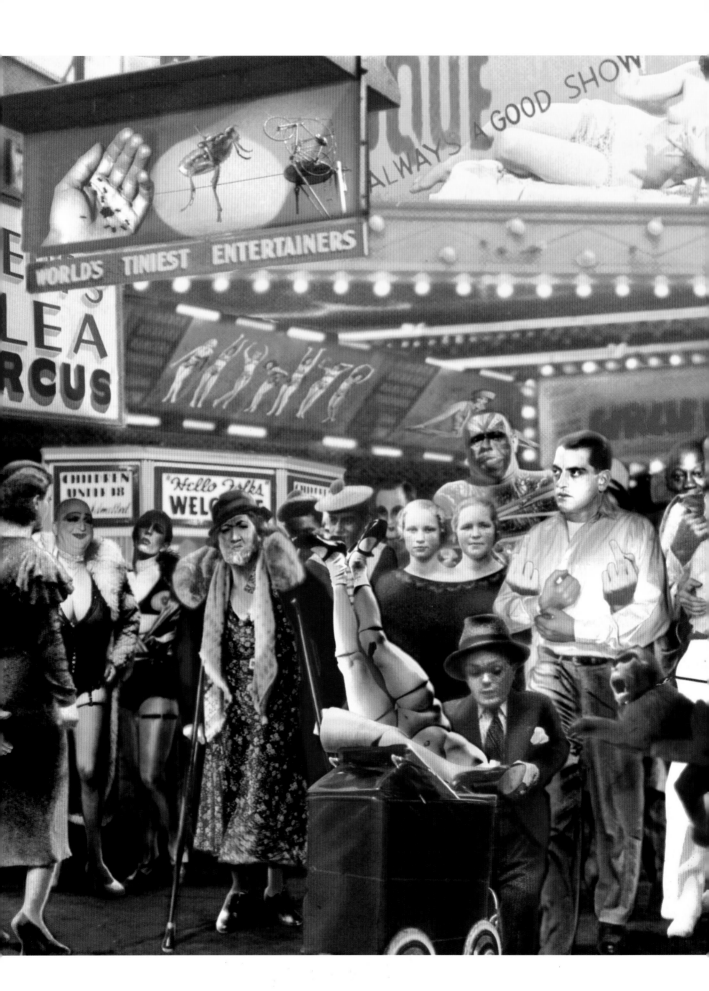

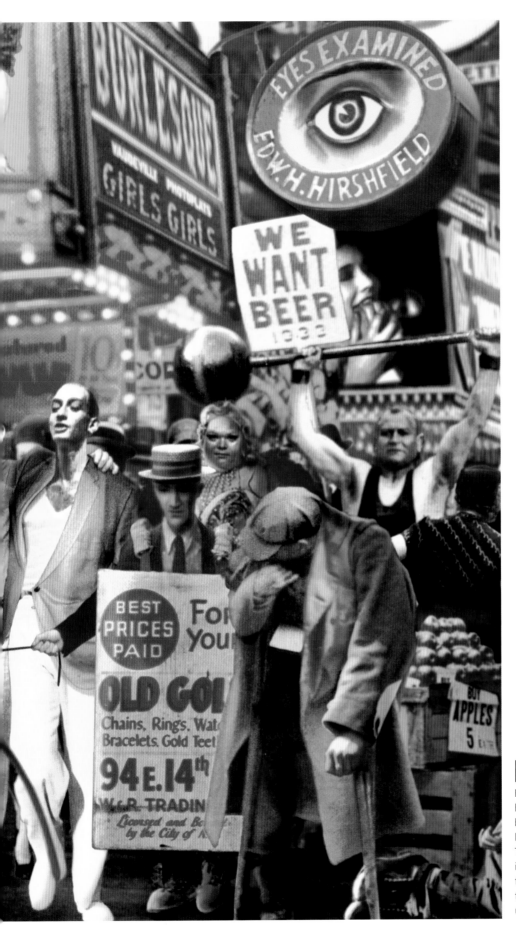

My duties as host were not always easy. The arrival of Dalí, Buñuel and García Lorca in New York had been so eagerly awaited—every budding Surrealist in Greenwich Village was dying to meet them. The Three Musketeers, however, had no interest in being lionized, preferring to walk the city streets. "Who needs these arty types?" Lorca said. "Take us to the regular Joes."

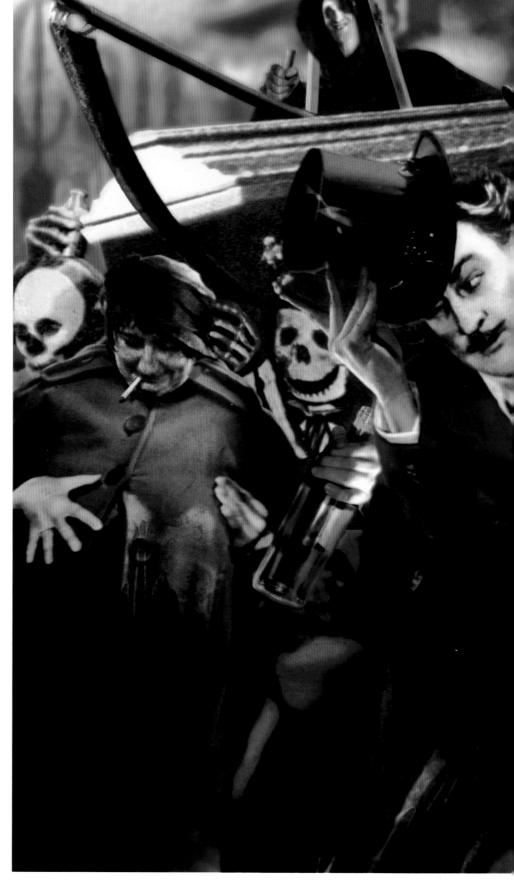

At midnight, the moment when Prohibition was officially dead, Times Square filled with drinkers dressed up as mourners, wild to dance on the grave. At the height of the wake, Barrymore recalled his friend's beginnings as a master juggler. "Give us the Lord's burning rain," he demanded, and Fields did not hesitate. Grabbing five bottles from bystanders, he began to flick them into the air and then, as they sped through his hands, to open them. One by one, while the bottles hurtled higher and higher, their corks flew off and the crowd was drenched with bootlegger's rum, which fell on their upturned faces like a healing shower of gold.

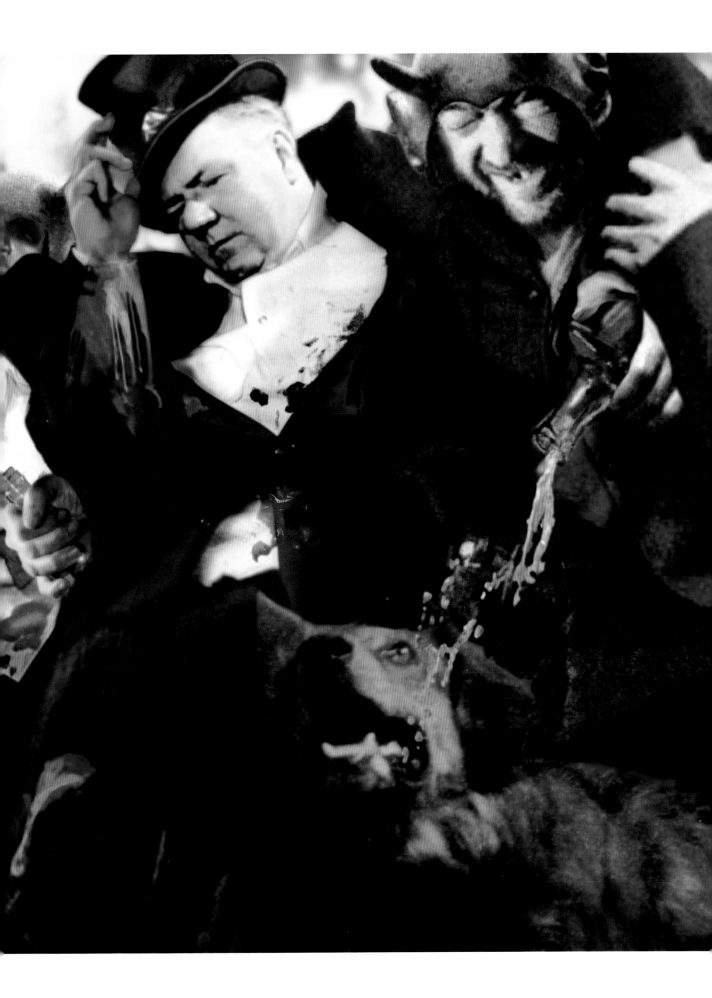

To Fred, Bonjangles was simply the Master. Their nights in Harlem were epics of good fellowship, though sometimes Astaire was prone to get overexcited. Once he phoned me at dawn, sounding uncommonly flustered. "I'm lonesome," he said sheepishly.

"How come?"

"I'm with a young lady who wishes to be remembered, and I lack the wherewithal."

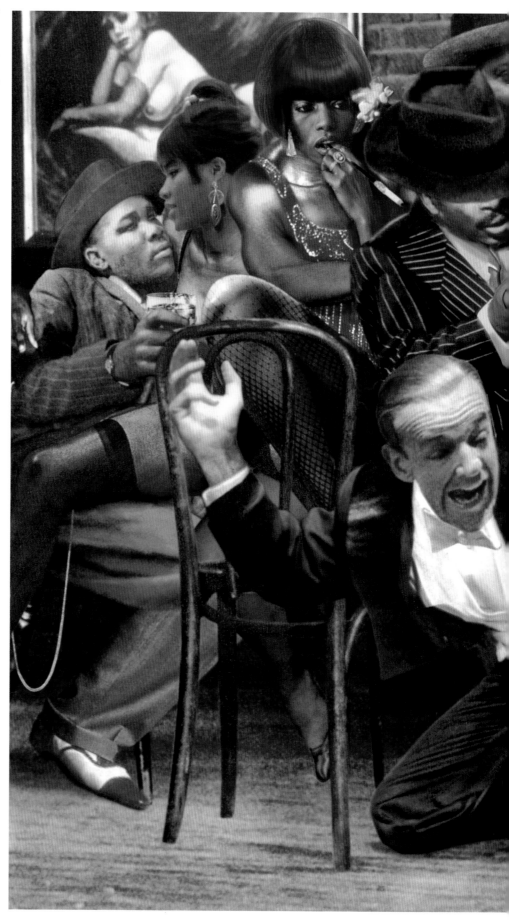

OVERLEAF:

Dr. Schweitzer did not wish to seem ungrateful, but this visit had been a mistake. Every minute he spent in Hollywood served only to remind him that his home was in Lambaréné. "This town is an inferno of vulgarity and folly," he lectured his host. "I must return to Africa."

"No sooner said," De Mille replied, "than done."

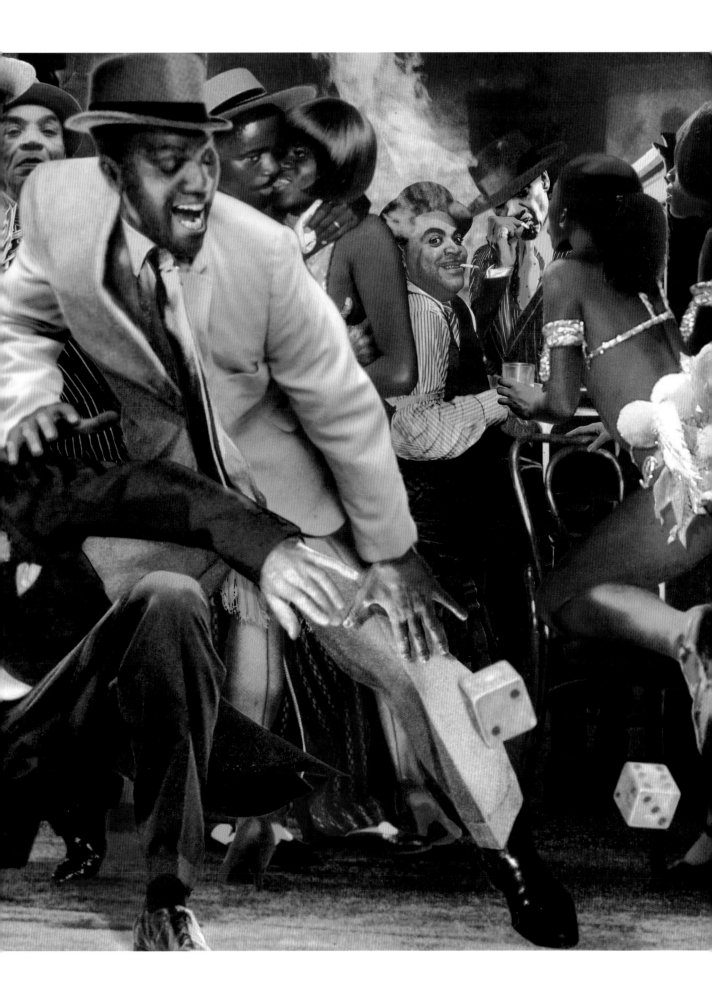

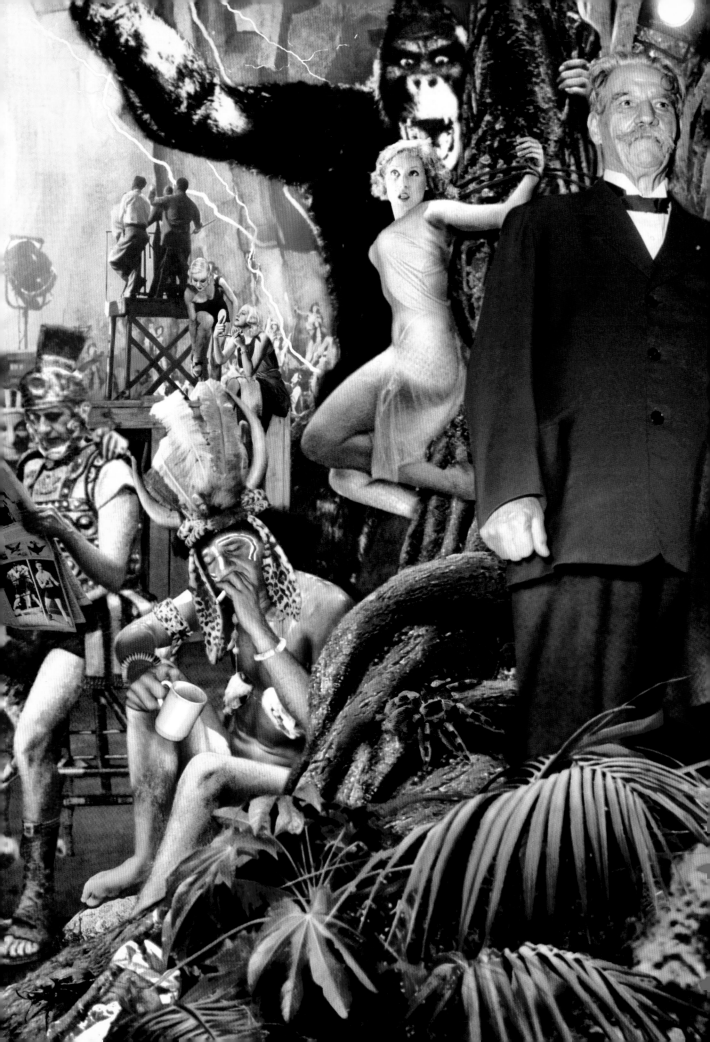

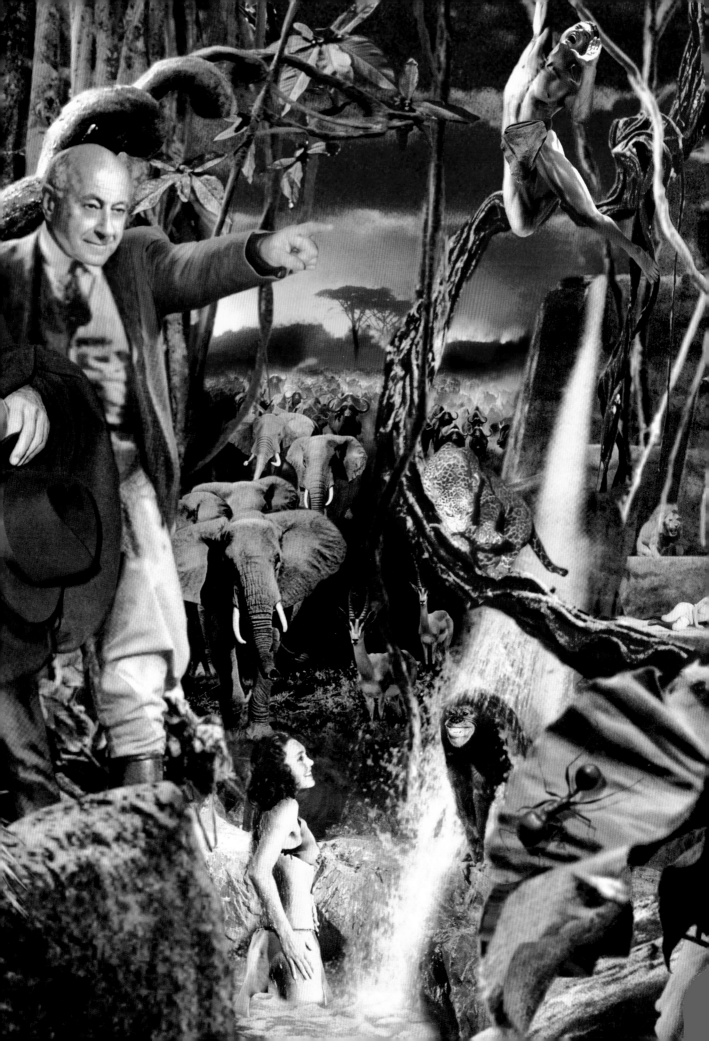

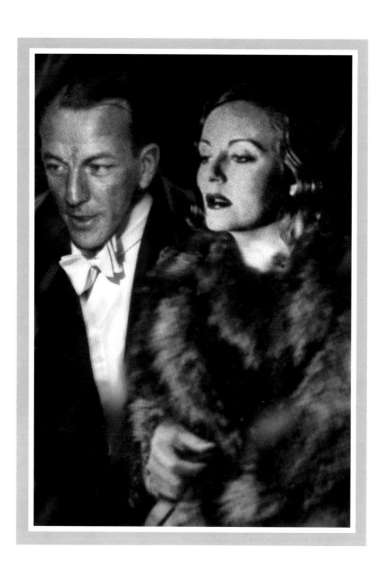

A CANAPÉ FOR ROBINSON

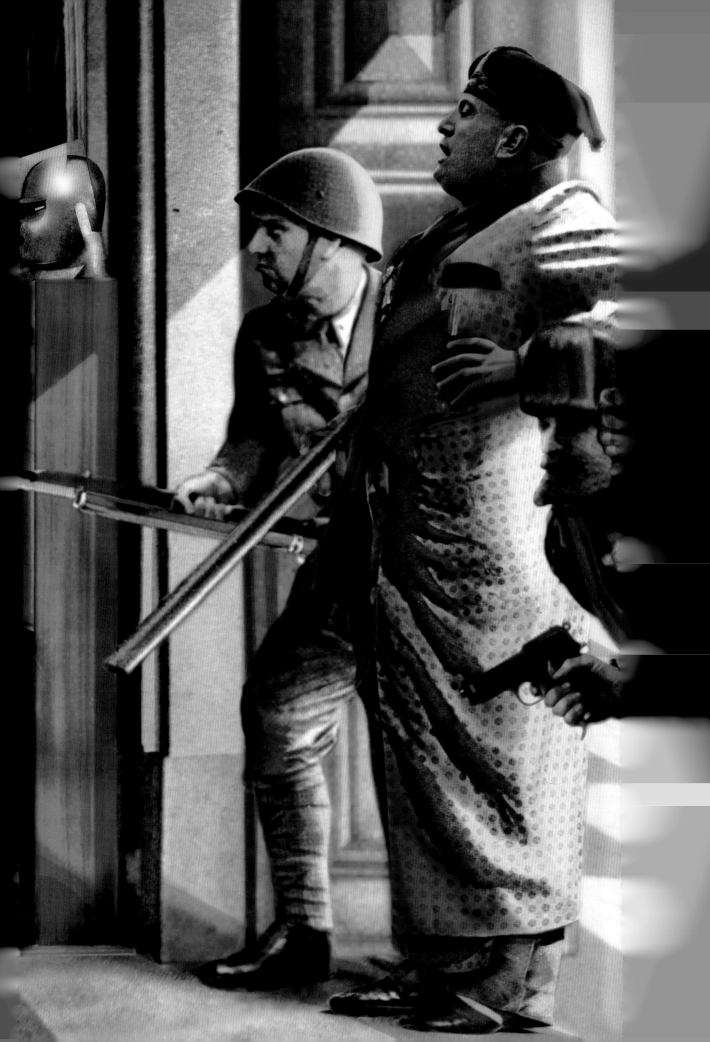

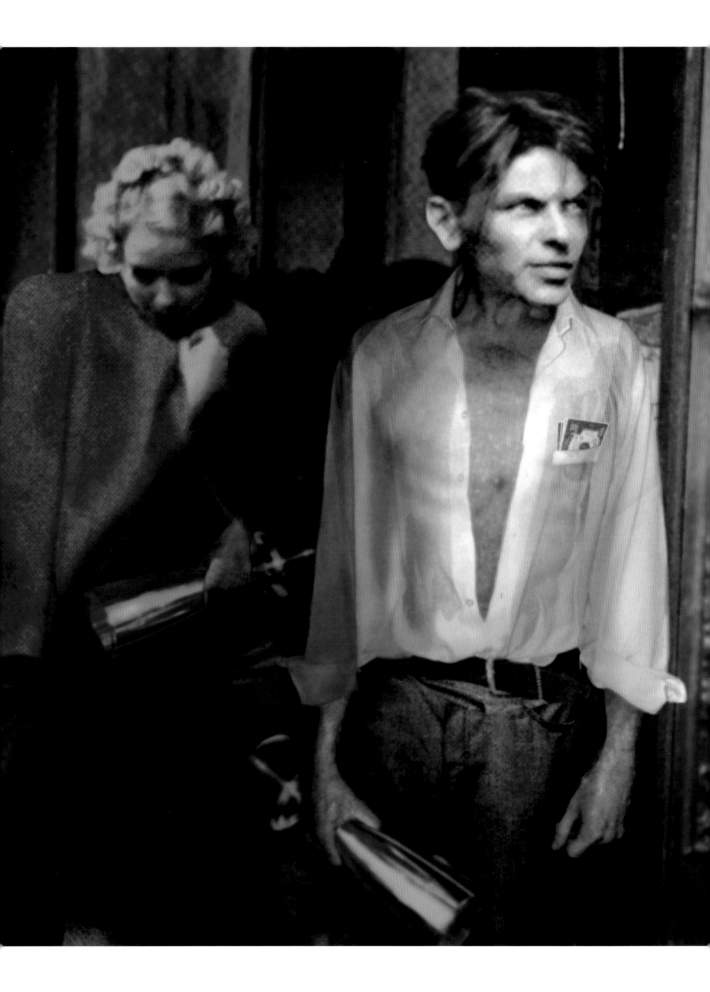

PRECEDING PAGES:

That night at the Palazzo Venezia, long after the banquet was over, il Duce was wakened by the sound of an alarm bell. Normally he would have let his guards deal with the matter, but a quick check revealed that the problem was in the basement. Snatching up his shotgun, he rushed toward that holy of holies, where he kept his most valued possessions. What vile traducer, he asked himself, would dare to tamper with my treasures? Surely no man in his right mind . . .

The dance marathon had lasted sixteen days. Only that morning, Roxie had pleaded with him to give up. "I've got to lie down. If I don't get some shut-eye, I'll die," she moaned. But Frank was no quitter. He'd promised his mother to bring back first prize, and that was one word he wouldn't break. "Keep on dancing," he said. "Don't make me kill you." Now the money was theirs, and Roxie felt miraculously restored. "Next stop Broadway," she said, but Frank saw no reason to leave Hoboken. If you could make it there, you could make it anywhere.

OVERLEAF:

On the drive uptown from the costume ball, Tallulah suddenly insisted, over Noël's weary protests, that we all get out of the taxi. "I've got to see a dog about a white lady," she explained—her way of indicating that she needed to pick up fresh supplies of cocaine—but she had forgotten the address and we found ourselves adrift on the Bowery, much to Mrs. Parker's exasperation. Robinson, her dachshund, was waiting at home, and she'd promised to bring him some canapés.

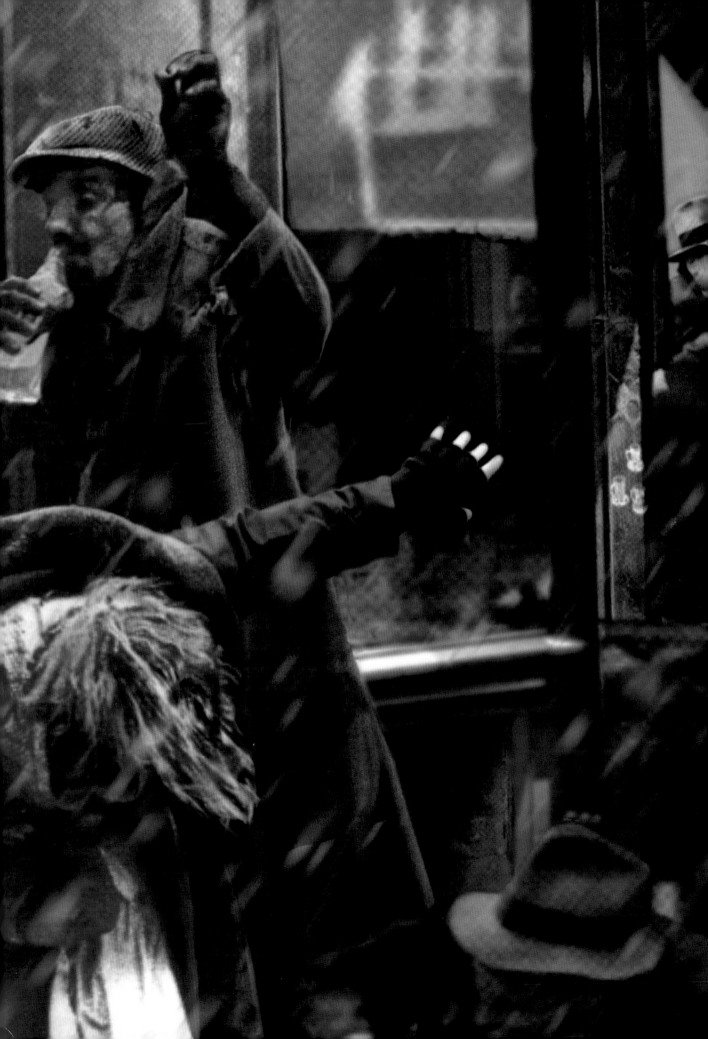

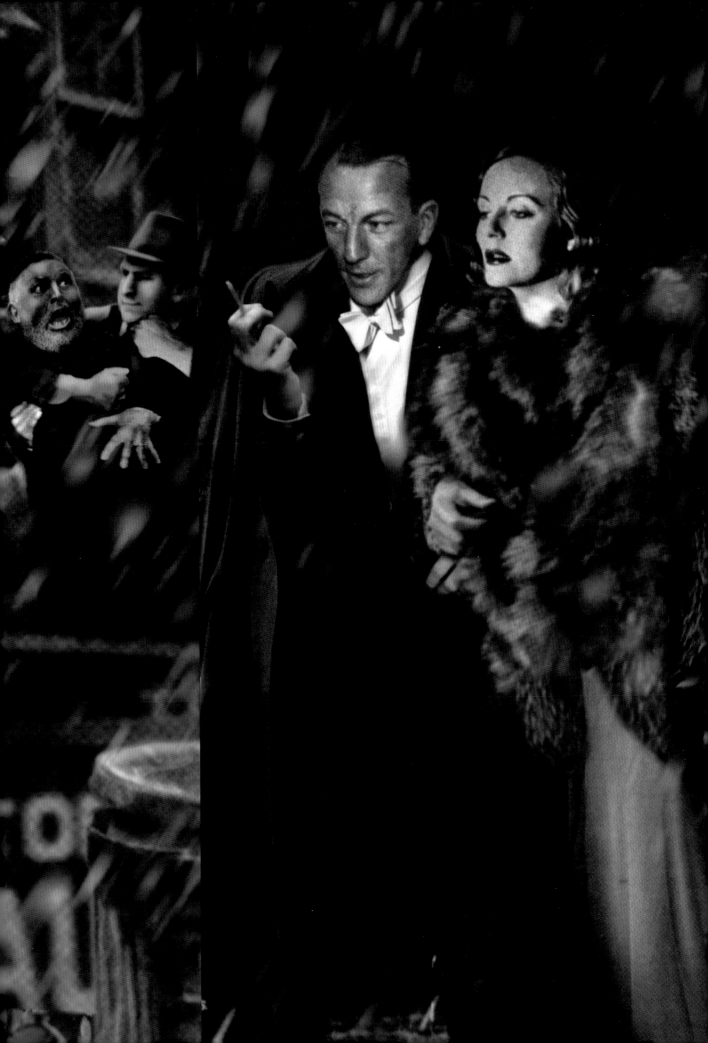

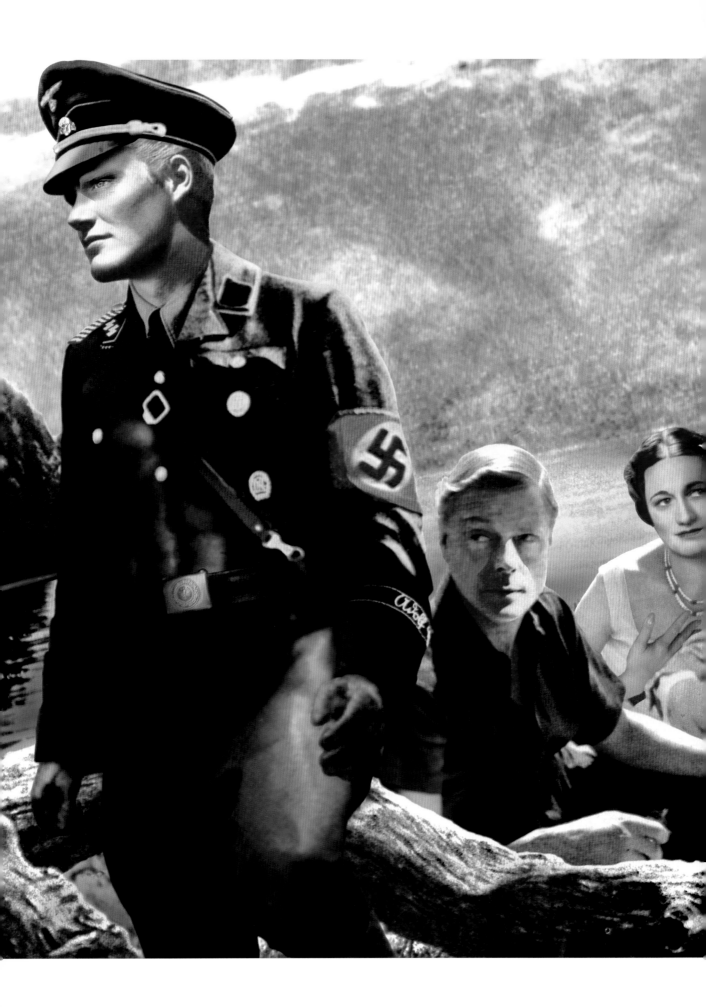

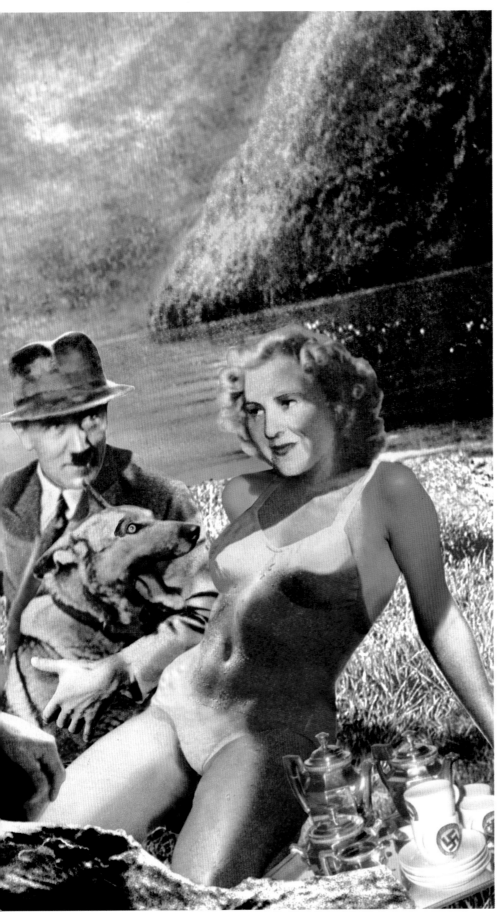

Hitler hated circles. A true Aryan thought in straight lines, hard and pure. "We must guard against the curved, unmanly blade," he said sternly, and Mrs. Simpson let slip a sigh. *Hard and pure,* she thought. But the Führer's gaze had strayed to Fräulein Braun. *Soft and warm,* he thought. But Eva only had eyes for the boyish Englishman. *Young and fresh,* she thought. But Windsor was lost in dreams of his own. *Strong and cruel,* he thought. But the guard, whose name was unknown, thought of nothing at all.

OVERLEAF:

Genet had not eaten for over forty-eight hours and his hunger had begun to give him hallucinations. When Satchmo and the Duke drove up to Maxim's, he saw them as barbaric demigods, and the largesse they scattered as pennies from heaven. In this heightened state, he could smell the coins as they tumbled past him—that elusive mix of sweat, earth and the odor of corruption peculiar to cash. The scent stirred a childhood memory of the little outhouse in the garden at Alligny-en-Morvan, with its cool slate floor and the sound of the rain knocking on the zinc roof. Life there had felt tender and airy, washed clean of all its burdens.

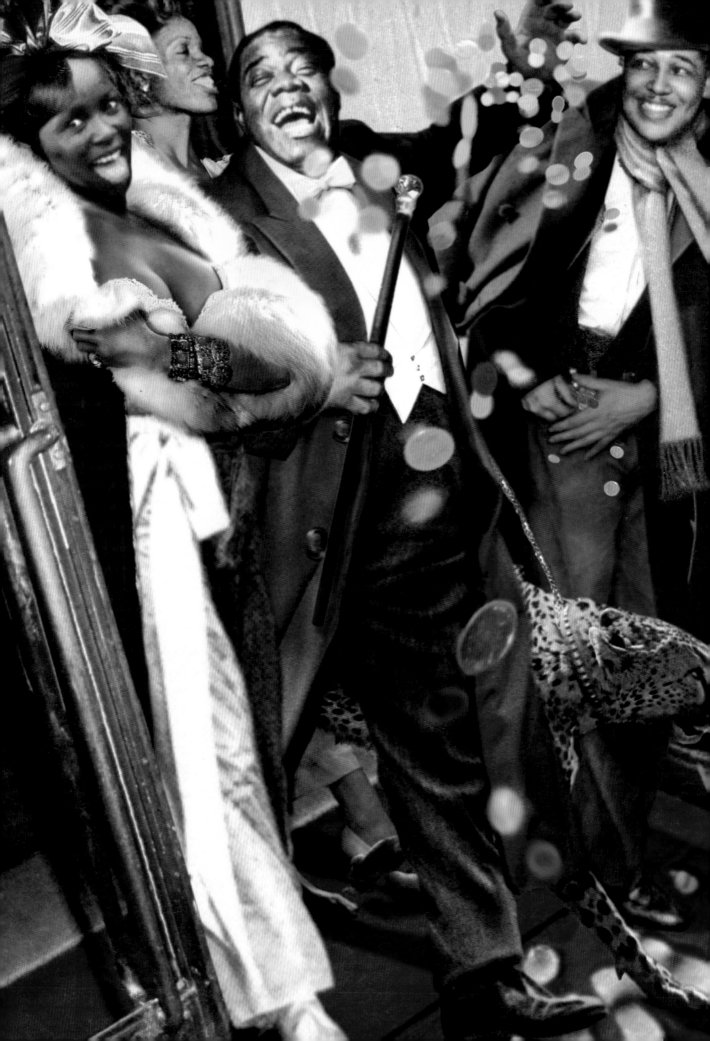

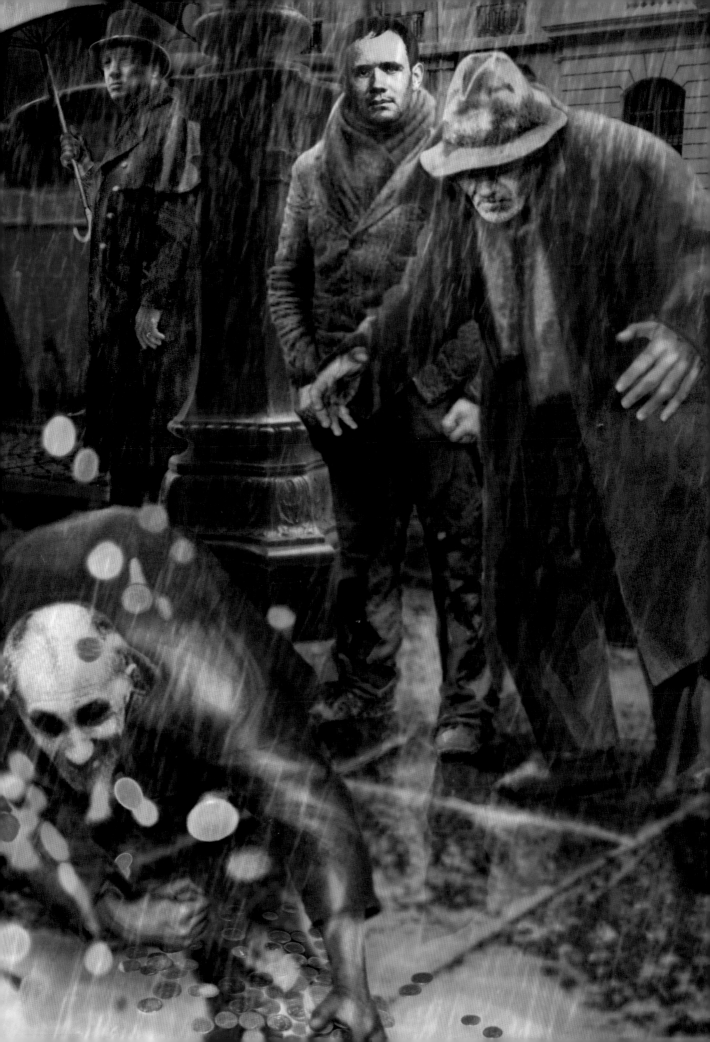

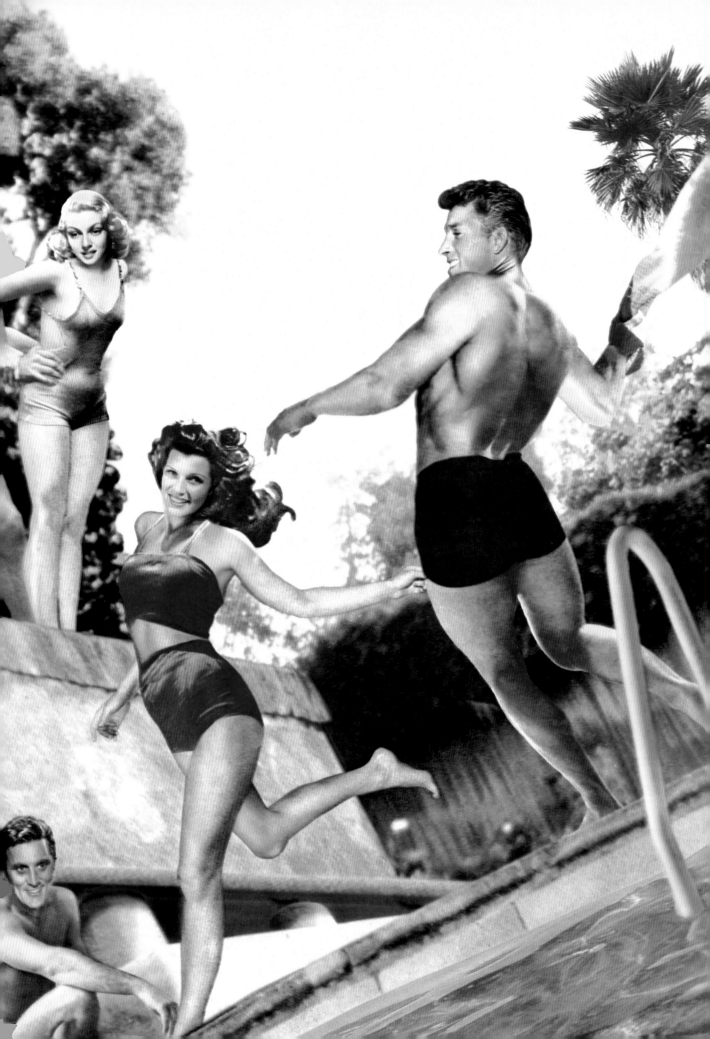

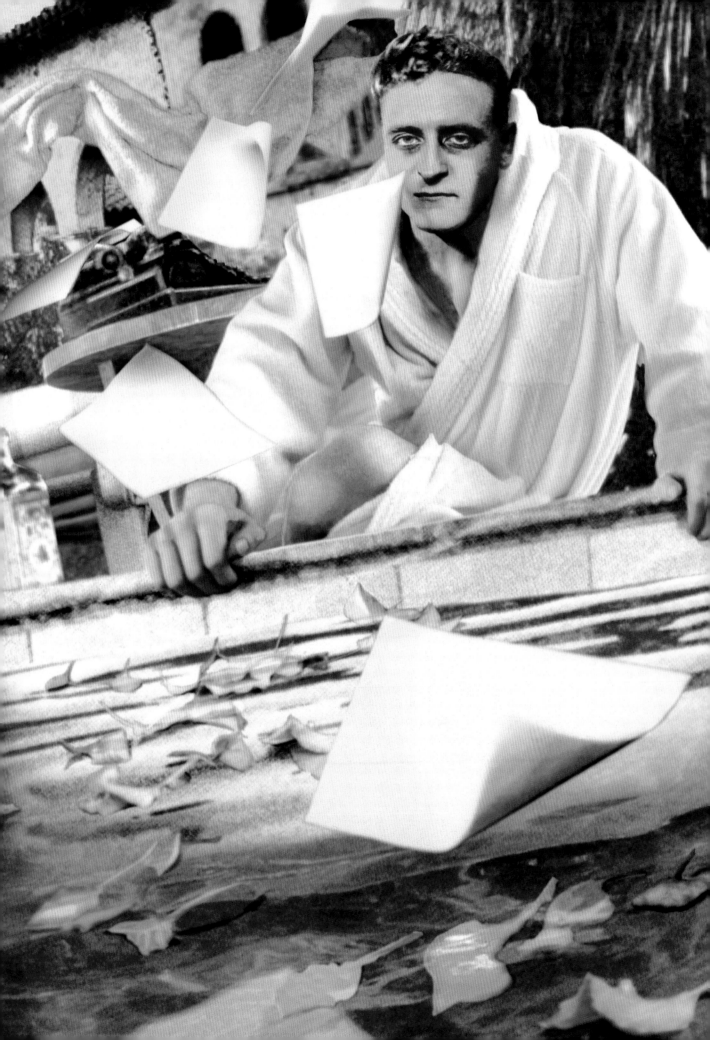

Some days, when Scott couldn't write, he would sit beside the pool at the Garden of Allah, watching the girls and boys at play. The one called Lana often gave him a smile, and once she asked him what he was writing. When he tried to show her, his hand shook so badly that he dropped the pages. "Boil some water—lots of it," she read aloud, leaning over his shoulder, her breath young and fresh on his cheek. After she'd returned to her playmates, he heard her ask them who the rummy was. "Old Fitzpatrick?" her boyfriend said. "He used to be a good man on structure."

Though both were strangers in a strange land, the two men had little in common. Gandhi didn't believe in the unconscious, and Freud had no time for passive resistance. "I prefer existence to extinction," said the analyst, who was dying of cancer. "Each," the Mahatma replied, "is an illusion."

Their only points of agreement were a shared dislike of English food and a weakness for English murders. Hour after hour, they argued happily about the comparative merits of arsenic and strychnine, cyanide and acid baths. The discussion left them with sharpened appetites, but when they took a look at the menu, their worst fears were confirmed. " 'Bubble and Squeak'? 'Spotted Dick'? 'Toad in the Hole'?" Freud read, and he heaved a despairing sigh. "Just a glass of water, please."

"And for me," Gandhi added, "a small cup of salt."

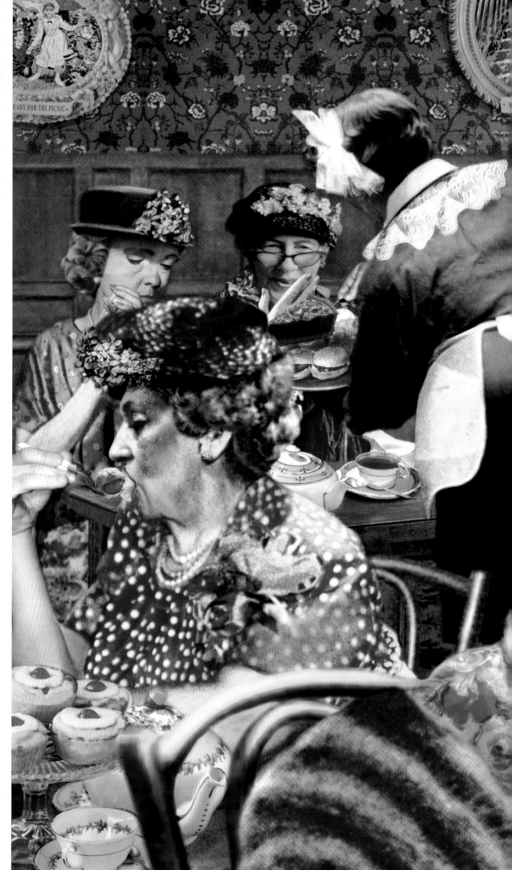

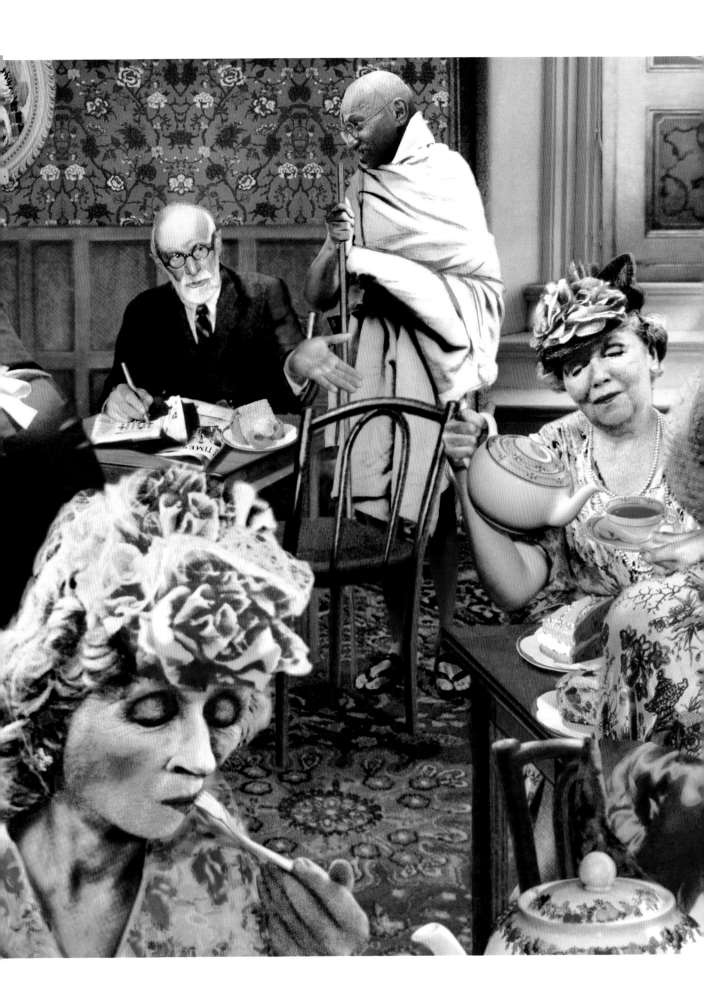

At the final moment, losing his nerve, young Tom tried to break free. But it was too late; Lady Day wouldn't let him go. "Don't you love your momma?" she asked.

"My mother? Of course . . ."

"That's good," said Billie. "Here's her milk."

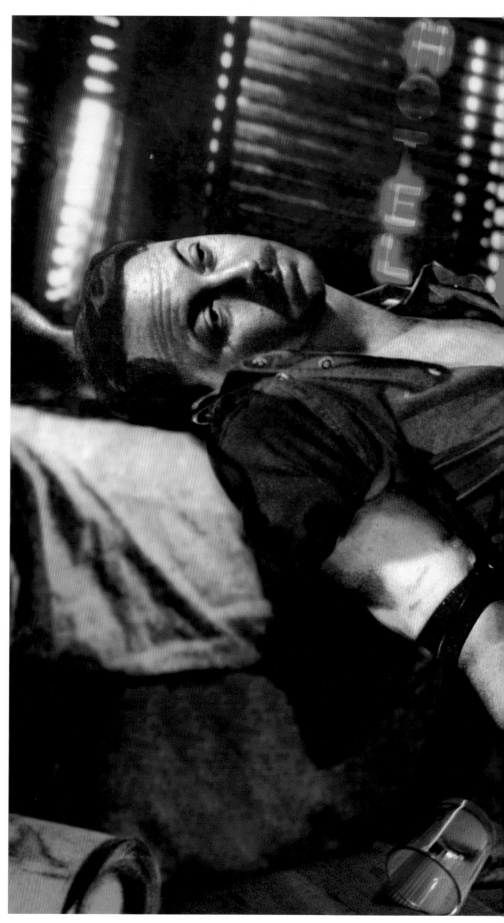

OVERLEAF:

Edgar was not a rhythm man. Whenever they visited a night-club, his friend used to tease him because he'd sit scowling at their table and refuse to even tap his foot. "It's all a front," Clyde liked to say. "In your dreams, you're a dancing fool."

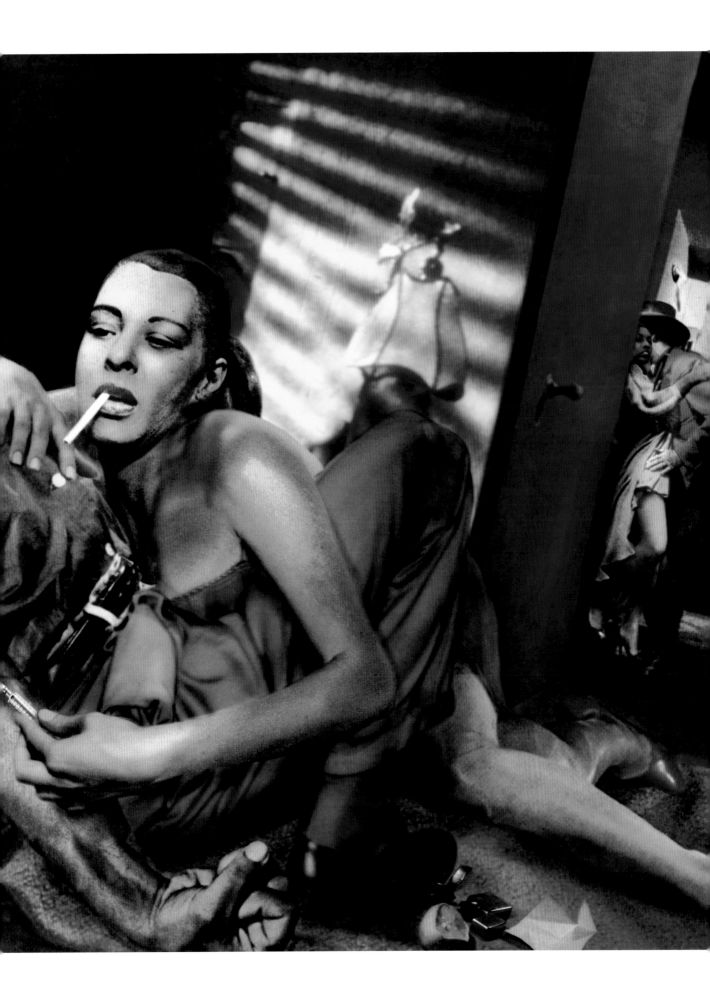

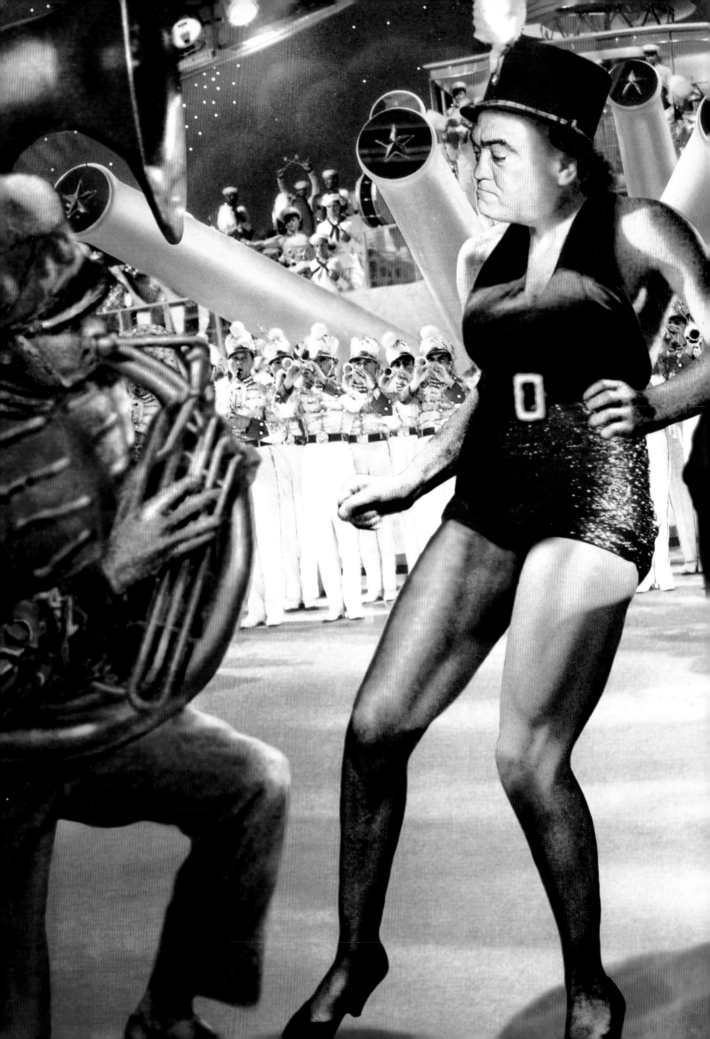

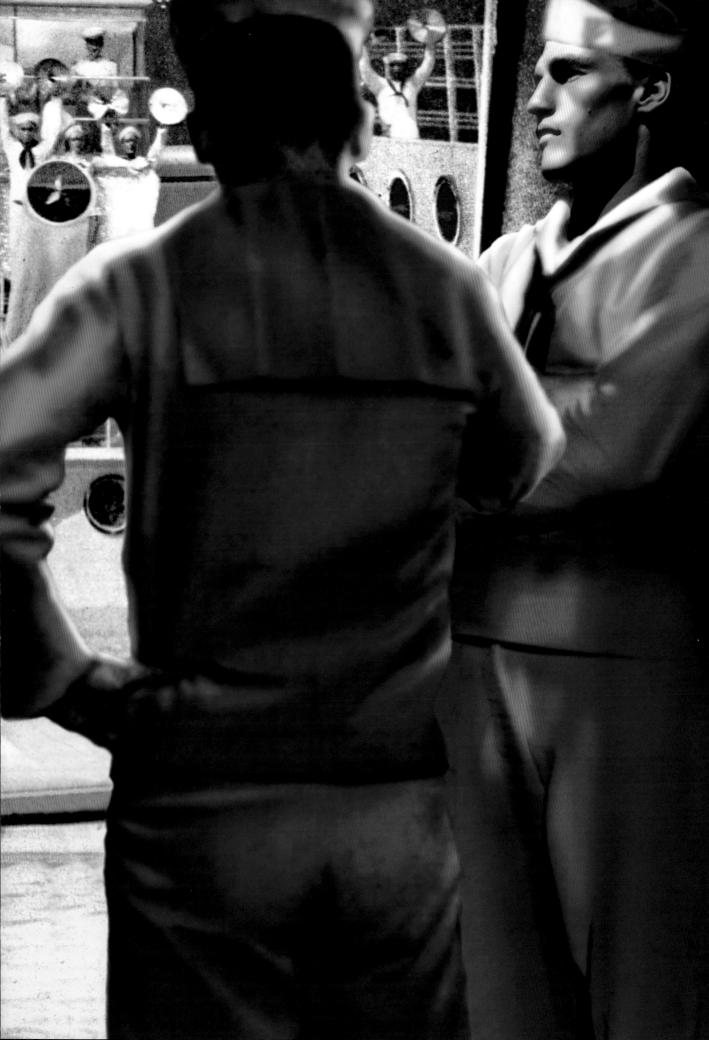

YOU OWE ME FINLAND

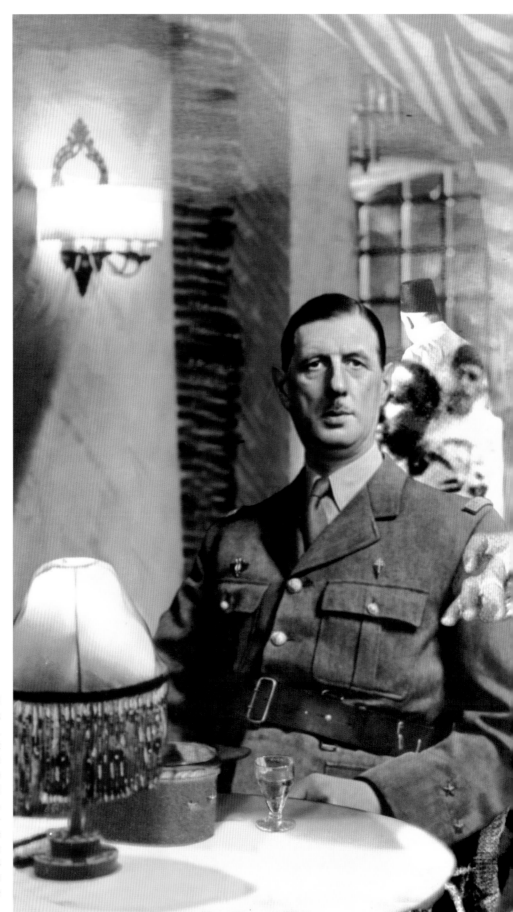

The General had never wanted to come to Casablanca, and his worst fears had been borne out. Churchill was a Judas, Roosevelt arrogant, Giraud a nincompoop. "I am surrounded by degenerates," he said. In an effort to distract him, I suggested an evening on the town, but the Vichy patrols and the clamoring beggars soon drove us from the streets. A visit to Rick's seemed in order. The General, however, was less than enchanted. "A kiss is still a kiss?" he groaned. "These people are imbeciles."

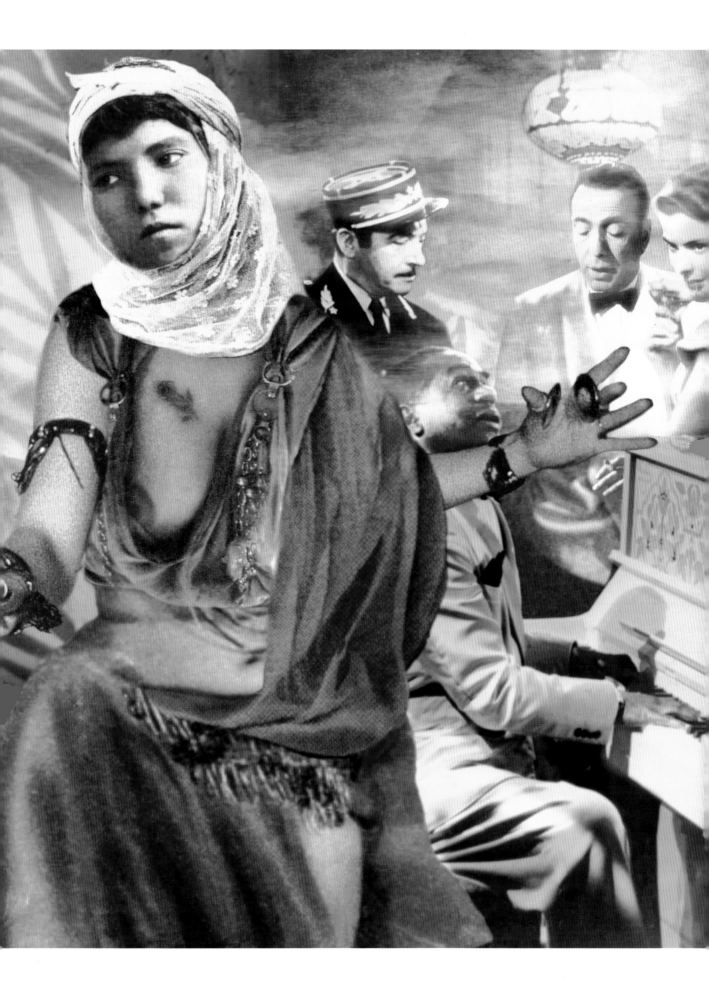

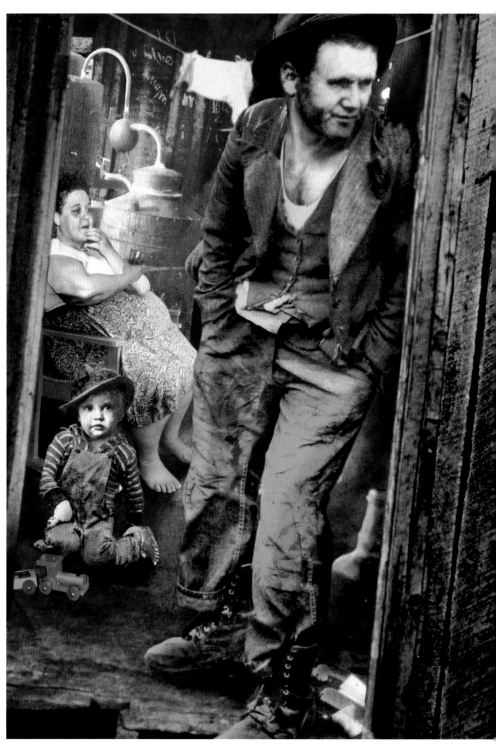

Somewhere near here, he'd heard, was the finest moonshiner in the whole hill country. But Faulkner was not easily convinced. His own people came from Pontotoc, where the 'shine was second to none. Once you strayed as far east as Tupelo, experience had taught him, you were in the unpromised land.

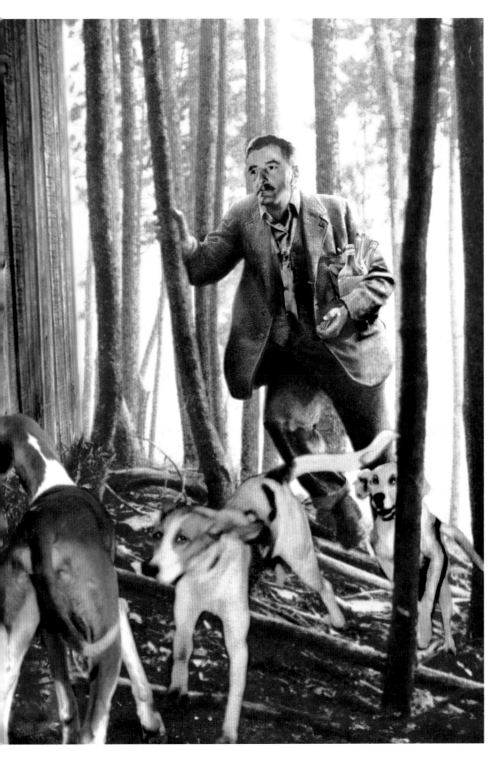

OVERLEAF:

Sleep in Yalta was impossible. Every night the riff-raff of the town caroused in the alley beneath my hotel window. Even in daytime one couldn't escape them. While the old men sat in the park and divided the world, derelicts and urchins clustered by the gates, rolling dice for the same stakes. When I tried to push my way through, my path was blocked by a young hooligan. "You owe me Finland," he said.

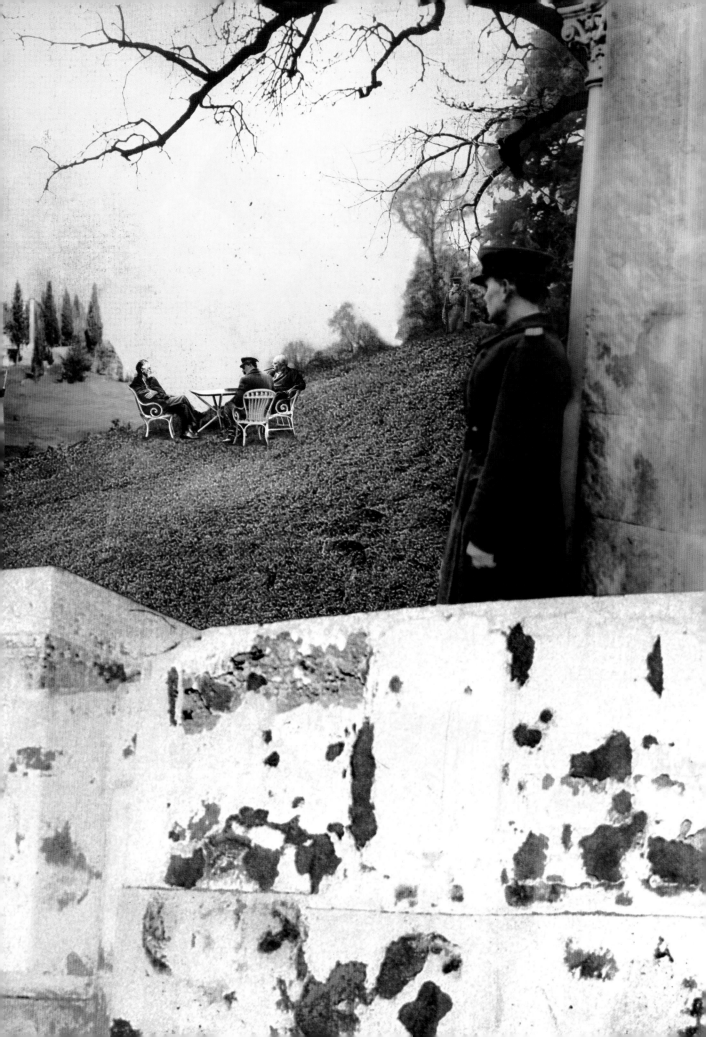

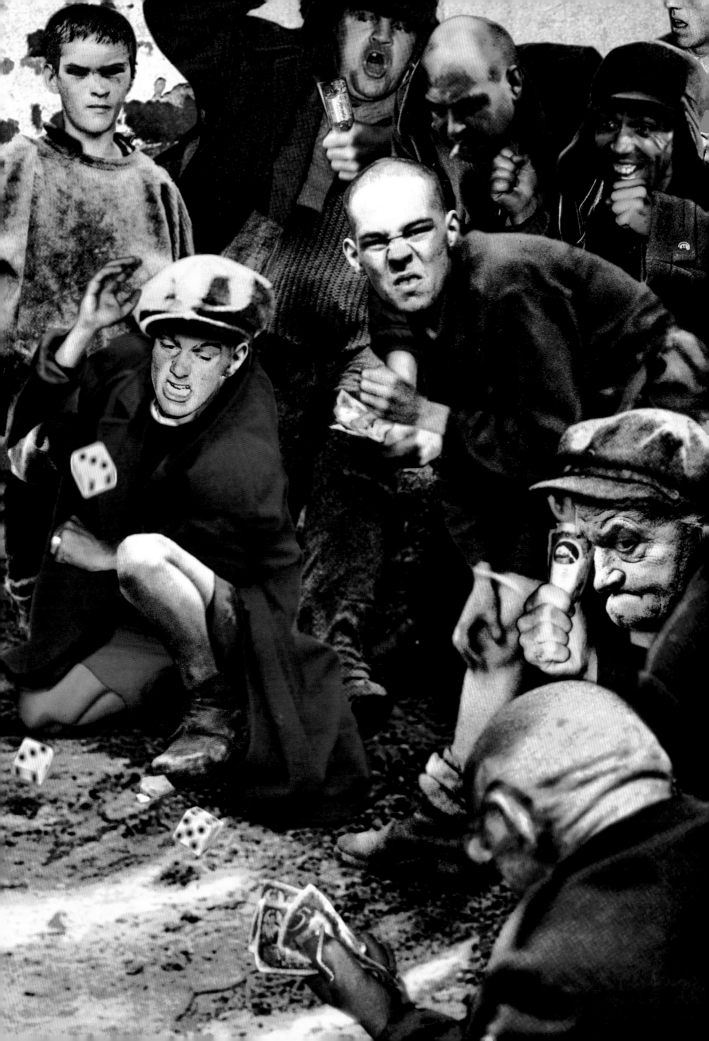

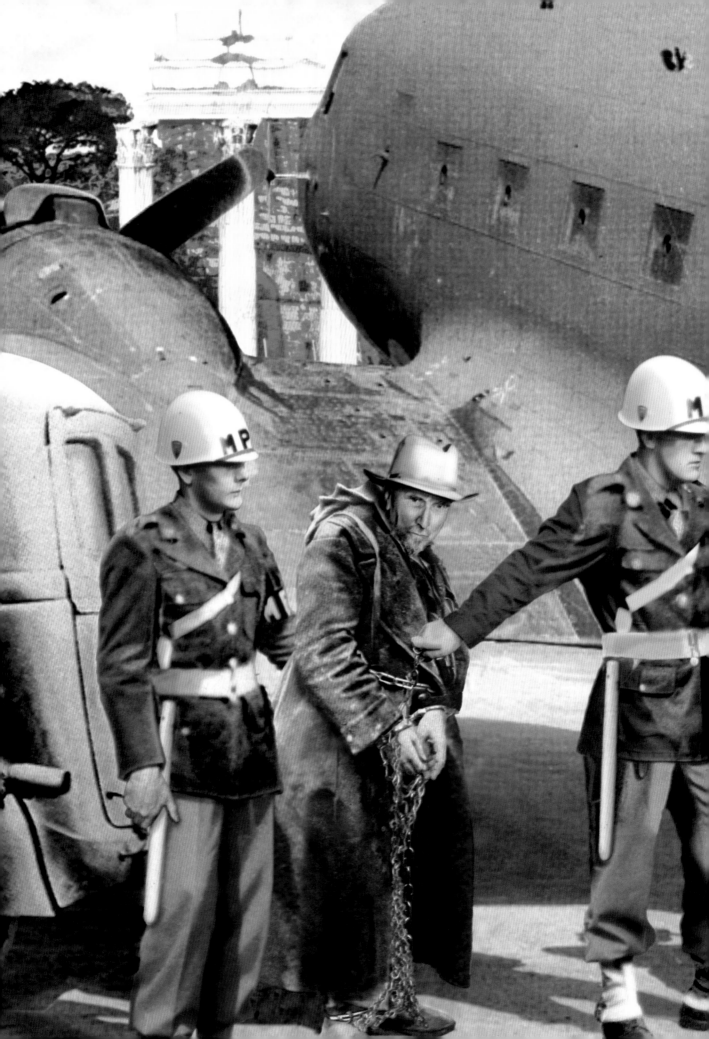

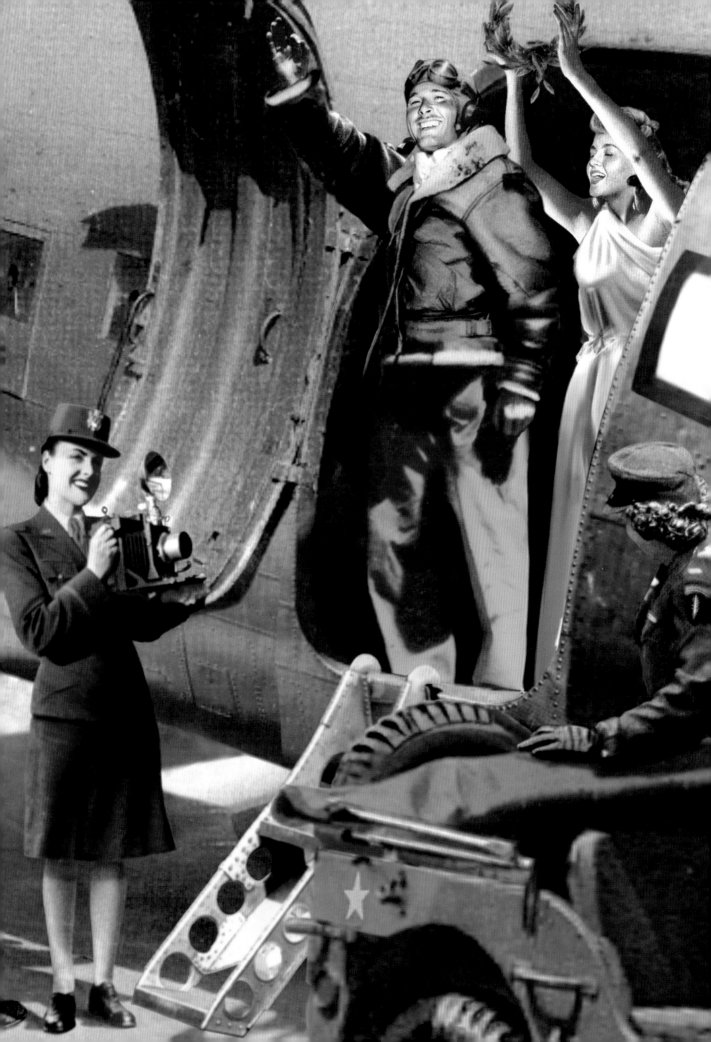

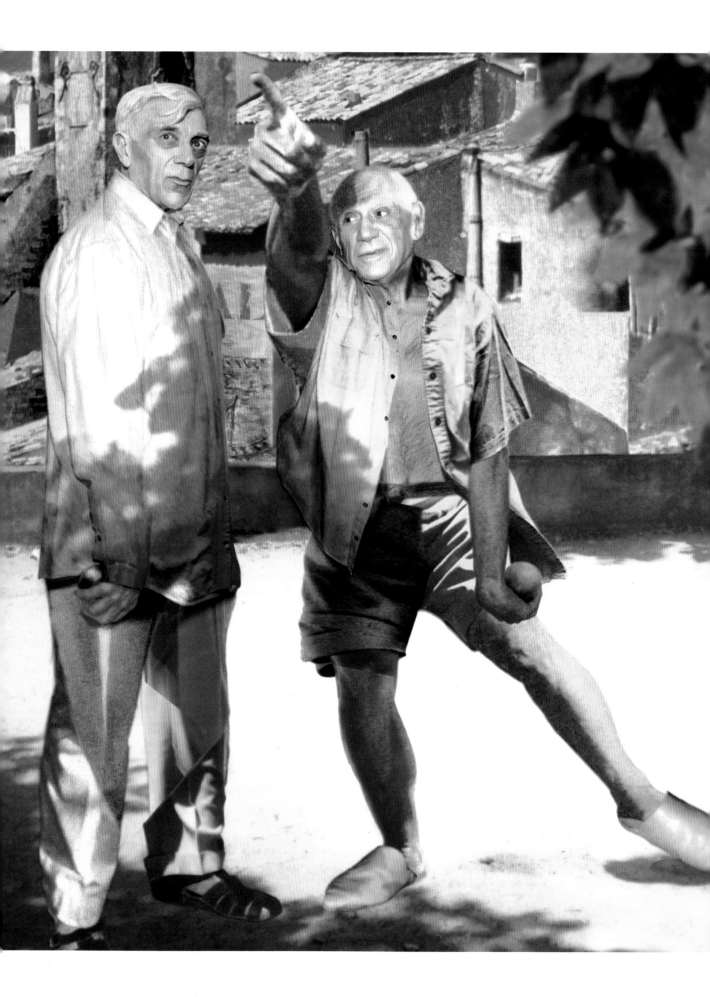

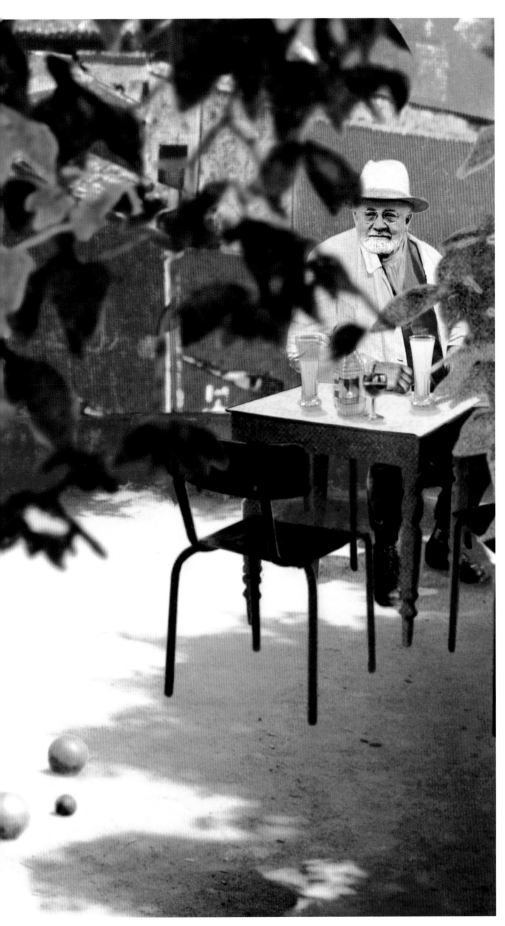

PRECEDING PAGES:

For a moment Ezra thought the cheering must be for him. The day had already been so full of surprises. First he'd been fetched from his cell and driven to the airfield. Now came the red carpet, the honor guard, the brass band. Yet something wasn't right. A Phoebus Apollo was blotting out the light. "*Sieg Heil,* old bean," this gilded youth murmured as he passed. Ezra sensed a Zionist trap.

Each afternoon after lunch, Pablo and Georges would go to war. Braque, disciplined and calm, appeared to be the better player, but Picasso always won. When Matisse asked him why this was, the victor just shrugged. "Georges does his best, but he lacks—how can I put it?—the true sporting spirit."

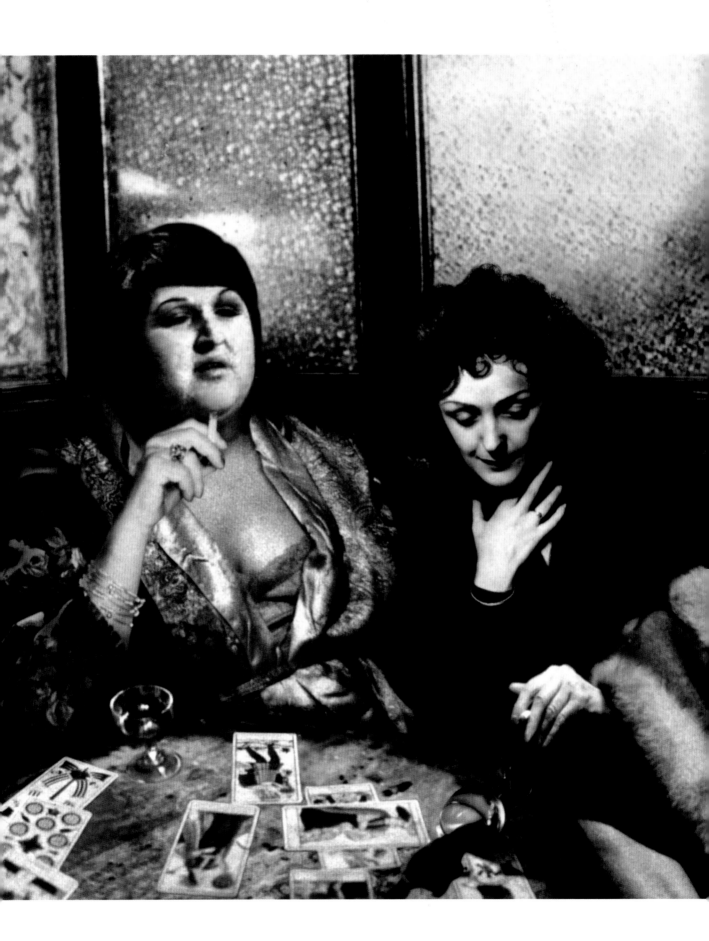

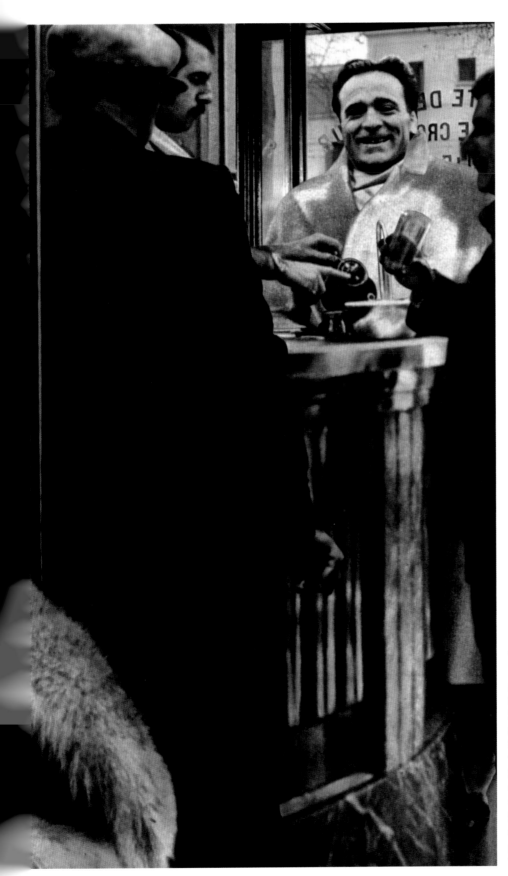

The day Cerdan's plane went down, Piaf remembered that night at Le Petit Zinc. Marcel hadn't wanted her to consult Madame Rosa. The woman was a witch, he said; the cards only tempted fate. But Edith, as always, refused to listen. She was worried about her health, about her career. When the cards were laid out, however, they told her nothing new. All that stuck in her mind were Madame Rosa's last words. "You have a good man," she'd said. "But he flies too close to the sun."

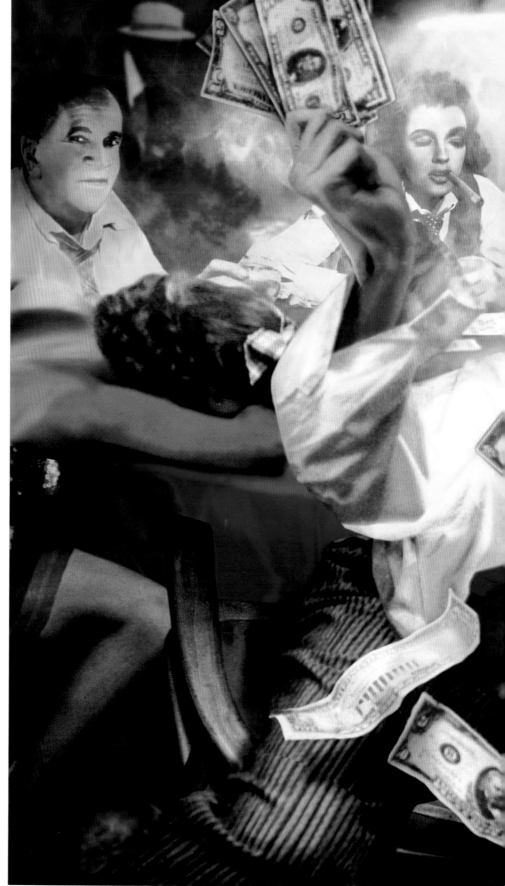

November 22nd

Dear Groucho,

I shall be delighted, indeed privileged, to be your guest for your performance at the Antiquarian Booksellers' convention in Atlantic City next week, and more privileged still to share in the contemplative pleasures of those good Havana cigars you mention.

Your fervent admirer,
Tom

OVERLEAF:

Considering the way they both haunted the cinemas, it was strange that Truffaut and Godard had not met earlier. But *Double Indemnity* was a good place to start. As the action unfolded, they began to mouth the dialogue, co-conspirators with Stanwyck and MacMurray:

"There's something in me, I don't know what. Maybe I'm crazy. But there's something in me that loves death. I think of myself as death, sometimes. In a scarlet shroud, floating through the night. I'm so beautiful, then. And sad. And hungry to make the whole world happy, by taking them out where I am, into the night, away from all trouble, all unhappiness . . . Do you understand me, Walter?"

"No."

"Nobody could."

"But we're going to do it."

"Yes, we're going to do it."

"Straight down the line."

"Straight down the line."

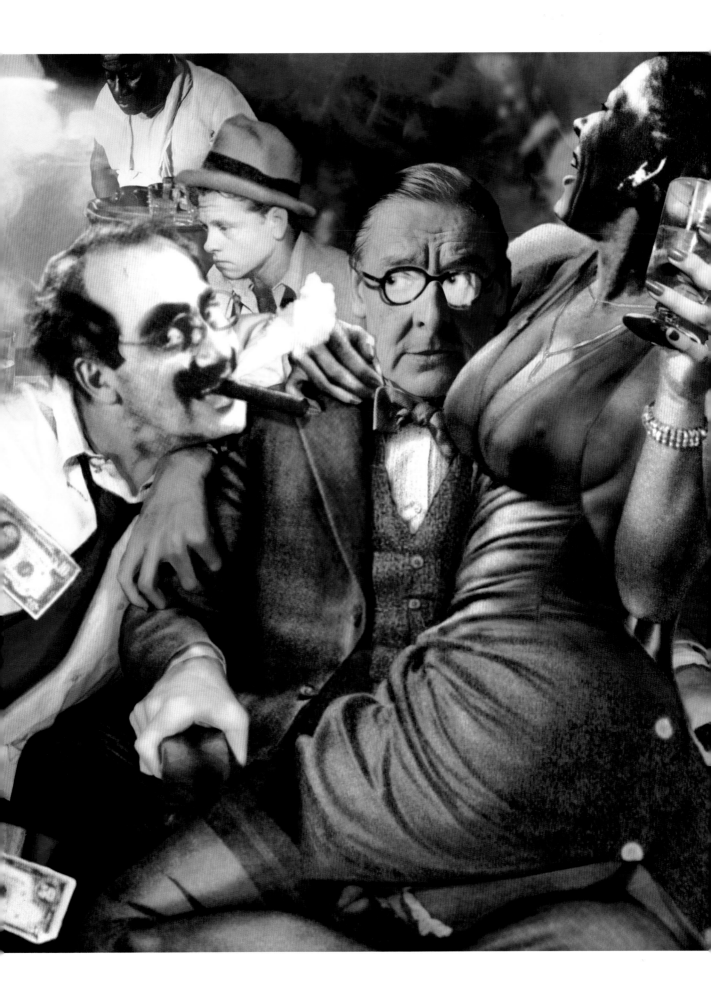

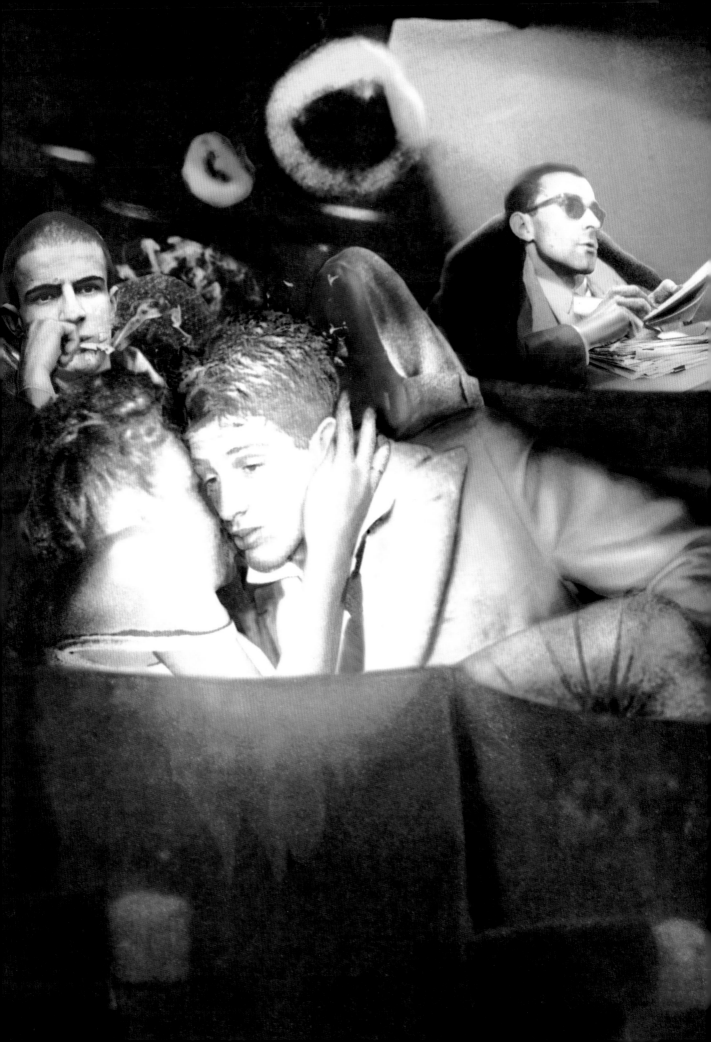

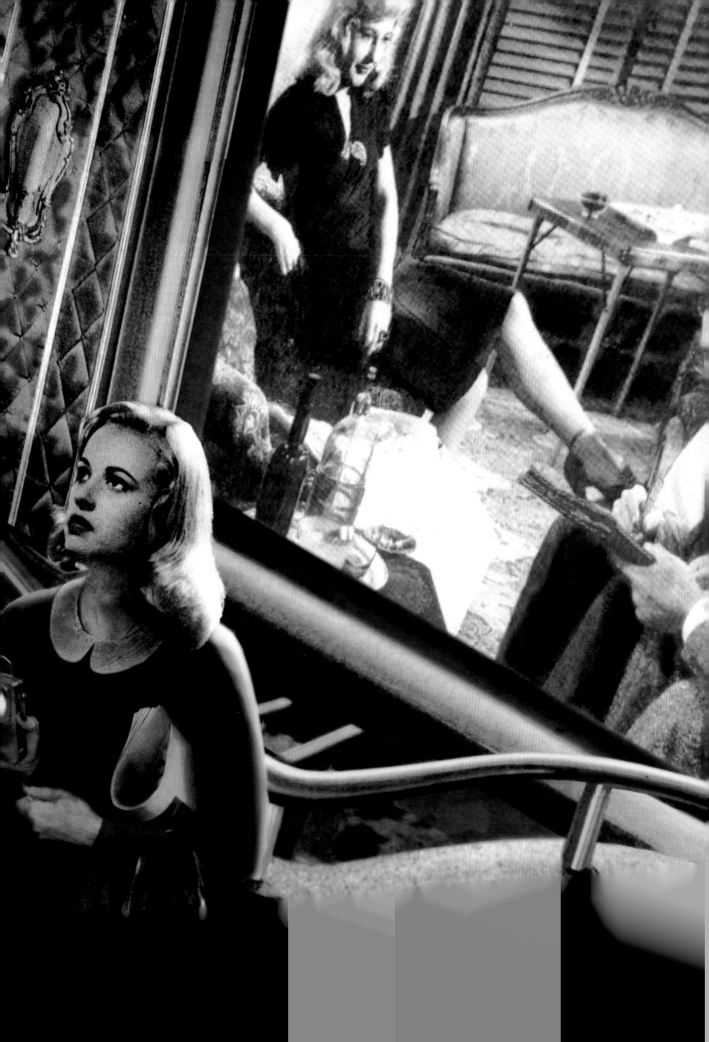

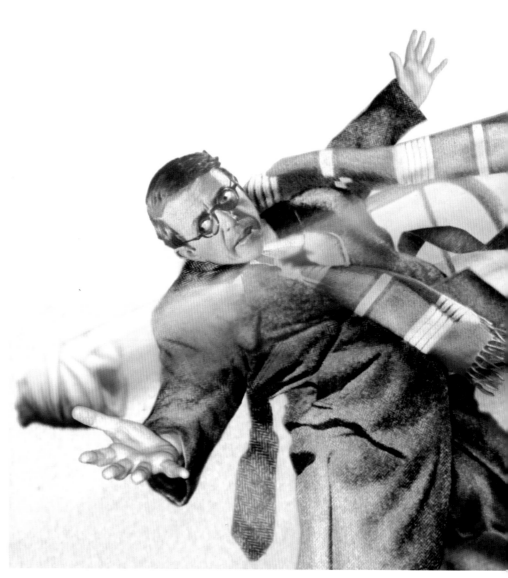

The recurrence of his TB kept Camus in the sanatorium all through that long, dark winter. A deep depression took him over, and he felt quite unable to work. Nor were his spirits improved by the presence of Bud Powell, who, deprived of his piano, had drawn a substitute keyboard on the wall and played "Glass Enclosure" for hours on end, until his fingers cracked and bled.

Even Sartre's visit did not prove a tonic. Camus was desperate to know how Racing were doing, but his old friend could tell him nothing. "Football," said Jean-Paul. "It is not a matter of life and death."

"But of course," Albert snapped. "It's far more important."

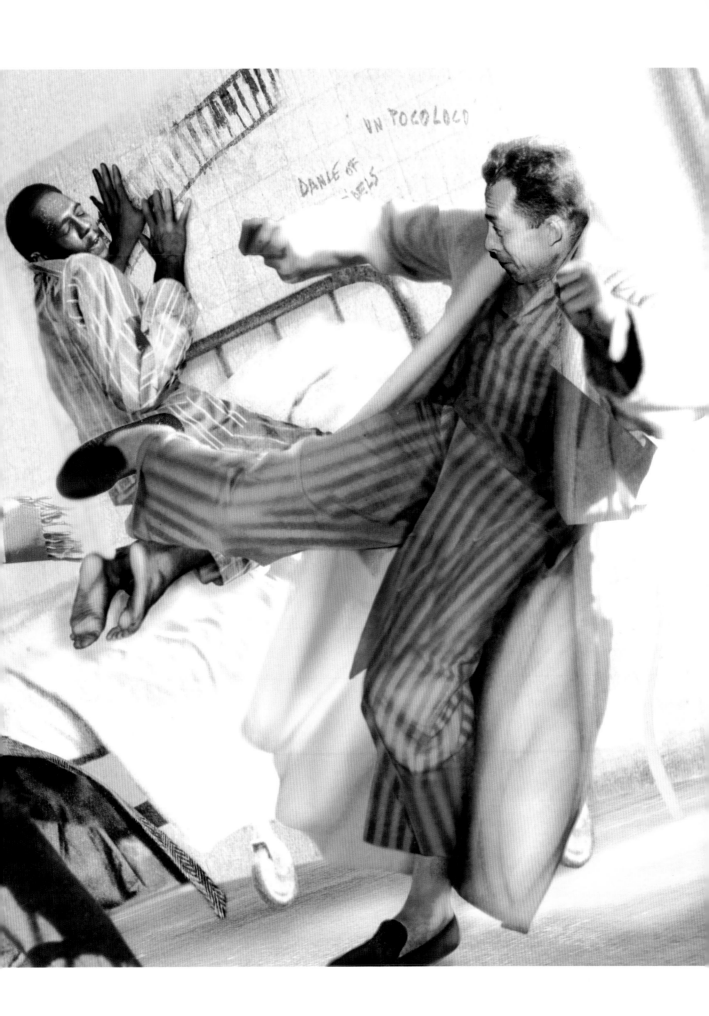

Howard had no problems with women. It was simply that, with the passing years, he came to prefer them dead.

If they'd had their wits about them when the New Orleans drug squad burst into Burroughs's house and rounded them up, they would have gone quietly and done the time. But the sheriff had made them a proposition. "Kerouac? Corso? Ginsberg?" he'd said, thumbing through their files. "The way I see it, you don't have to go to the pen."

"We don't?"

"Not if you play your cards right and join up with my outfit, the Bayou Bengals. We're always looking for new boys."

"What kind of boys?" asked Allen, intrigued.

"Good boys who've made mistakes. The kind of boys, like you, who just need a little guidance to turn them into real men."

"Where's the catch?"

"No catch," the sheriff swore. "It's like summer camp."

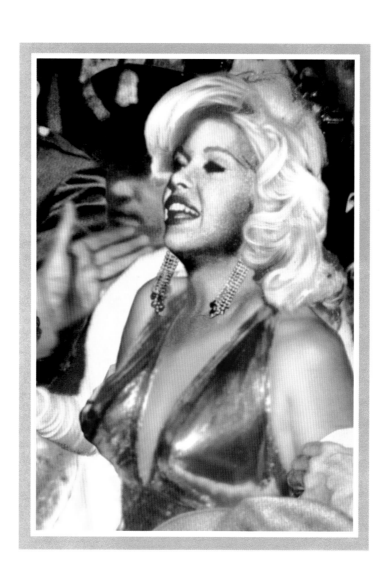

AH, THE SEX THING . . .

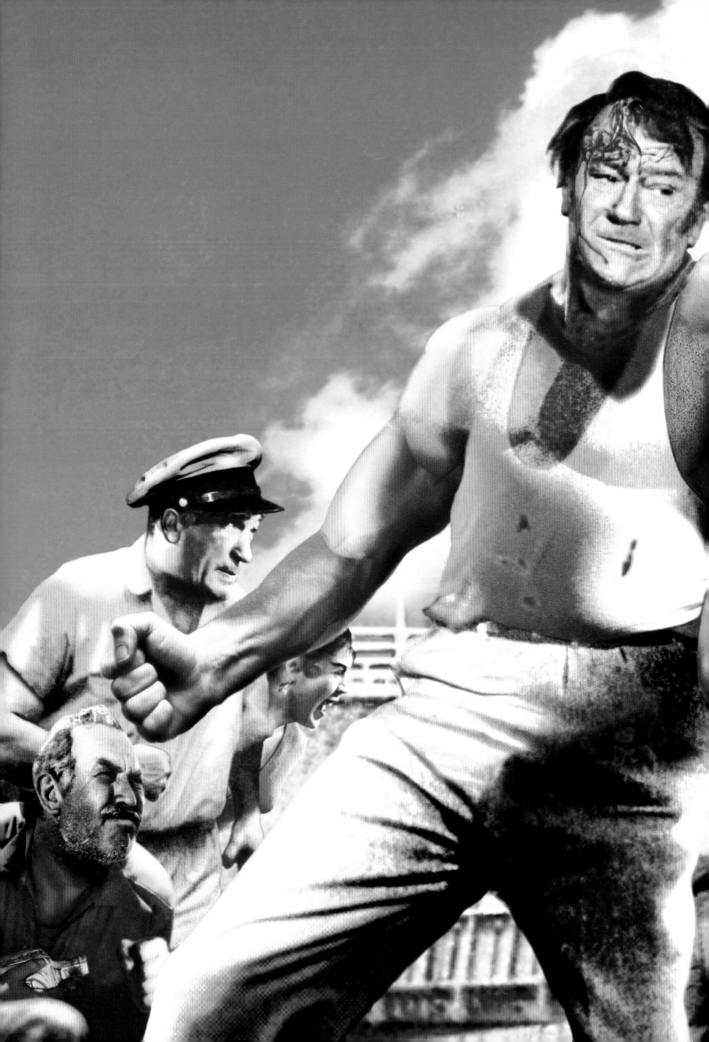

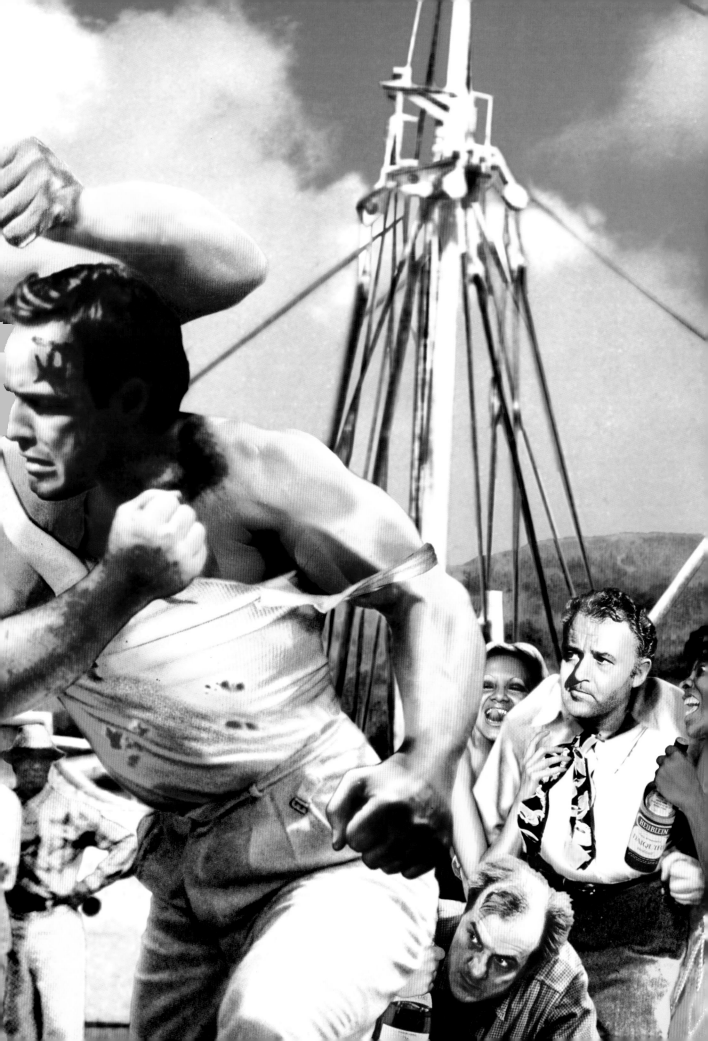

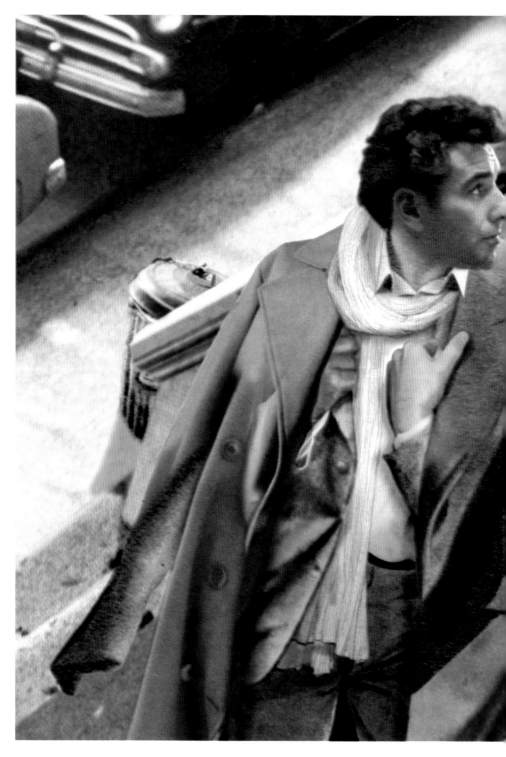

The Duke had been seeking a showdown for months. With *On the Waterfront,* Brando had overtaken him at the box office, and Wayne was inconsolable. To be supplanted by this mumbling, un-American poseur was more than he could stomach. Now, on another waterfront, the moment had come to settle the score.

Egged on by his drinking buddies, Wayne began to spew abuse—commie, fag, nigger-loving pervert—but his rival seemed bullet-proof. It was only when Marlon turned his back dismissively and started to saunter off that his fatal flaw was revealed. "Know something, pilgrim?" the Duke drawled. "You've got a fat ass."

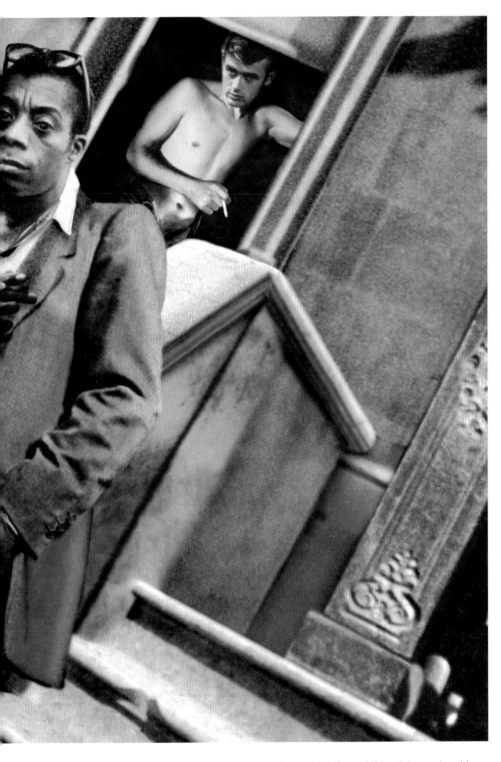

This time it's the real thing," Bernstein told me.
"A boy who loves me for myself. Someone
sweet and unspoiled, fresh off the farm. And—
what's most marvelous of all—I can trust him
absolutely. His heart is pure."

By the time I arrived to bail him out, Lenny was spitting mad. It wasn't his night in the cells that was eating him up, he said, but the company he'd had to keep. "The worst fucking audience I've had in my life," he complained. "I busted my hump all night, but he never cracked a smile. I gave him all my best bits— Hop Smoke a Reefer, Father Flotsky, The White-Collar Drunk. I even let him have a blast of How to Relax Your Colored Friends at Parties. 'I'd like to have you over to the house . . . Only I gotta sister . . .' Nothing! The fucker just sits there and stares. When I ask what's eating him, he tells me, 'Allah Akhbar.' I mean, Jesus Christ! What kind of talk is that?"

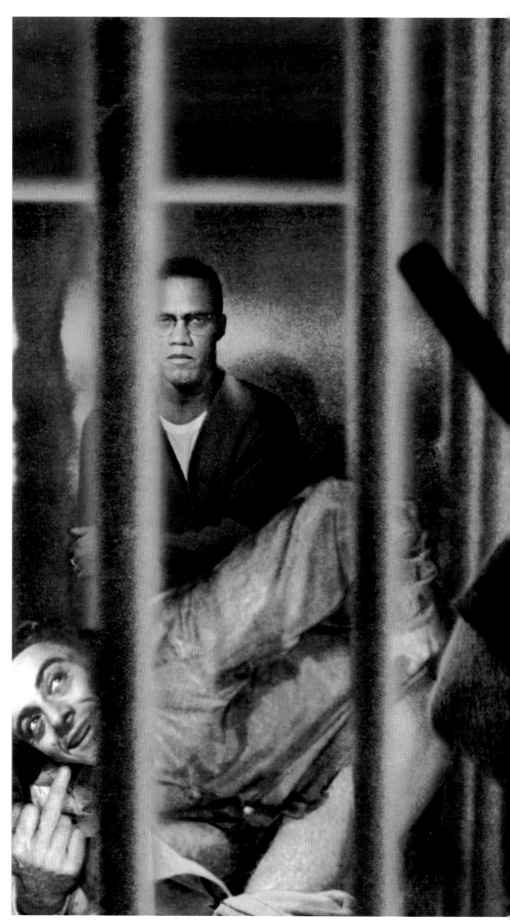

OVERLEAF:

There was a time when Havana was a good town and the life there had a fine balance," Ernest wrote years later. "Then new people came in. They weren't bad all through, but they didn't know the rules and had no respect for style. Afterward, the town was never much good again."

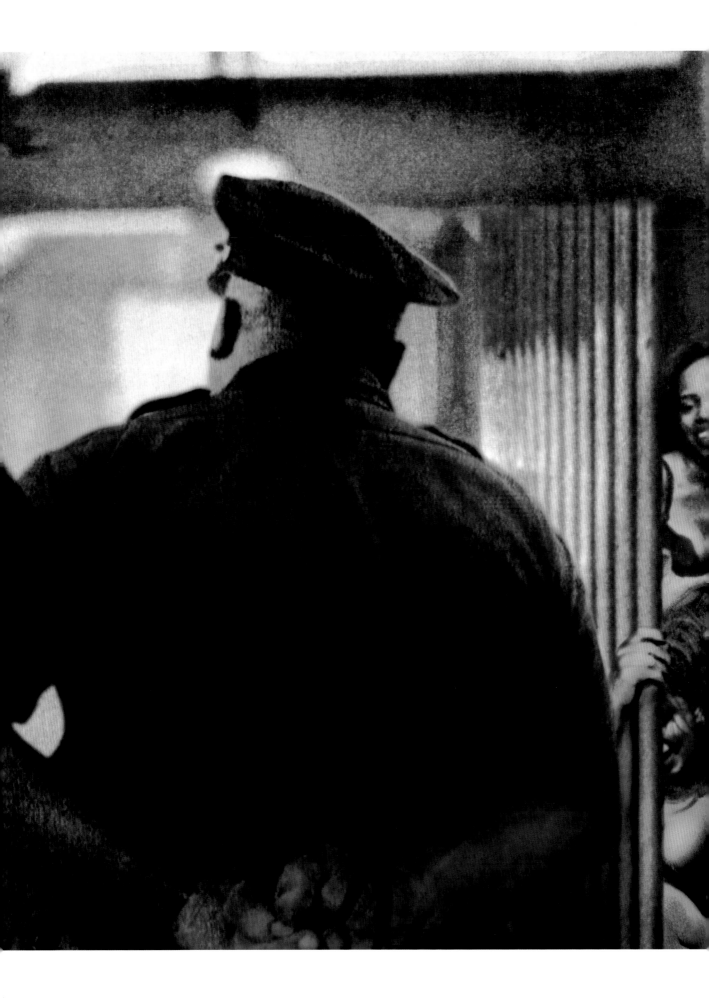

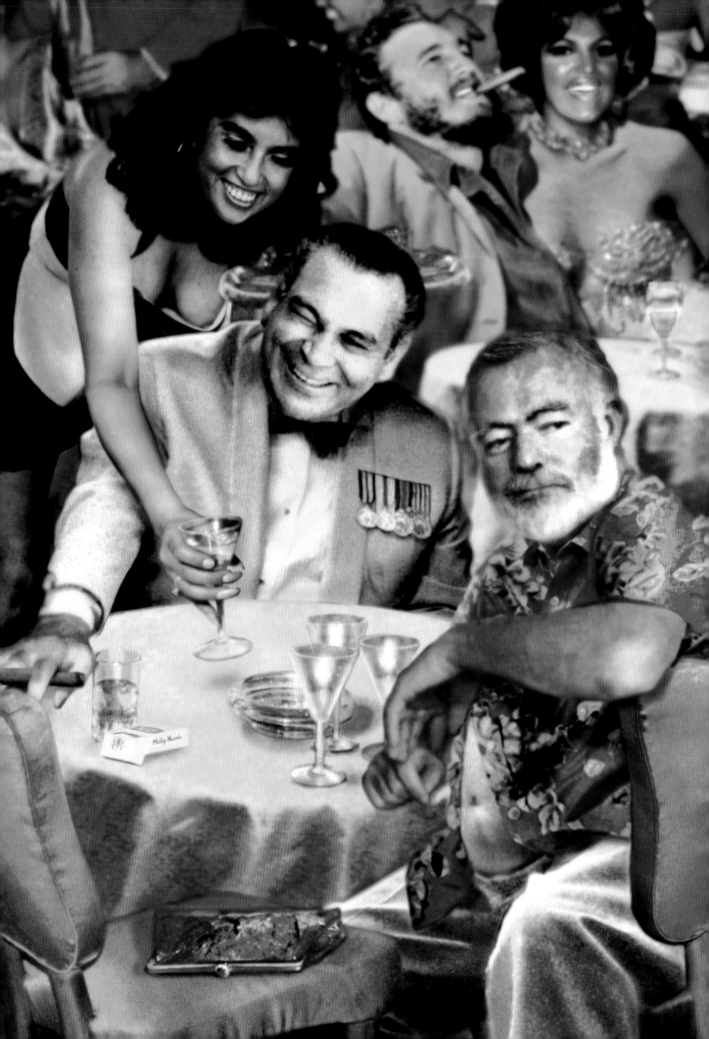

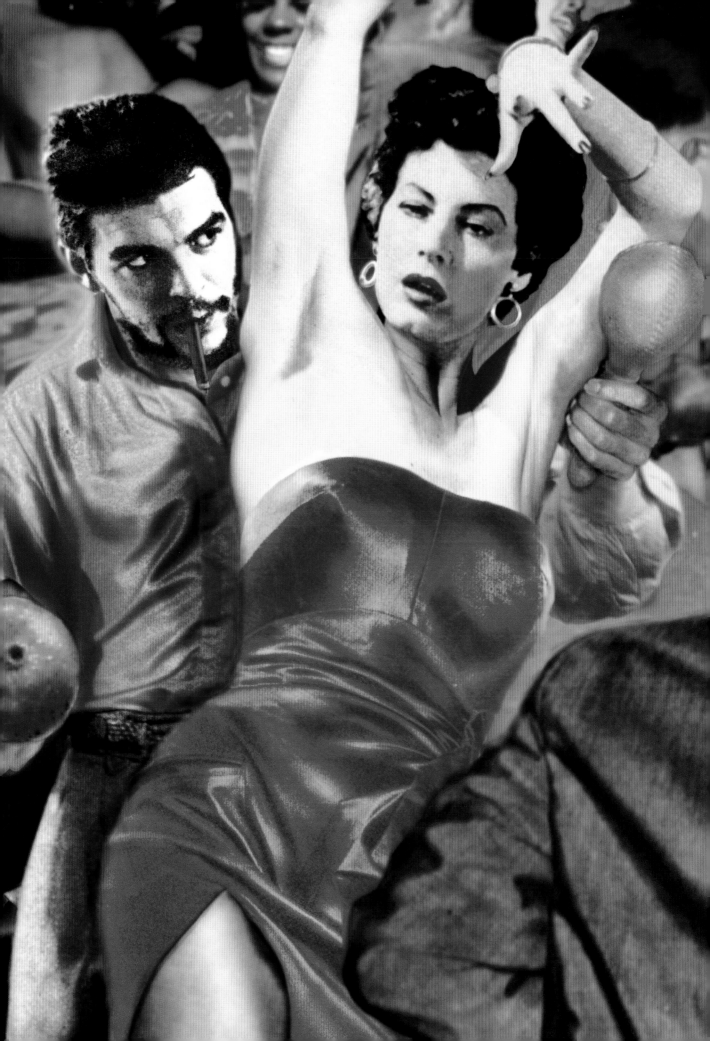

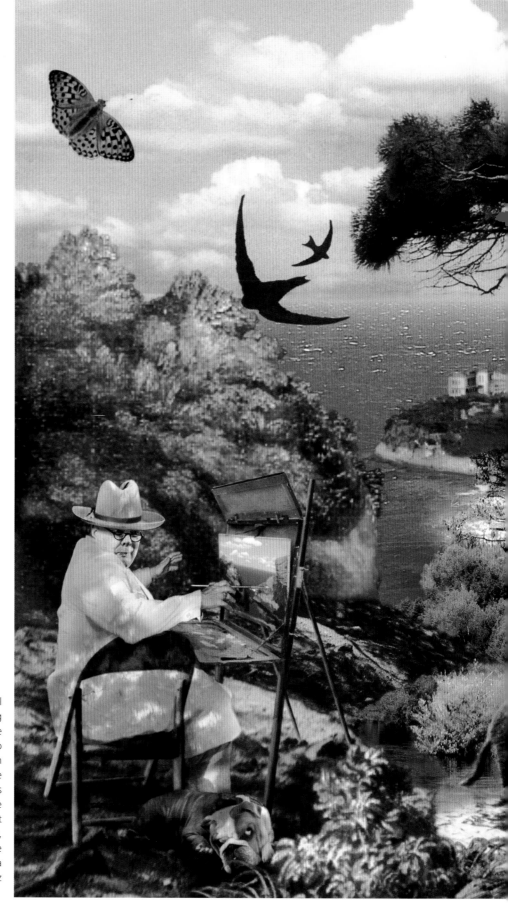

Having retired from the political battlefield, Churchill took long holidays in the hills high above Monte Carlo, devoting his days to writing his memoirs and painting. On the surface, he had never been more serene. Only in his private journals did he betray self-doubt: "I make no pretensions to being a great painter," he confessed. "Of course, like any other amateur, I should like to achieve, just once in my life, a masterwork; to become Velázquez for a day, or perhaps Botticelli . . ."

It wasn't fair, Teddy felt. All his life he'd taken the blame. Boy Blunder, his brothers used to call him. Yet none of it was his fault. Jack and Bobby, fueled by good scotch, had been horsing around on the penthouse terrace. Then Jack bet he could walk the balustrade with his eyes shut. All of a sudden he was hanging by his fingertips, thirty-nine floors above Park Avenue, and Bobby was diving to save him, both of them yelling for Teddy to help. But the wind up here was fierce and his head was spinning from the scotch. His brothers kept cursing him. That was so unjust. They knew he was afraid of heights.

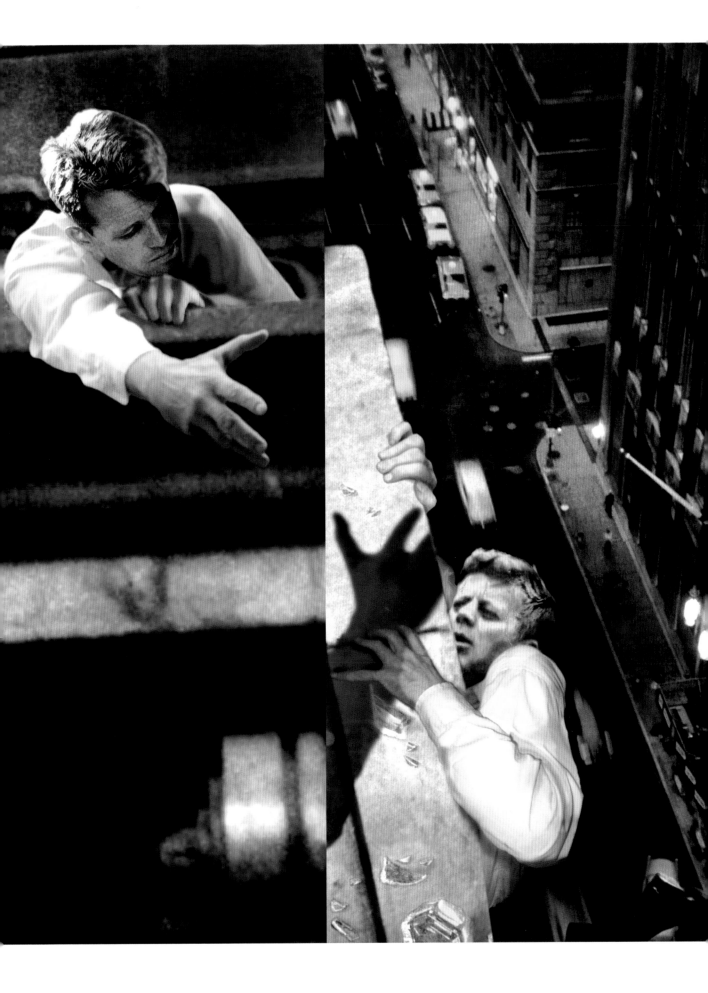

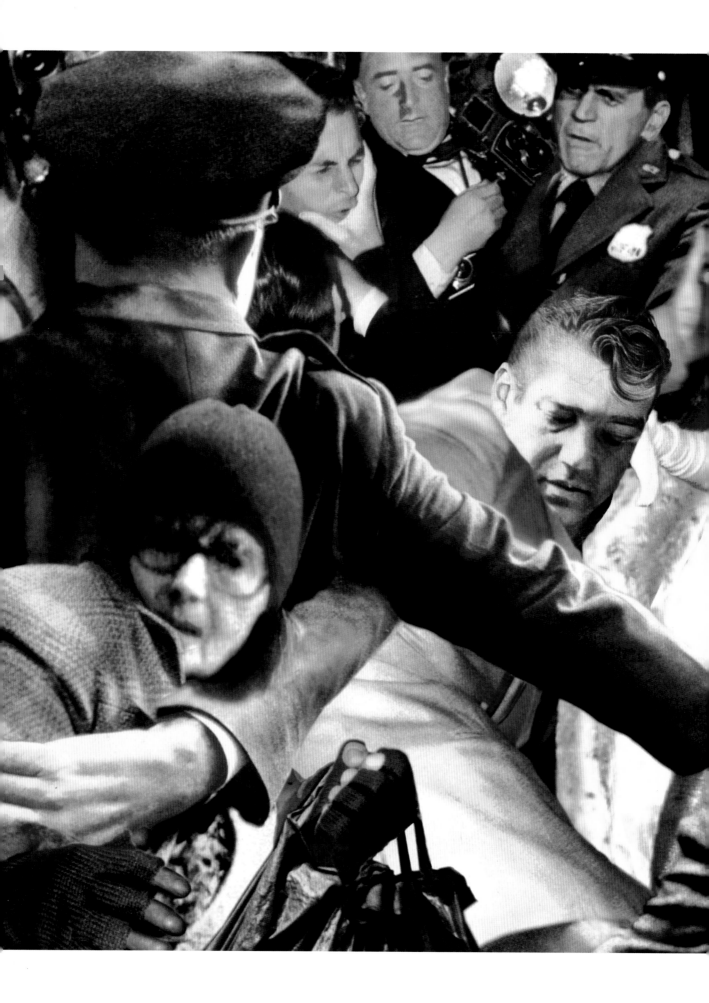

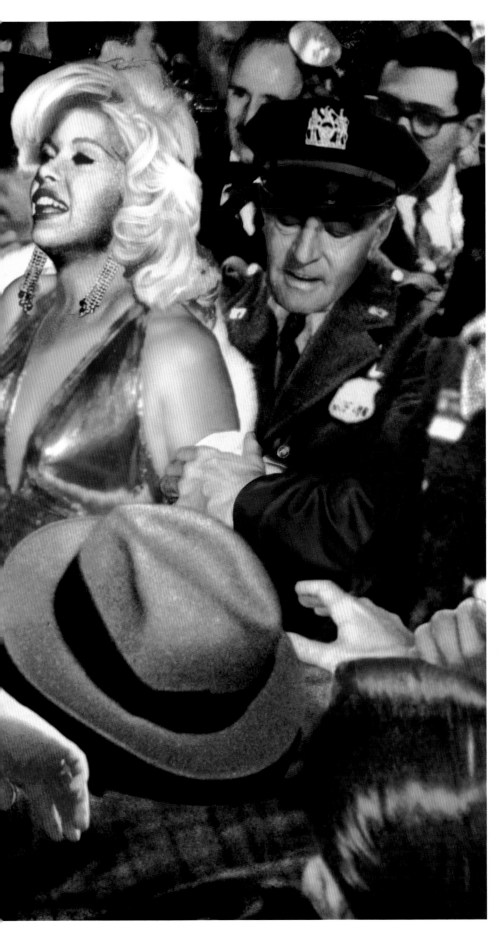

Just because she wanted to be alone, it was assumed that Greta was not interested in people, whereas the opposite was true. She regarded humanity as a fascinating species, infinitely curious in its habits and petty passions. Her greatest pleasure was to take long walks around Manhattan, disguised in dark glasses and frumpish clothes. In that way, she could be alone in a crowd, free to study these strange creatures, with no danger of real contact. Sometimes, however, the crowd misbehaved. A stranger might reach out to touch her, and then she'd come running to me for shelter. "Who is this Mansfield person?" she demanded, still breathless from the fray. I did my best to explain, and at last she regained her poise. "Ah," she said dismissively, as if recalling a long-buried rumor. "The sex thing . . ."

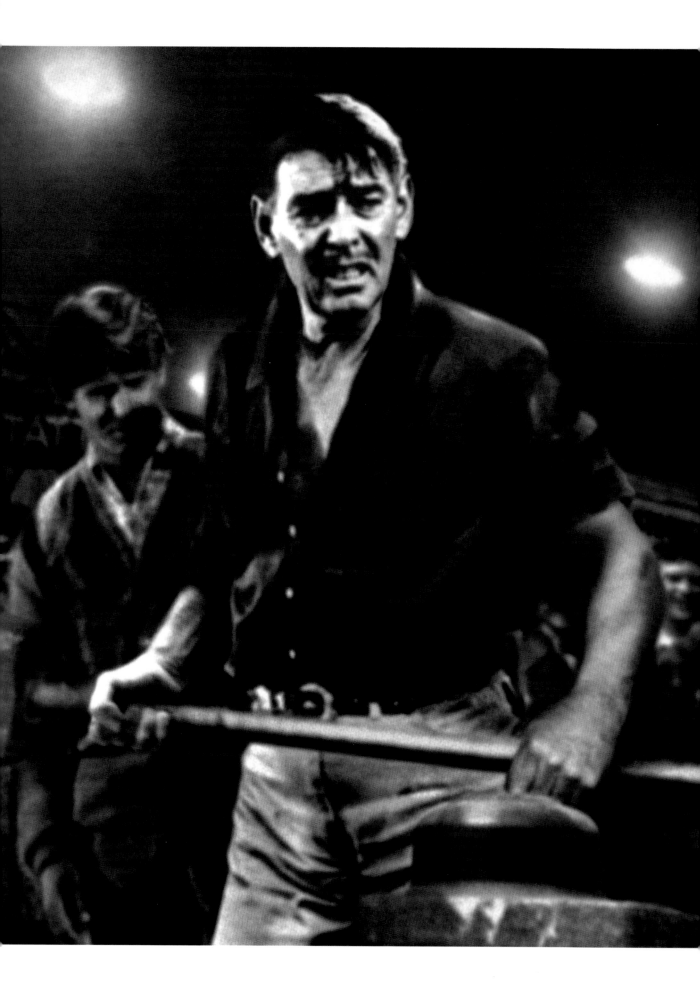

He'd had two heart attacks already, and the next would probably finish him. Before he died, he wanted to take one last journey through the landscapes of his beginnings—the farms of Ohio, the lumber camps of Oregon, the oil fields of Oklahoma. One night he came to Bigheart, where he'd worked alongside his father, who always thought him a weakling.

By chance, a carnival was passing through town. Strolling the midway, Gable stopped at the Test Your Strength machine. Once, when he was eighteen, his father had got him a job as a tool dresser, twelve hours per shift at the business end of a sledgehammer, for a dollar an hour. He'd never been so brutalized or humiliated in his life, yet tonight he felt strangely tempted to swing that hammer again.

Now that she'd had herself barred from the casino, only speed had the power to make Sagan feel completely alive. Then she was in a ditch near Meudon, and a passerby was dragging her clear of the wreckage. "So much pain," Françoise moaned. "I need my medicines." Her rescuer said he knew a doctor—an eccentric spirit who'd had a bad war but was a gifted healer. When they reached his house, she found an old tramp dressed in rags, yet his voice was tender. "What took you so long, my dear?" he asked her, filling a syringe. "I have been waiting all night."

They came for her at dead of night. Before she could cry out for help, she'd been bundled into the back of a waiting car and was speeding blindfolded through the dark London streets. When her sight was restored, she found herself in a basement, trussed up like a Christmas turkey, along with all her chums. "Tell us what you know, or else," the fat man commanded her with an evil laugh. But Christine was a true patriot who still kept the commemorative teacup she'd been given for the Queen's coronation. So she gritted her teeth and thought of England. "I won't talk," she said.

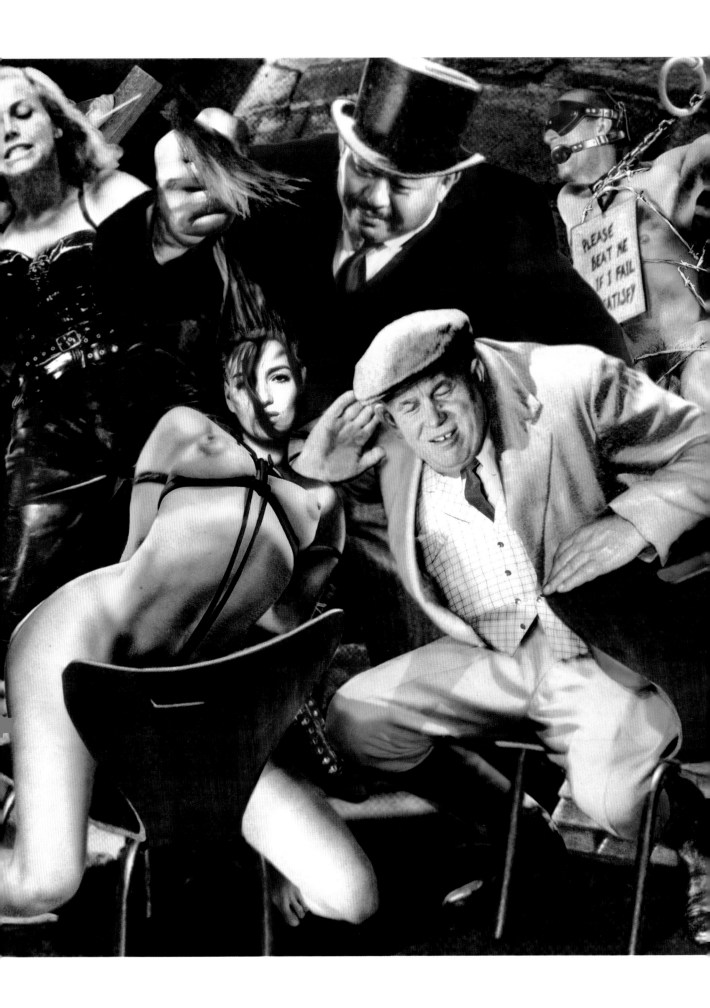

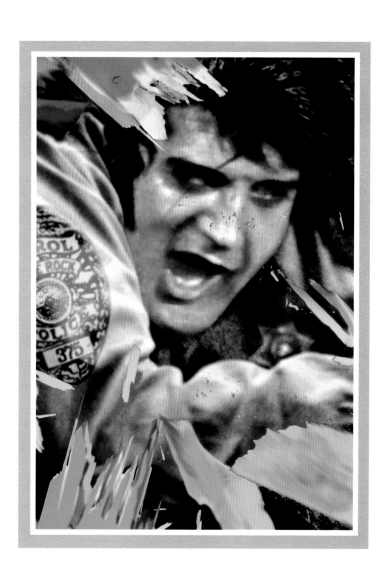

CALL IT AMERICA

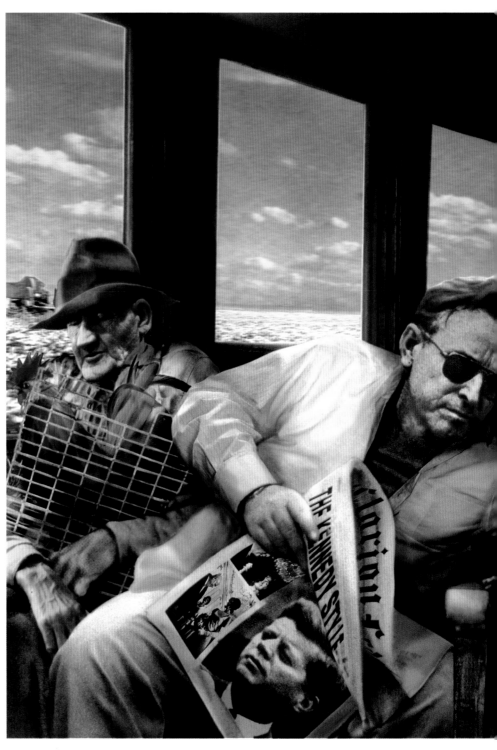

Sounds screwy to me," Oswald said.
"That's what makes it a winner," Ray insisted.

"But I got nothing against Kennedy. It's the coon I hate."

"The Rev's fine and dandy with me. JFK's the real poison."

"So what do you suggest?"

"You scratch my itch," Ray said, "and I'll scratch yours."

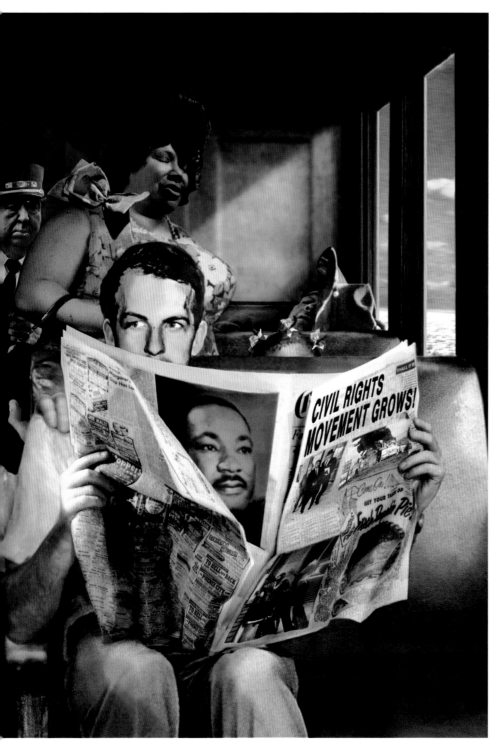

OVERLEAF:

"You never had a Black Cow?" Cassius said, and stepped on the gas. "Girl, you haven't lived."

It was their first date, a broiling summer afternoon, and the champ had taken a day off from training. They were cruising the Jersey Turnpike, with no particular place to go, when his sweet tooth kicked in. "The secret is in the root beer," he told her. "You can have your vanilla ice cream, your chocolate syrup, your little bitty cherry, but if the root beer isn't A&W, you don't have a real Black Cow."

The first place they stopped tried to fob them off with Coke, the second with Pepsi, the third with the wrong brand of root beer. "No dice," said Cassius, and they were back to the highway. Smokey Robinson and the Miracles were singing "Ooh Baby Baby" on the radio. "One more time," the champ said, pulling up at a Tastee-Freez, and at last his perseverance was rewarded. The girl took a sip. "You're right," she said. "I haven't lived."

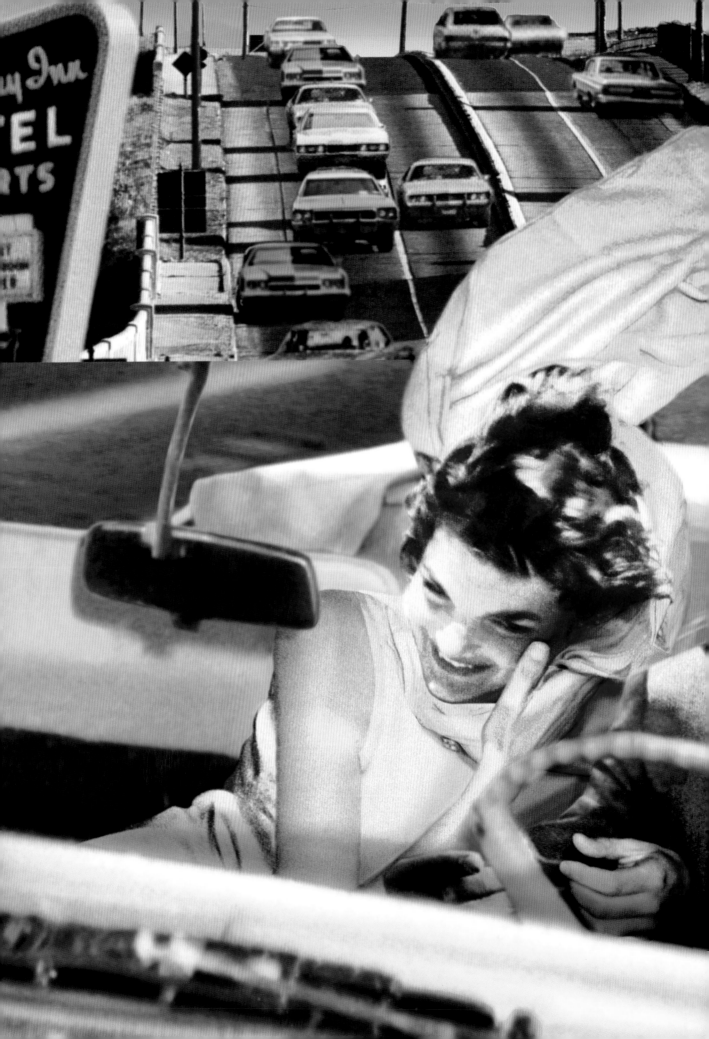

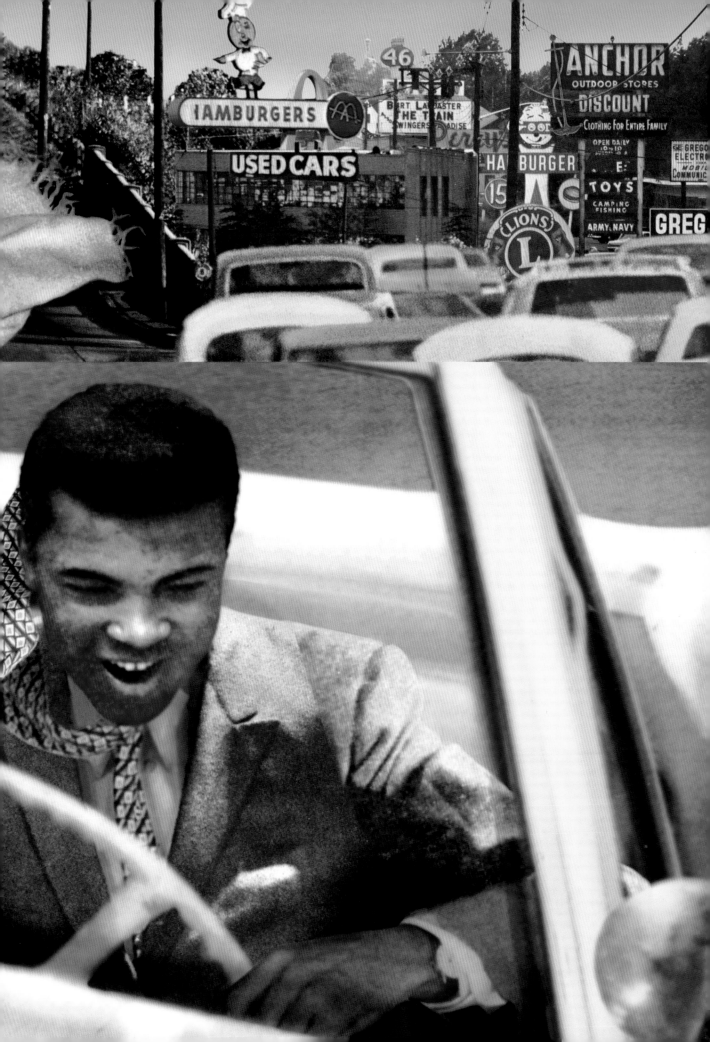

His quest, which had seemed doomed to eternal frustration, was at an end. Afterward, describing his first sight of this magical creature, Vladimir wrote: "I find it most difficult to describe with adequate force that flash, that shiver, that impact of passionate recognition."

Each wrong note was a stone in
Maria's heart. It was bad enough
that Ari had dragged this prissy little
American along on the cruise, and
worse that he wanted to possess her,
but the singing was the last straw.
Every night after dinner he'd lure the
young widow on deck to look at the
stars and serenade her with hideous
pop tunes. His voice was as flat and
rough as a gravel road, yet Jackie
kept urging him on. "You should
make a record," she cooed; and
Ari, in his infatuation, believed her.
"Strangers in the night, two lonely
people . . . Lovers at first sight," he
crooned, until Maria could not stand
another note. "It's a B natural, you
moron!" she screamed.

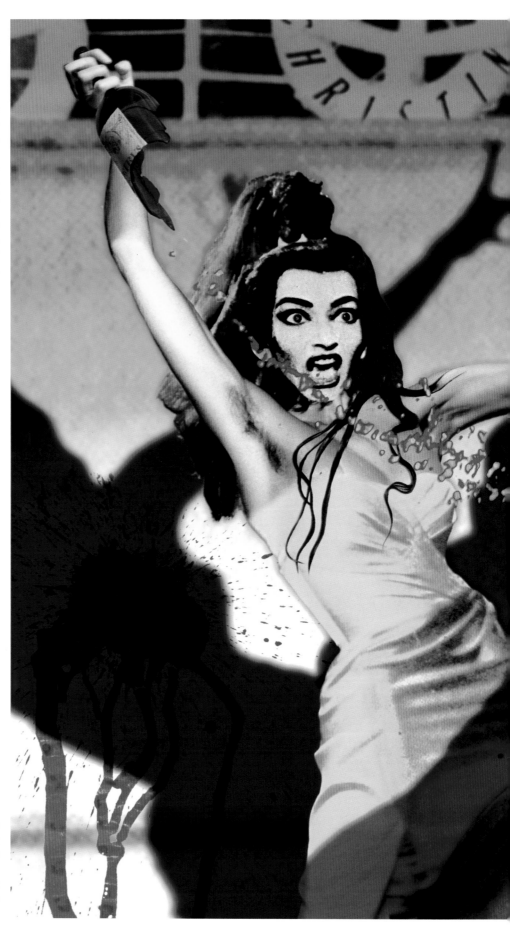

OVERLEAF:
Polanski was uneasy in his mind.
Something about this street both
attracted him and filled him with
dread. "It's getting kind of dark. I
think we should turn back," he said.
Nicholson, however, was just hitting
his stride. "Forget it, Roman," he
said. "It's Tijuana."

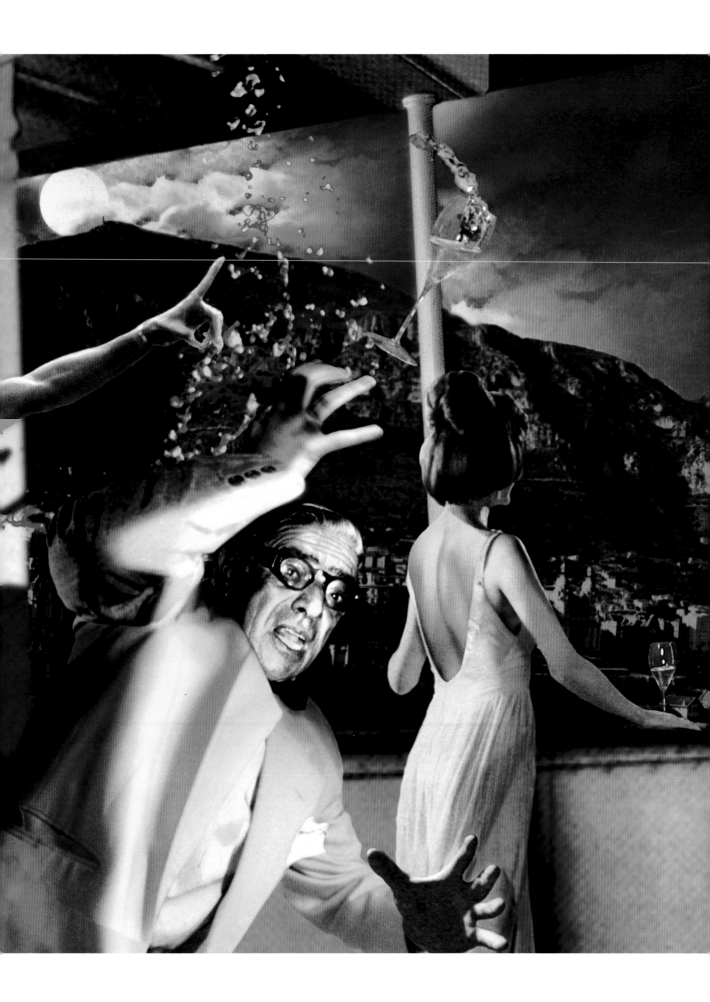

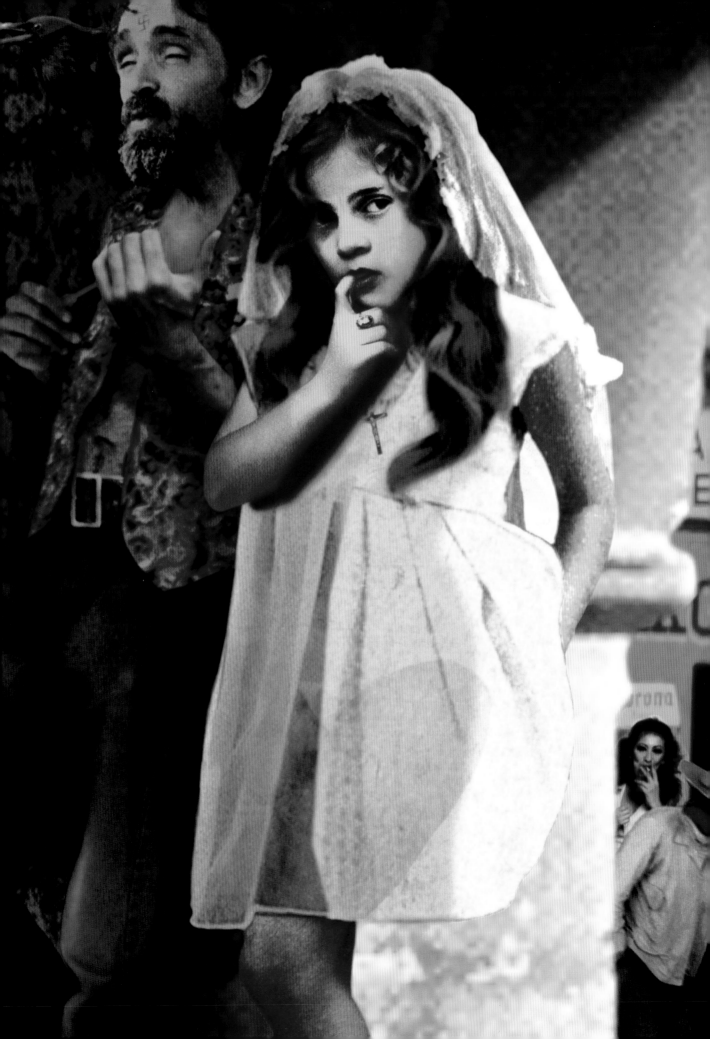

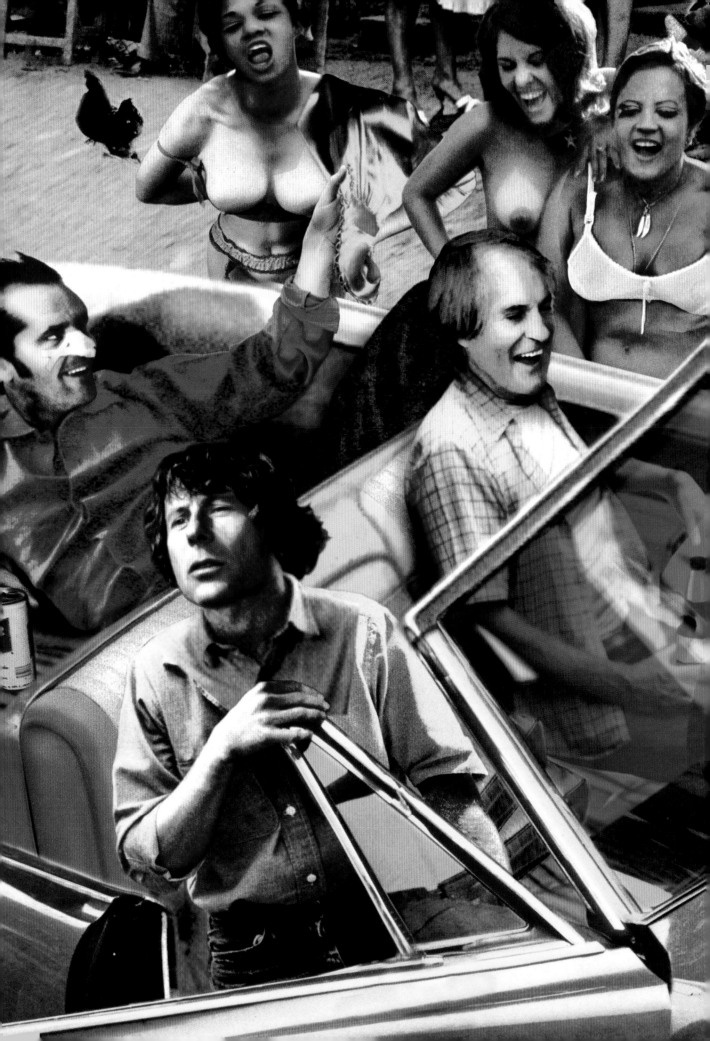

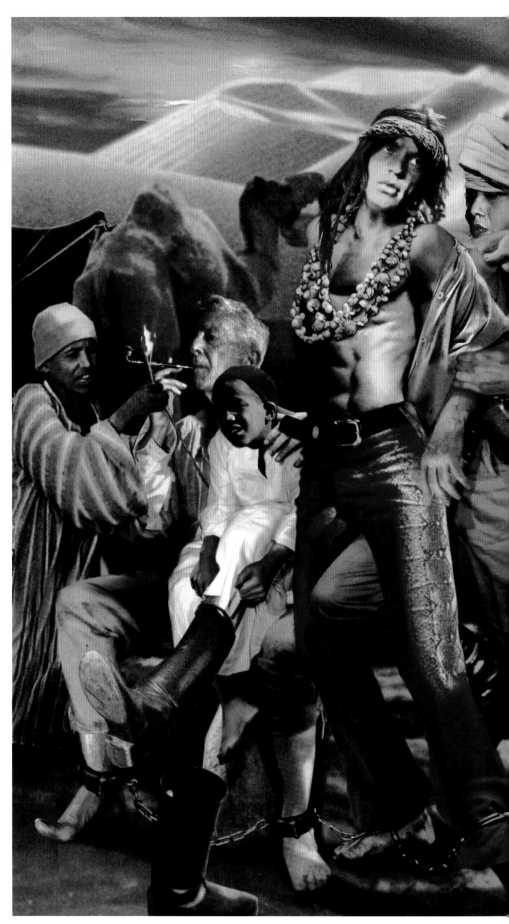

Marianne's feet were killing her. She'd always been a martyr to bunions, and this wasn't the King's Road. All she wanted was to get back to Tangier before she was permanently lamed or bandits got hold of them, but Mick was adamant. He'd come all this way to record some tribal music and he wasn't leaving till he'd found it. Wasn't that the sound of drumming, just over the next range of dunes?

OVERLEAF:

Dear Mr. President,

First I would like to introduce myself. I am Elvis Presley and admire you and have Great Respect for your office. I talked to Vice President Agnew in Palm Springs three weeks ago and expressed my concern for our country—the Drug Culture, the Hippie Elements, Black Panthers, etc. Sir, I can and will be of any service that I can to help the country out. I call it America and I love it. I wish not to be given a title or an appointed position. I can and will do more good if I were made a Federal Agent at Large. . . .

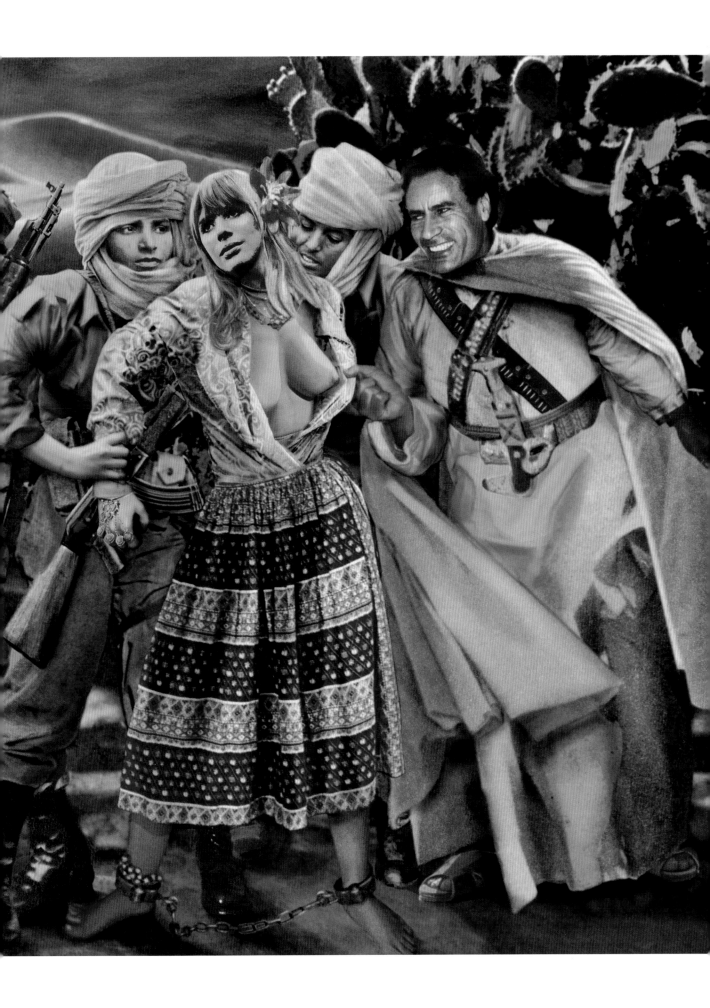

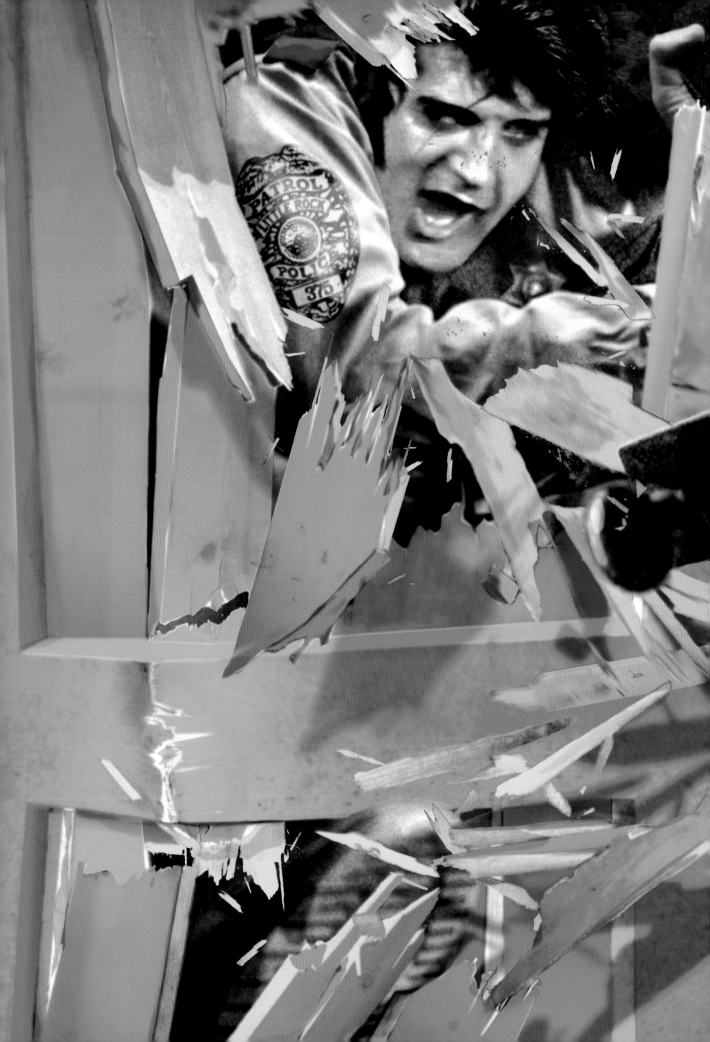

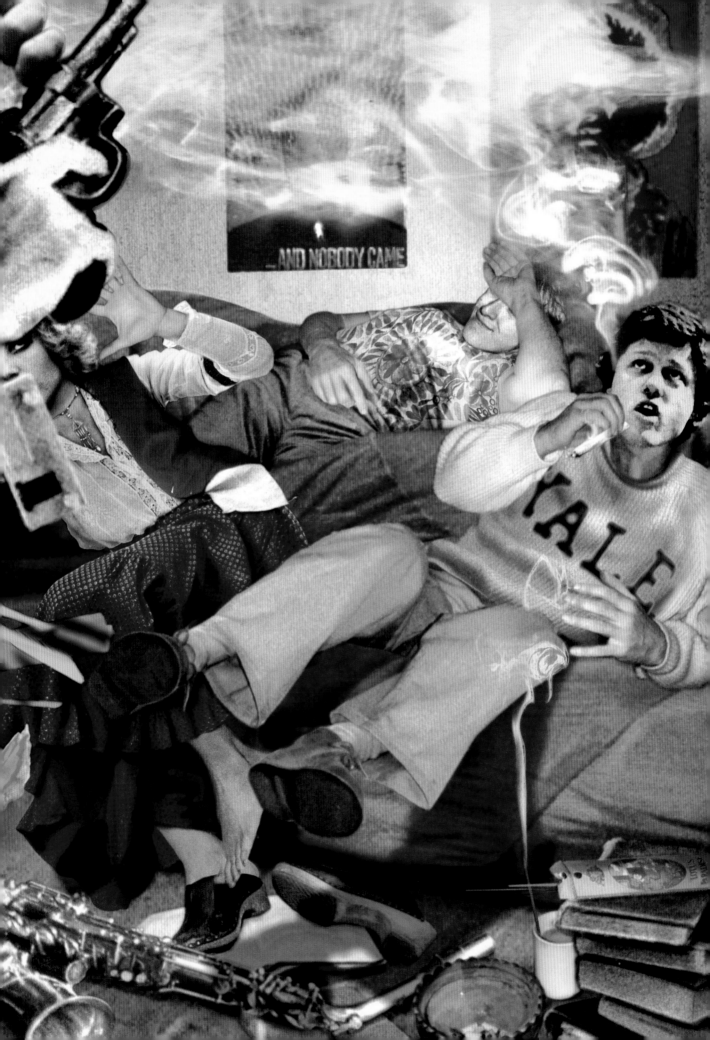

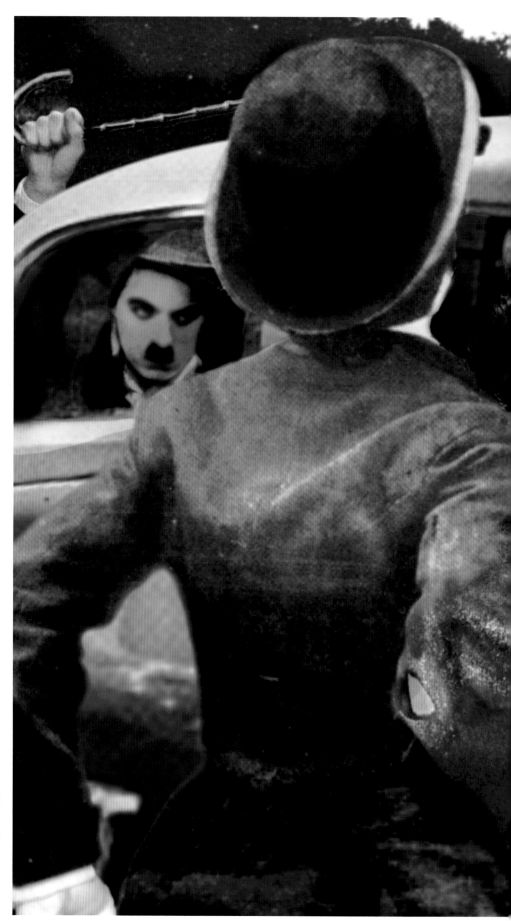

In Charlie's view, he had earned the right to peace, but his fans refused to let him be. His estate at Corsier-sur-Vevey was besieged by rabid fans who seemed to believe they owned him. When he tried to have them dispersed, they turned nasty. This old man wasn't Chaplin, they said. Just another fat millionaire.

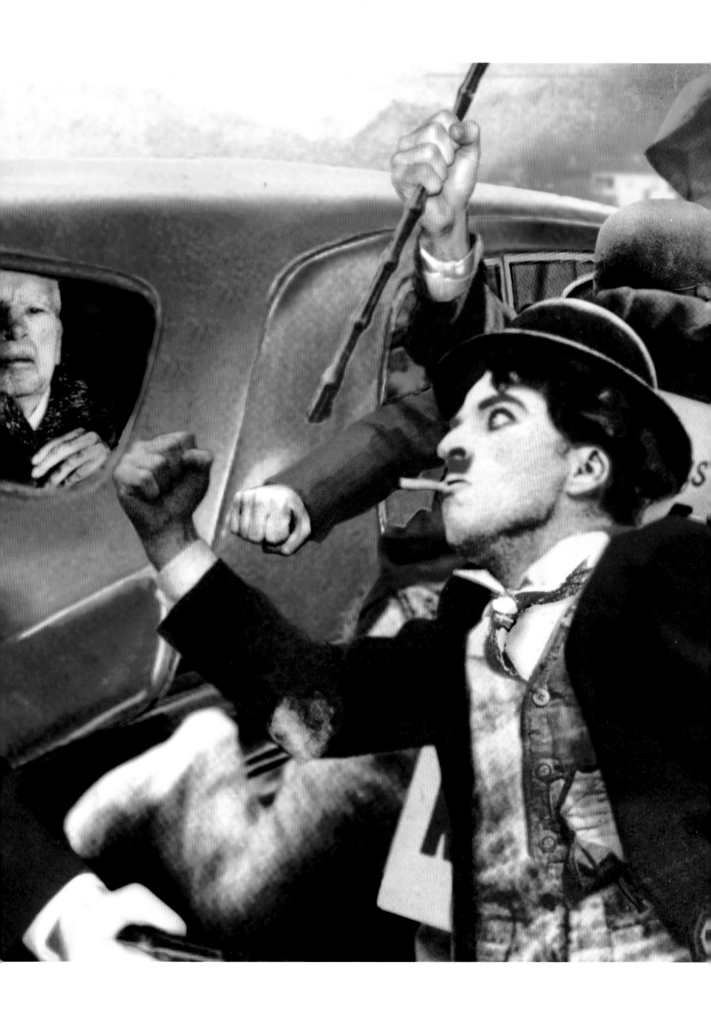

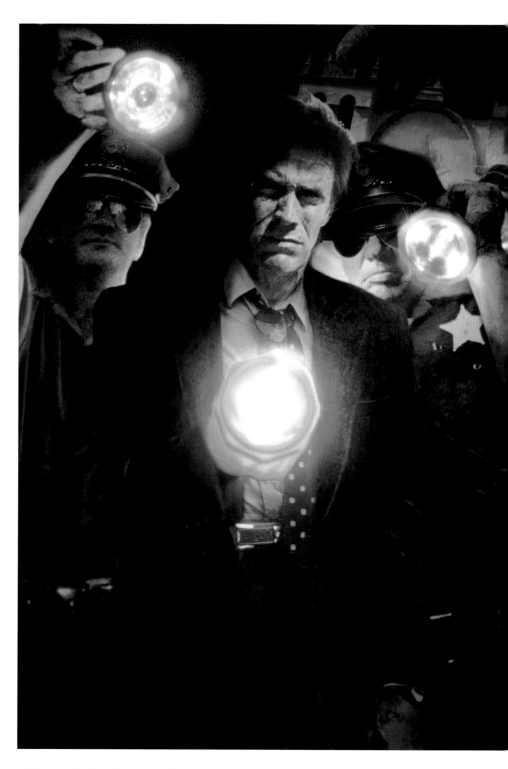

Clint was having dinner when the call came in from Sergeant McGinty: "A truckload of wetbacks, headed your way." So Eastwood raced to head them off. Not that he had anything against Mexicans, or any other immigrants, but as mayor of Carmel he knew his duty. He couldn't sit back and let aliens sneak in. They might take the jobs of good American boys.

OVERLEAF:

On that last night in the White House, after they had prayed together in the Lincoln Bedroom and Kissinger had departed, the President tried to think how all this had happened. He'd wanted to believe that his life was controlled by fate, that he was in the hands of a guardian angel, but she had not kept faith with him. He remembered the time, as a small child, when his mother had left him and gone to his older brother, who was dying of TB. He'd been alone then. He was alone again.

Or was he?

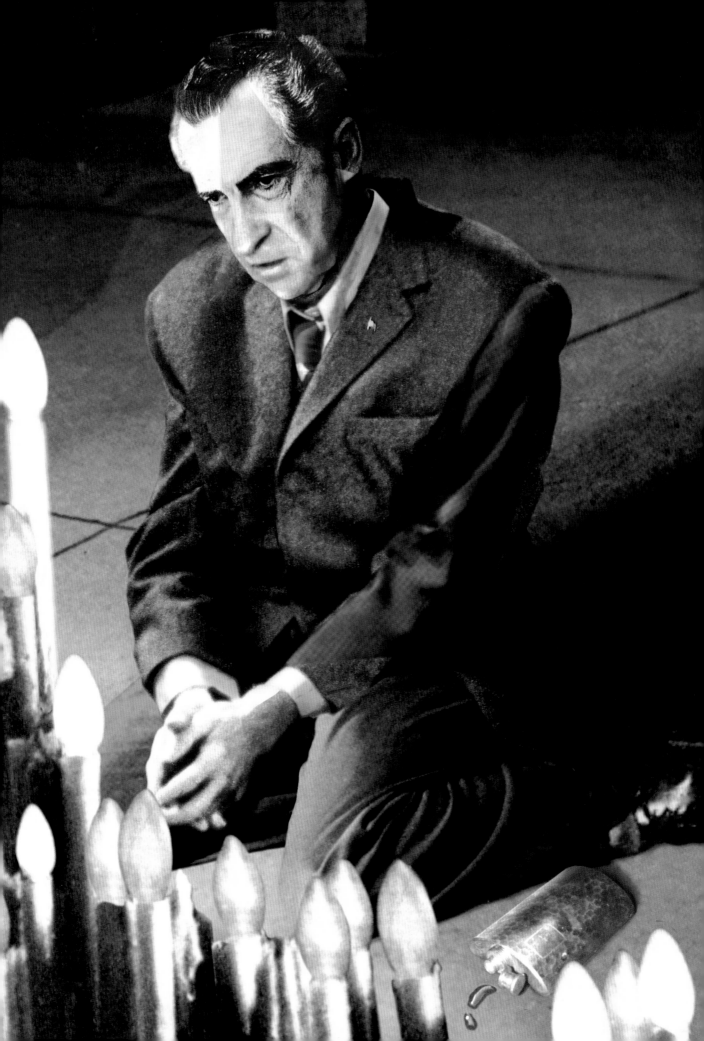

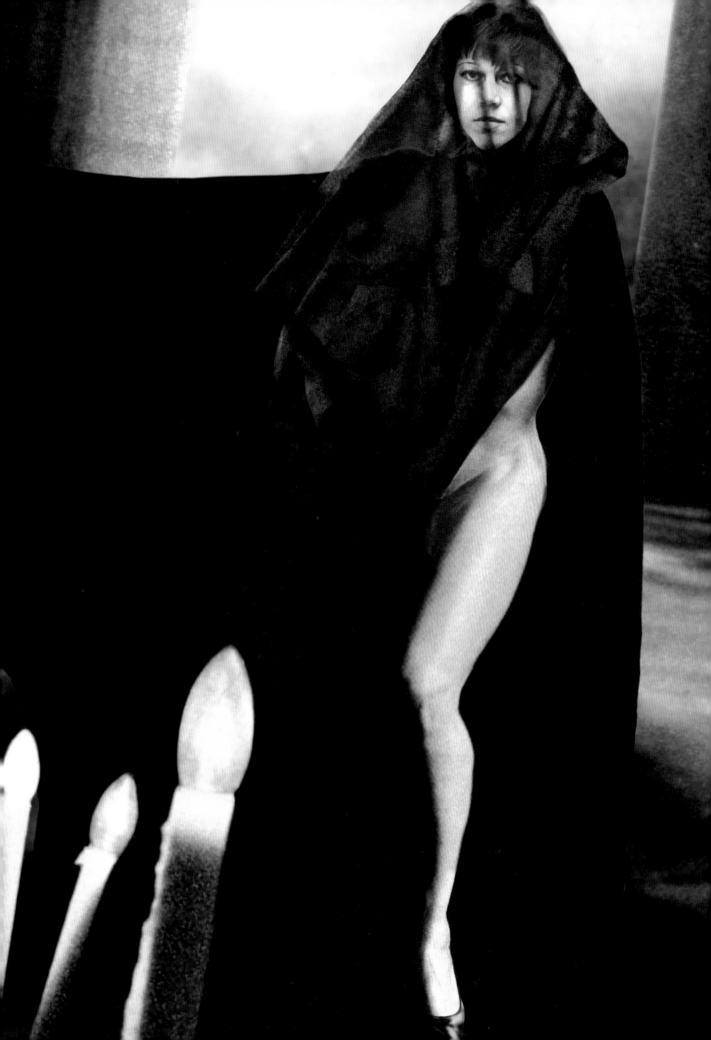

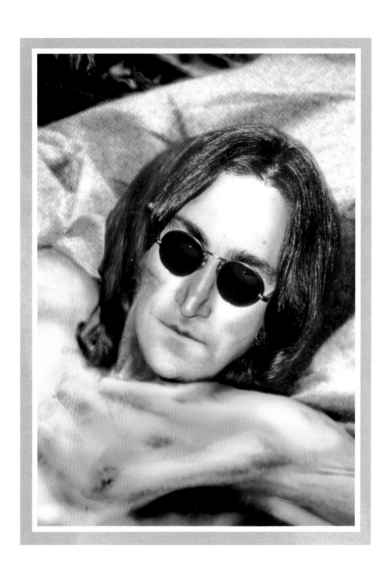

STRANGE DAYS INDEED

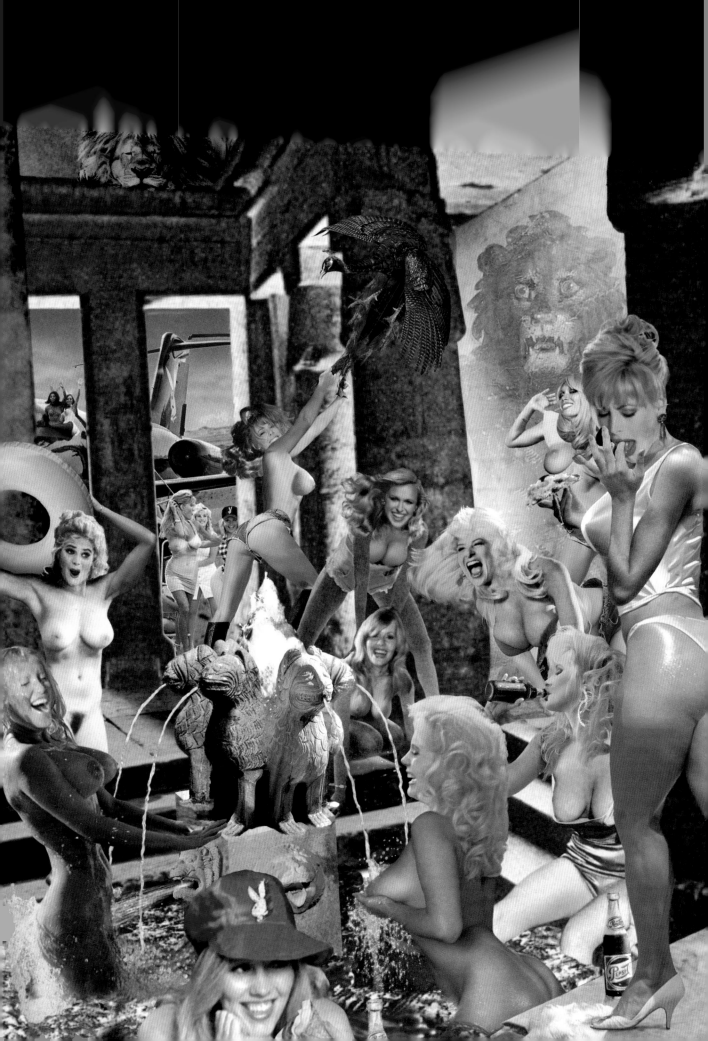

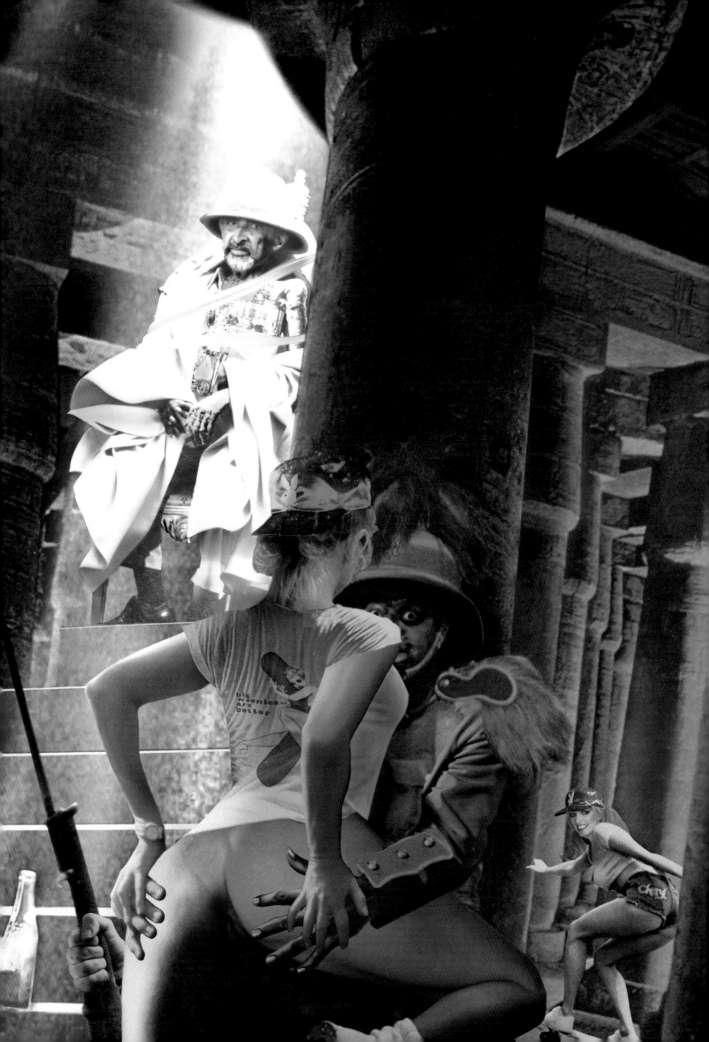

Beauty has no country. The Playboy bunnies, flying to perform for the troops on the Gaza Strip, were filled with apprehension when their plane ran into foul weather and was forced to make an emergency landing. The palace guards, however, gave the girls a royal welcome. If it hadn't been for the old scarecrow in the funny hat, they might have imagined they were back home with Hef.

Meadville? It could have been almost anywhere. Turn back the clock twenty years and Jean might have been in her own hometown. If she'd had a choice, Seberg never would have agreed to judge the local beauty contest, but the film people had stopped calling and she had to get money somehow. Now the winner kept plaguing her with dumb questions. It was just as well the girl didn't know what a racket the movies really were, or she wouldn't be so dewy-eyed. All that Jean could do was pass on a few glamour tips and wish her the best of luck. Not that it would do any good. The poor child just didn't have what it takes.

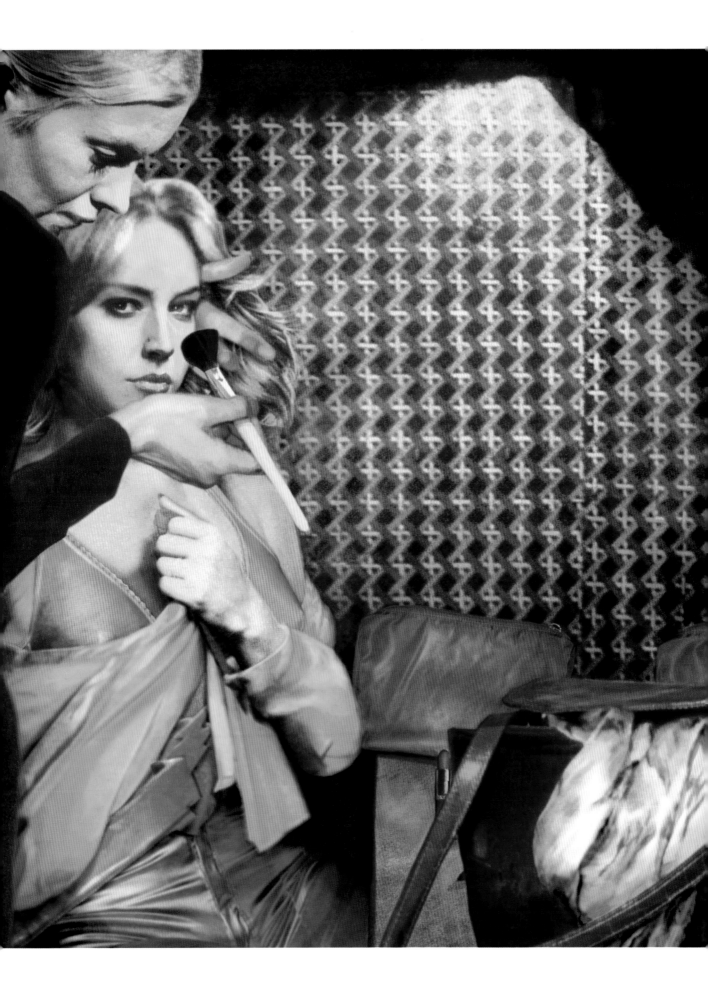

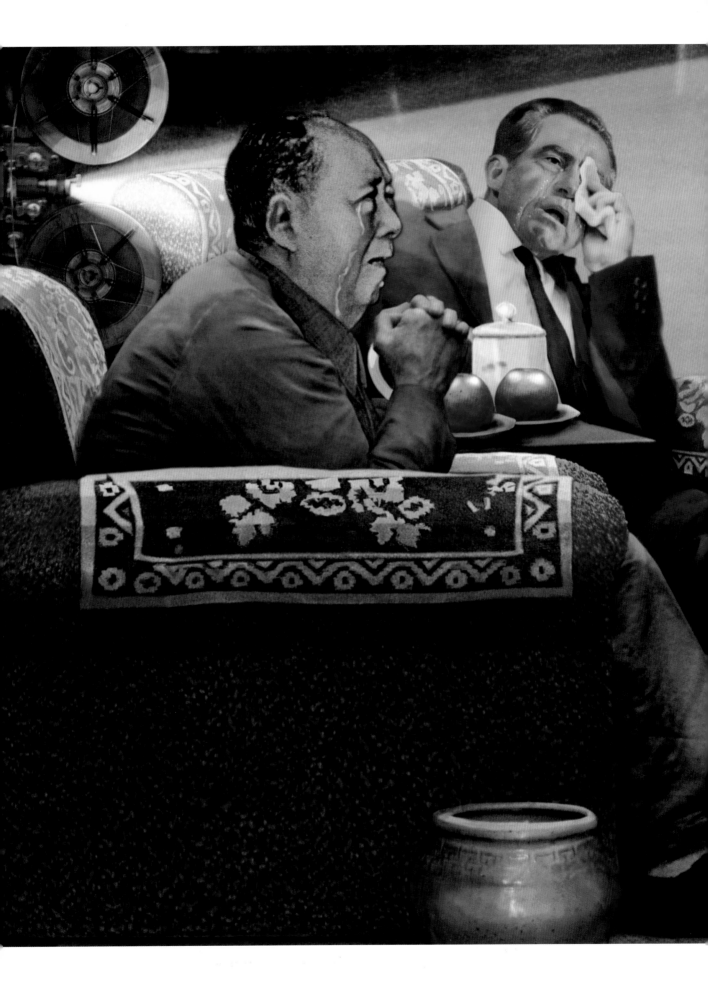

Late at night, when the aides and advisors had retired to their beds, the two old warriors would sit up together and speak from the heart. Their talk then was not of human rights or trade agreements, but of something that transcended mere politics: the art of survival against all odds.

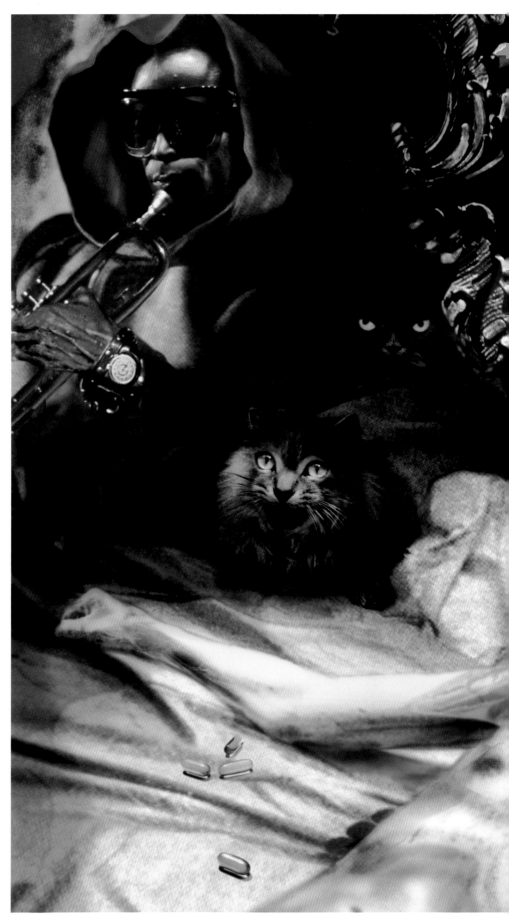

Strange days indeed. Some mornings, drifting in and out of sleep, he couldn't remember who he was or what had brought him here. Mother was writing in her dream book again; the dark prince played a threnody. It occurred to Lennon, as he shut out the light, that John might already be dead.

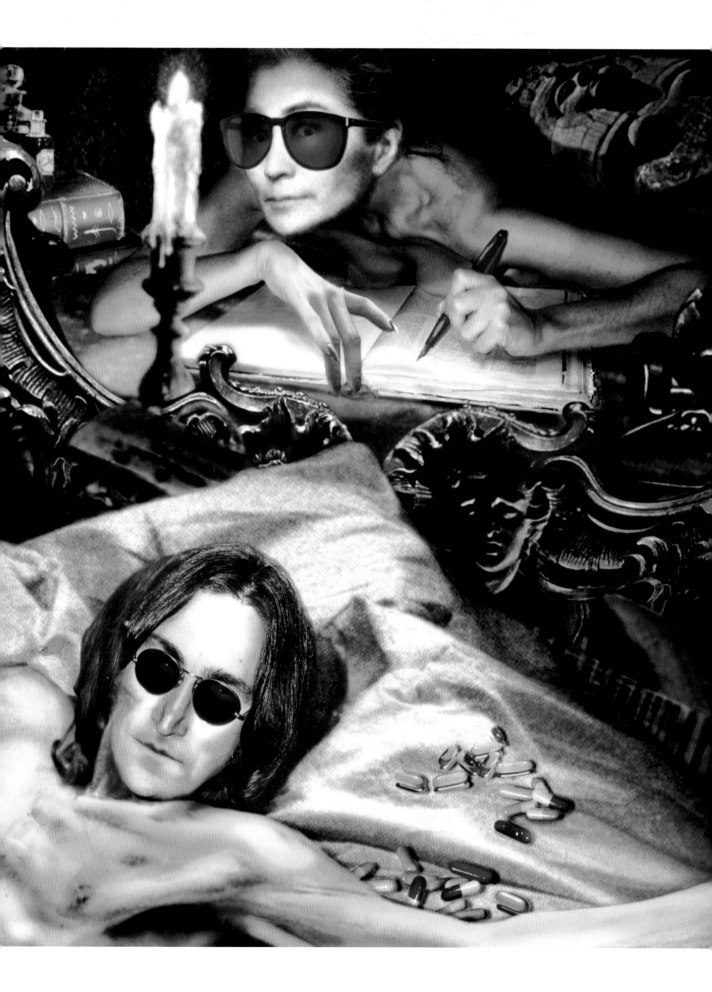

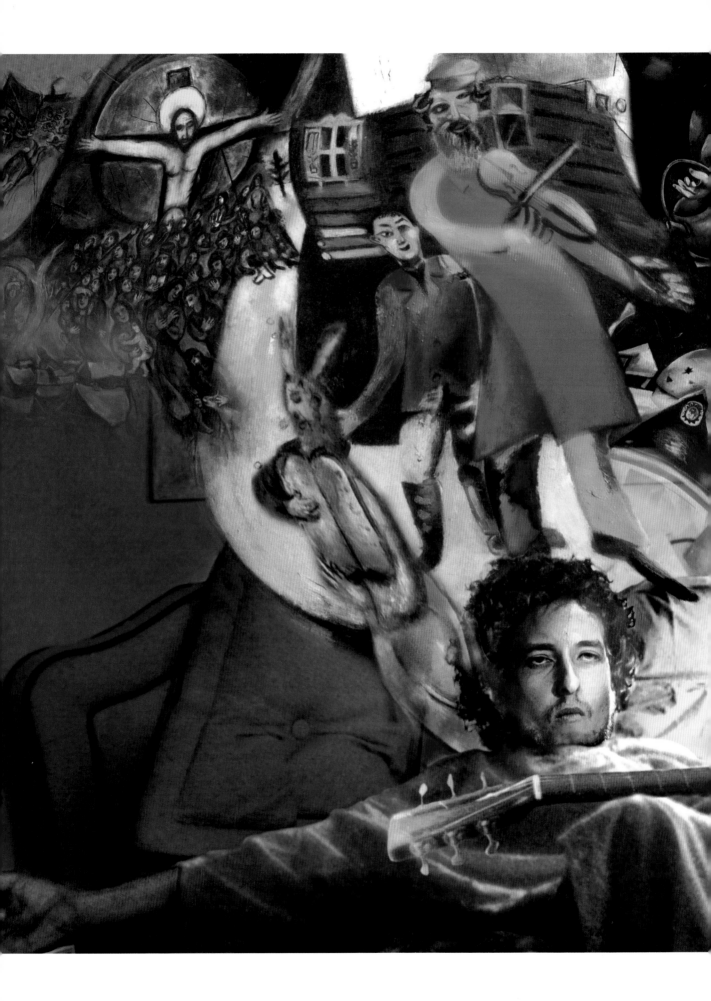

Bob was so looking forward to seeing Israel at last. He had already spent a week in a kibbutz and bathed in the Red Sea. Then the old woman insisted on feeding him. Matzoh-ball soup, chopped liver, gefilte fish—all the same dishes his grandma used to make, back when he was a child and still had a home. His plate was full before he remembered how much he hated this stuff. It was the taste of family, of little Bobby Zimmerman. All night long it lay on his tongue like a curse.

Idi told me he felt betrayed. "These English are very bad peoples," he said. "They spread filthy lies about me everywhere, their government and their press, they are testing my patience sorely. I think I must tell the Queen what they do. She is a good woman, I love her very much. She will be most angry when she knows the evils her servants have done. Yes, it is true, I must speak to her ear. I will walk into her palace. The guards will not stop me; I too am a monarch. His Excellency President for Life Field Marshal Al Hadj Doctor Idi Amin Dada, V.C., D.S.O., M.C., Lord of All the Beasts of the Earth and Fishes of the Sea and Conqueror of the British Empire in Africa in General and Uganda in Particular—no guards can hope to deny me. I will pass through their midst as an eagle passes sparrows, and so to the royal bedchamber. There I will tell my full sorrow. 'Mrs. Queen,' I will say, 'you are sadly misled. Your fickle husband, Mr. Philip, talks only rubbish to you. Your prime minister is lower than jackal dung. Only I truly estimate your worth. And only you, Mrs. Queen, will know the secrets of my deep heart. We are bound together, this I know for fact. We are the only rulers by divine right. Don't you think, Mrs. Queen, it is time we were wed?' "

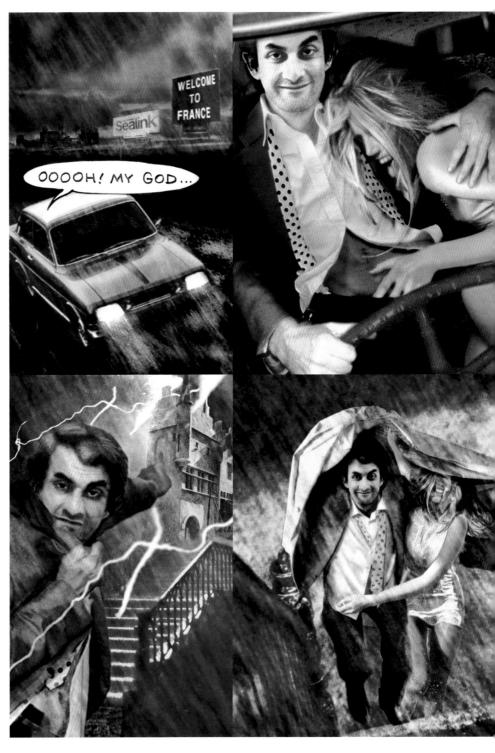

The publication of his novel had left young Salman drained, so he decided on a quick trip over to France, where Annabel could always find ways to help him relax. Some kilometers north of Paris, however, a violent thunderstorm struck. He tried driving through it, but the car soon broke down, and the lovers found themselves stranded.

"Where are we?" Annabel asked.

"Lost," Salman replied grimly, trying to ignore the howling of the wolves. But his fears were soon allayed. The lightning revealed a nearby château, its windows warm with firelight, and a kindly old man, who bade them step inside.

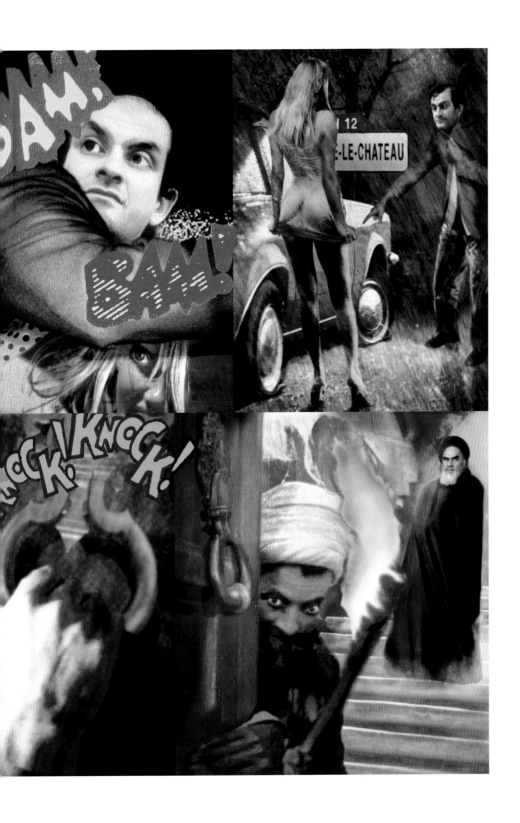

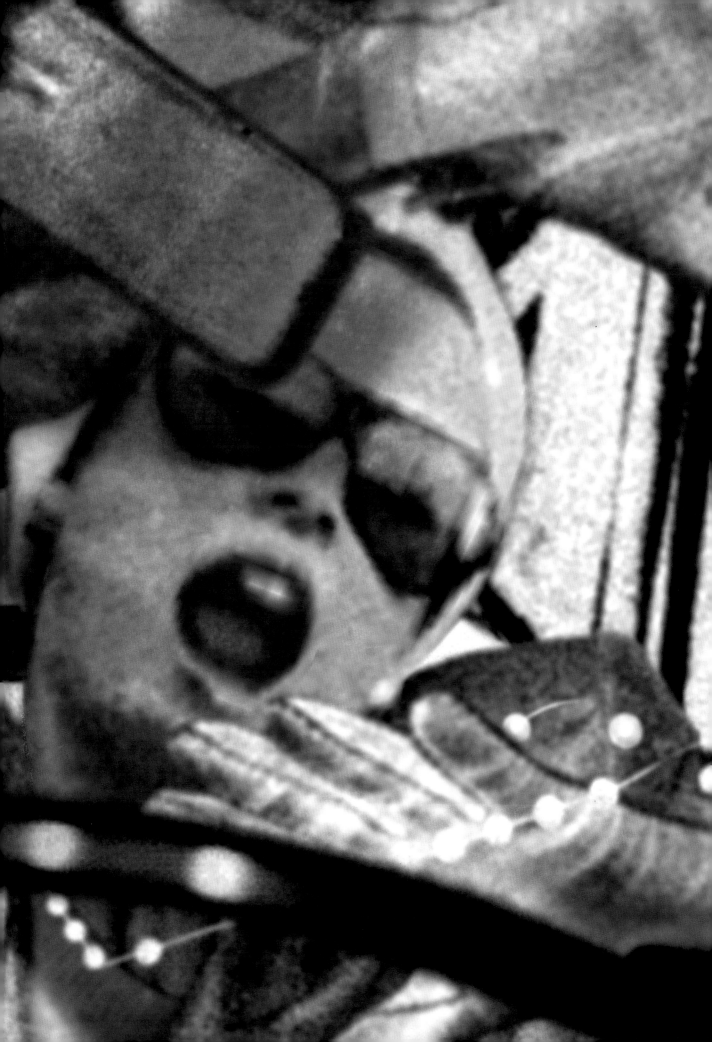

PRECEDING PAGES:

Now that Hitchcock was dead, the princess saw him constantly. His shadow crossed the doorways of the palace, the gardens of the casino, even the window of her bedroom. She couldn't sleep; he was driving her slowly insane. As a last resort she decided to take a long drive, miles away from anywhere. Out on the corniche, between the sea and the clear blue sky, she would be safe.

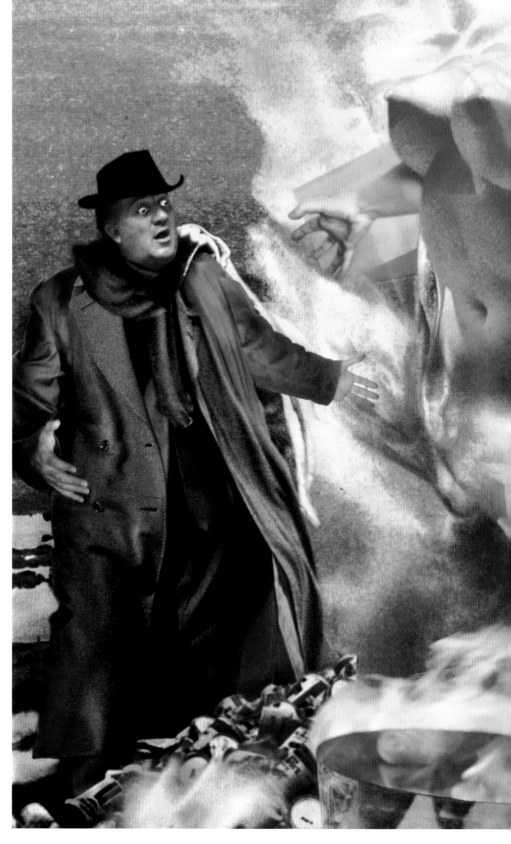

Federico approached his dreams like a lover approaching a tryst, or a fat man approaching a freshly baked pie. First he took a long, luxurious bath. Then he had himself wrapped in an enormous white towel by a woman with out-size breasts. She must not wear a brassiere, or else the whole ritual was spoiled. She had to hold him against her bare breasts, rolling him back and forth as she dried him off. He once told me that when the towel brushed his sex and made it swing like a bell-rope, it was such a lovely feeling he prayed it would never stop. Afterward, the woman would lead him to his bedchamber. He liked to sleep in a large, high bed, between cool sheets but under a warm comforter. At the sight of it, a sly, almost childlike smile would steal across his face. "My carriage awaits," he used to say, gently shutting the door.

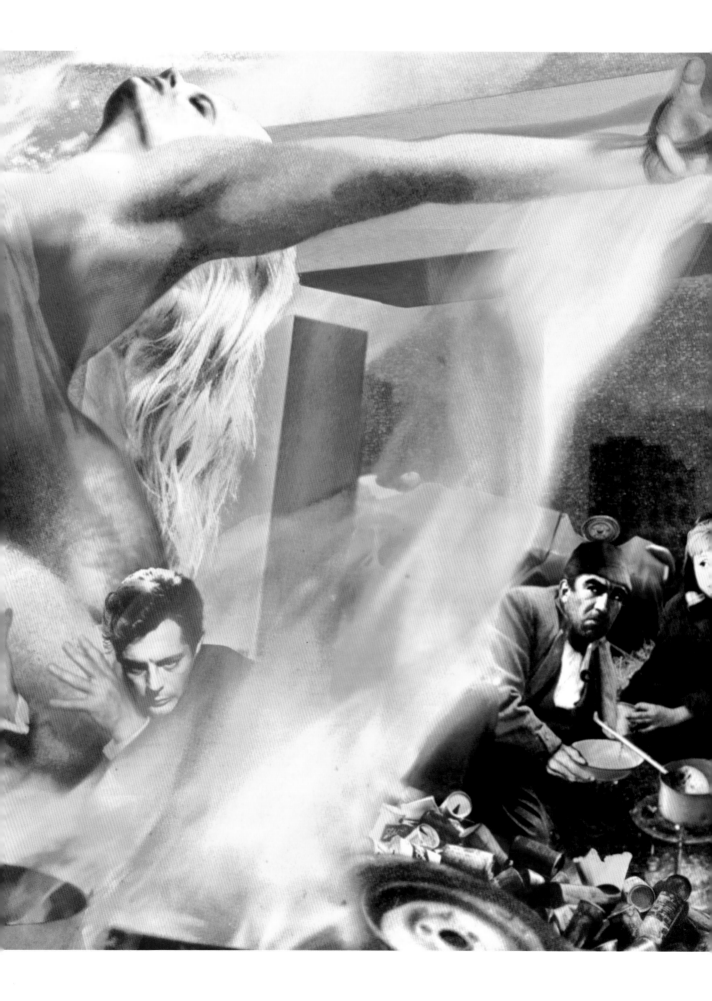

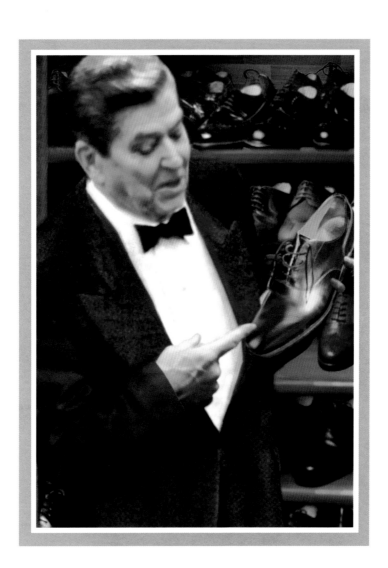

THE LAST TIME I HAD SUCH FUN

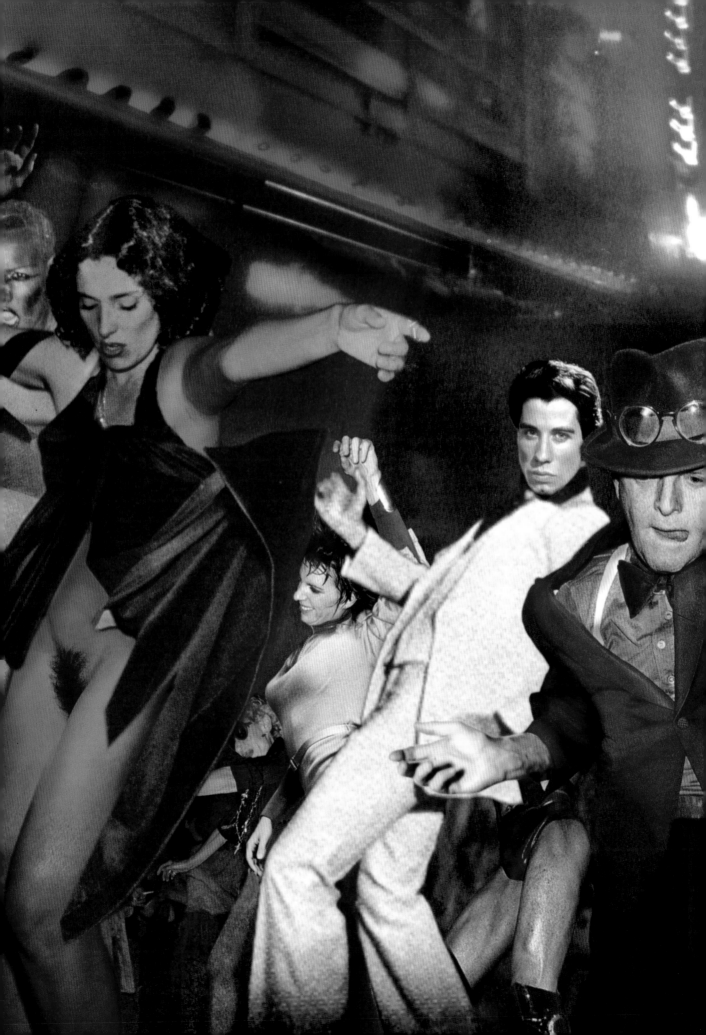

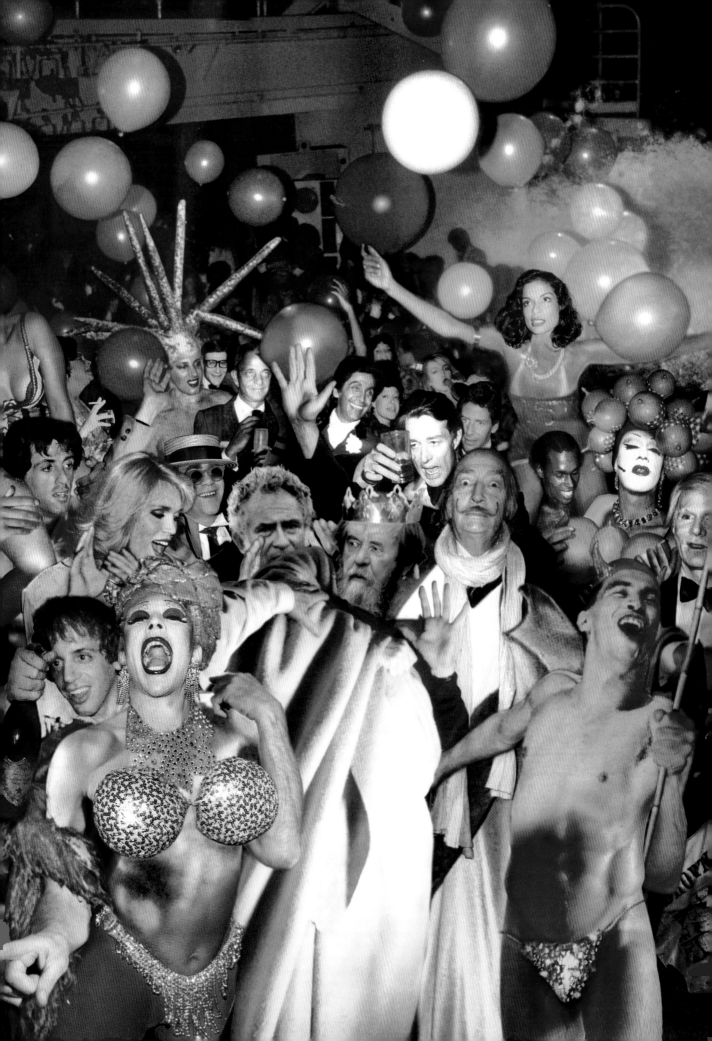

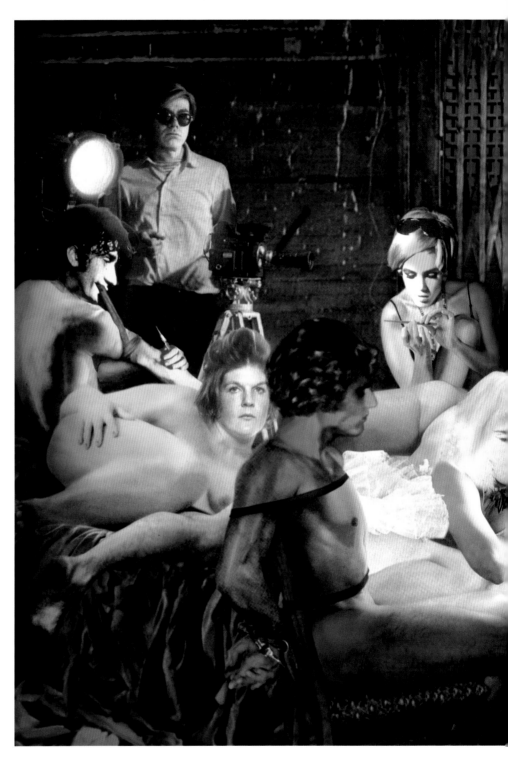

Everyone agreed. While Solzhenitsyn was in New York, he simply must pay a visit to Studio 54; and the sage, who dearly loved a revel, was only too happy to oblige. By the time our party arrived, the evening's revels were at full spate. "Isn't this to die for?" Truman asked. But Aleksandr, busy with pleasure, couldn't spare the breath to reply.

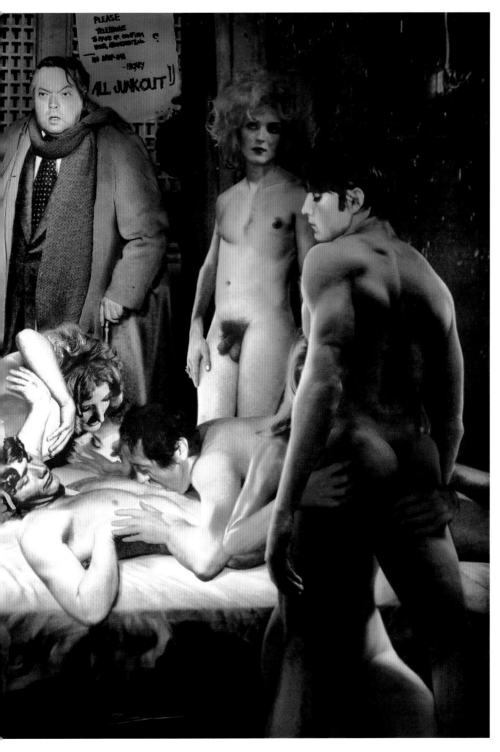

For a moment, as he was ushered into Warhol's presence, Orson was reminded of Falstaff and Hal. "God save thee, my sweet boy!" he declaimed.

"My king! my Jove! I speak to thee, my heart!"

"Gee, thanks," Andy said. "That's so sweet of you."

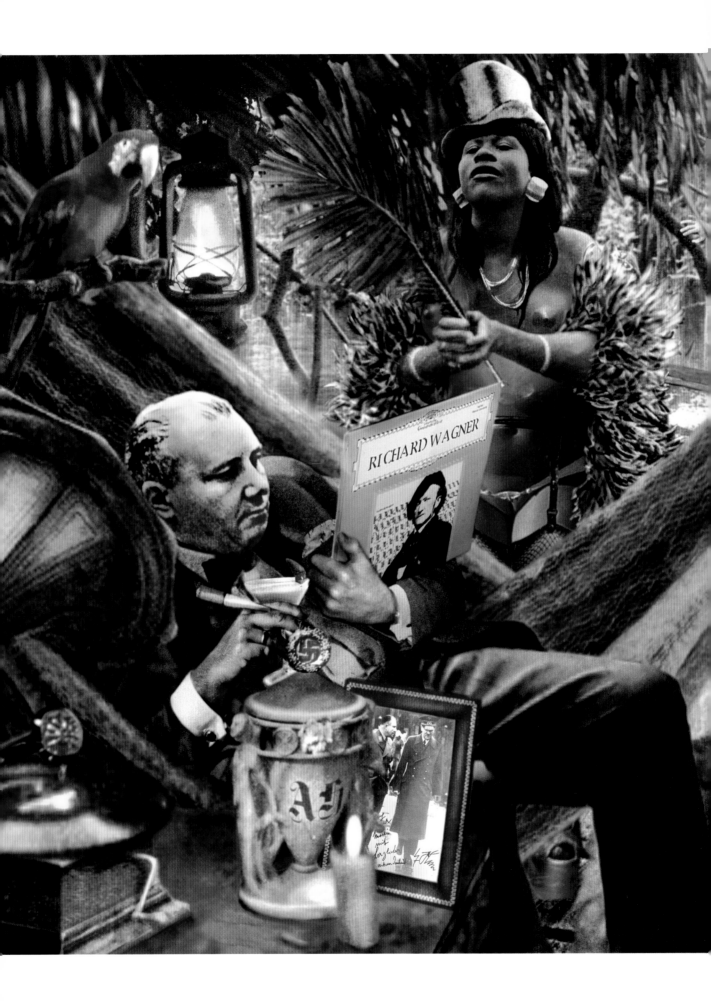

In his letter, Lucan said that the chaps had been absolute bricks. It can't have been much of a treat for them, getting woken up in the middle of the night to be told that he had brained his nanny in error and needed a quick getaway, but they'd never batted an eye. "Just you leave it to us, old thing," they told him. "Help yourself to the whisky, and we'll have you straight in a jiffy." And so it had proved. A false passport, a fast boat across the Channel, then a nice slow cruise to South America, and here he was, right as rain. "We know the very place," his chums had promised. "You'll be among friends."

OVERLEAF:

Nancy's true genius lay in her common touch. There was nothing snobbish about her, no hint of the parvenue. And she always knew how to break the ice at parties.

This particular soiree had got off to an awkward start. The men insisted on comparing assassination attempts and showing off their scars. But Nancy, ever the perfect hostess, quickly put her other guest at ease. "Why don't we go upstairs to my room, just us girls," she suggested, "and leave these old fogies to their war stories?" The men, however, refused to be left behind, and soon the White House rang with laughter. "I can't remember," said the Pope, "the last time I had such fun."

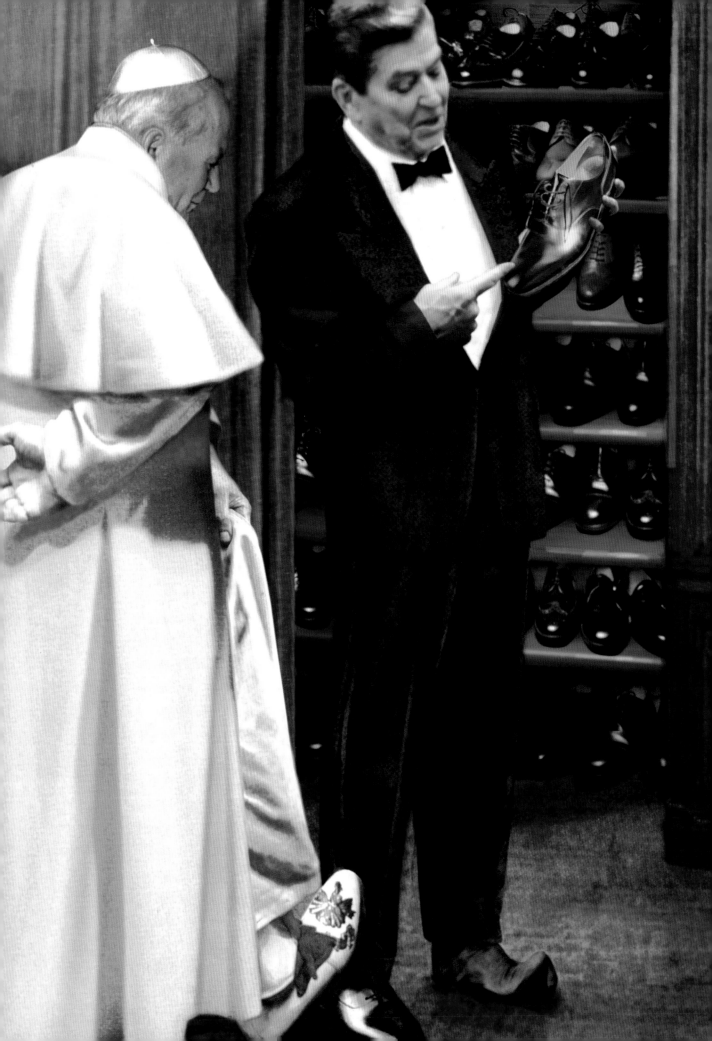

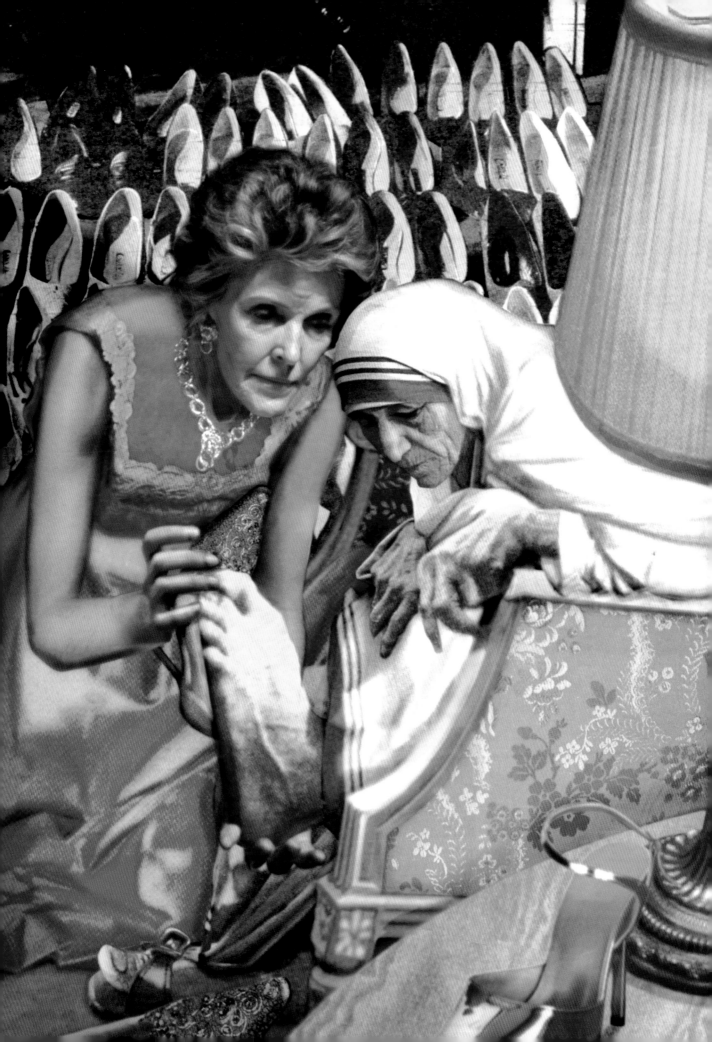

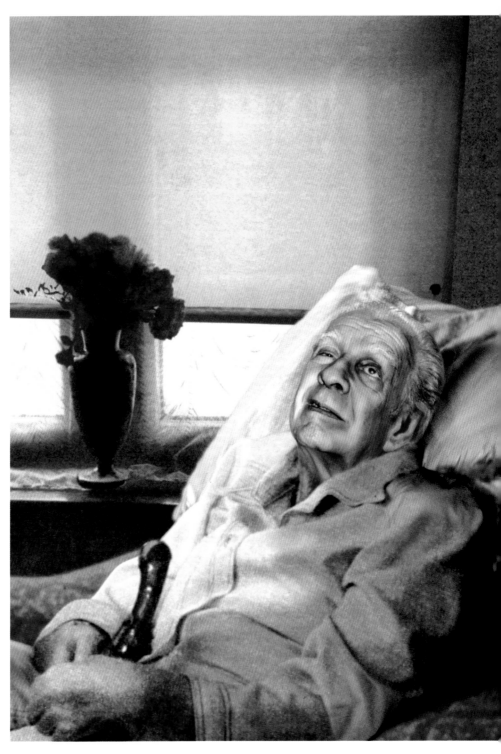

All day Borges lay on his sickbed, listening to the cheers and chants in the street, and at nightfall he called me to his side. "I have a small idea for a story. A mere bagatelle, but you may find it amusing," he said. "A footballer is playing the most important game of his life. All through the match he struggles and strives in vain, reaching for one moment of greatness, but the goal continues to elude him. At last, in despair, he is reduced to praying for a miracle. And his God answers

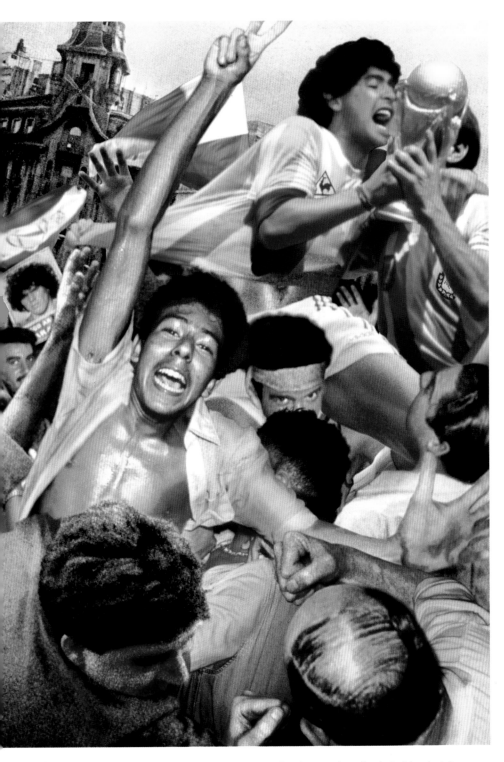

him. Reaching out His hand, He flicks the ball into the net and the match is won. Only much later, when the game has passed into legend, does the footballer realize the cost. He is condemned to replay the match endlessly in his mind. But never again will his God reach down." Borges paused for breath, then turned his face to the wall. "I call it 'Mano de Dio,'" he said.

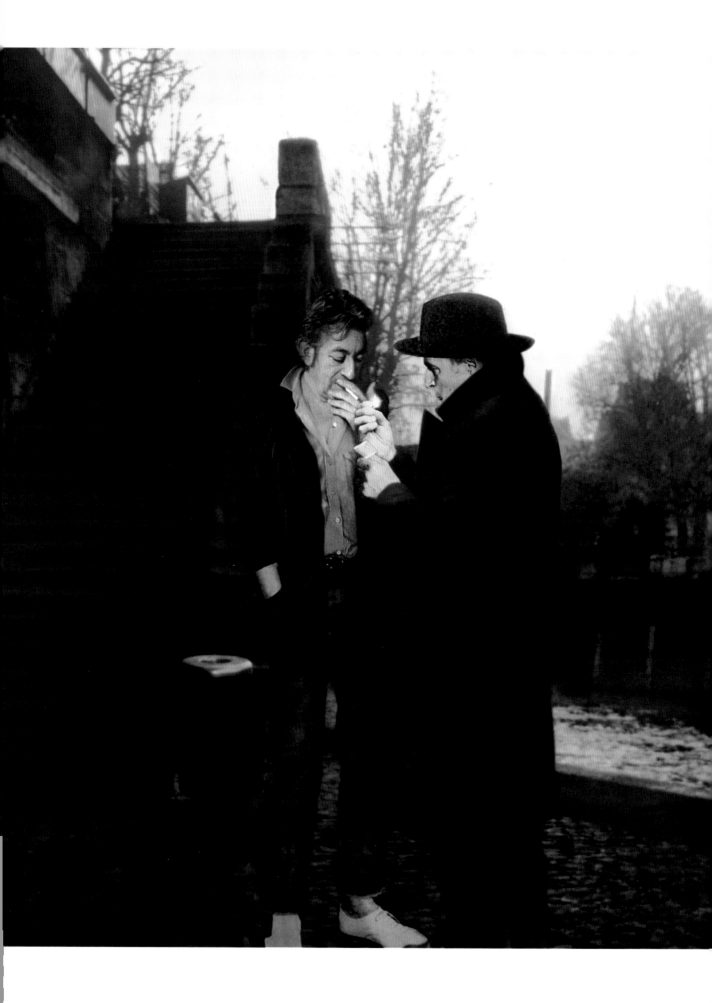

Often, as Gainsbourg strolled home at the end of his night, he would pass Mitterrand at the start of his day. The two men, despising each other, had always refused to exchange courtesies. Now both were dying. All their hungers and furies were spent, and nothing remained but a vast solitude. "How cold these mornings are," Serge remarked. "The wind cuts like a knife."

OVERLEAF:

Few thought of Margaret as a sentimental woman, but she was deeply touched, upon her retirement, when her colleagues suggested that she should have her portrait painted by England's greatest living artist. "I must confess I am not familiar with his work," she said. "What kind of stuff does he do?"

"A lot of religious subjects. And dogs," Mr. Major reassured her. "I'm told he does a lovely dog."

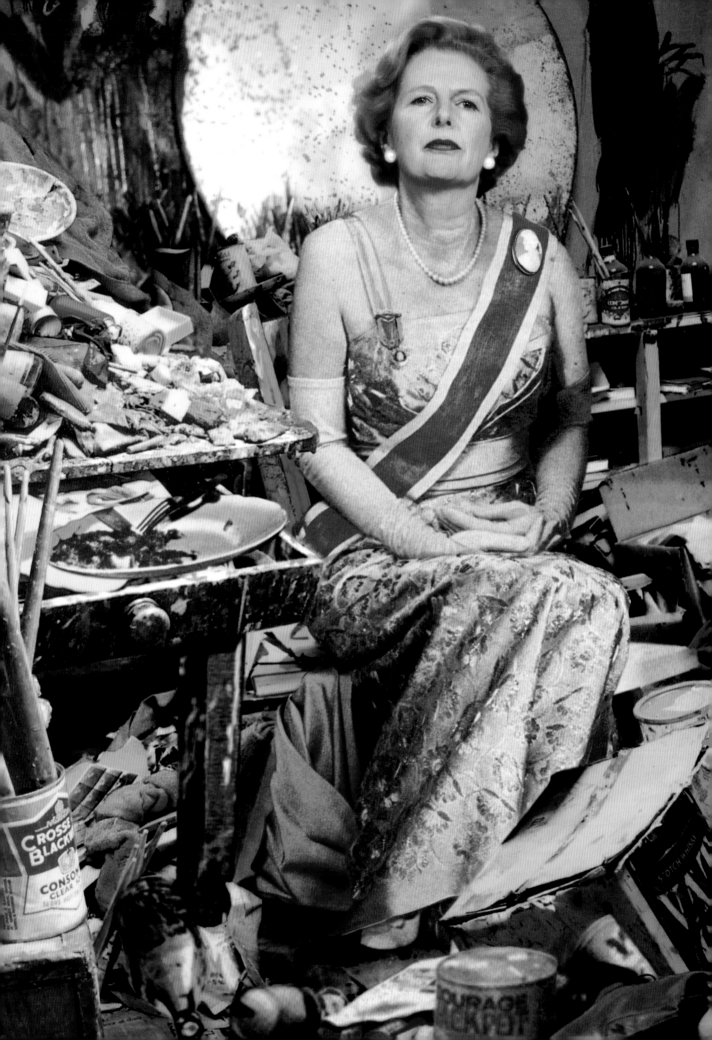

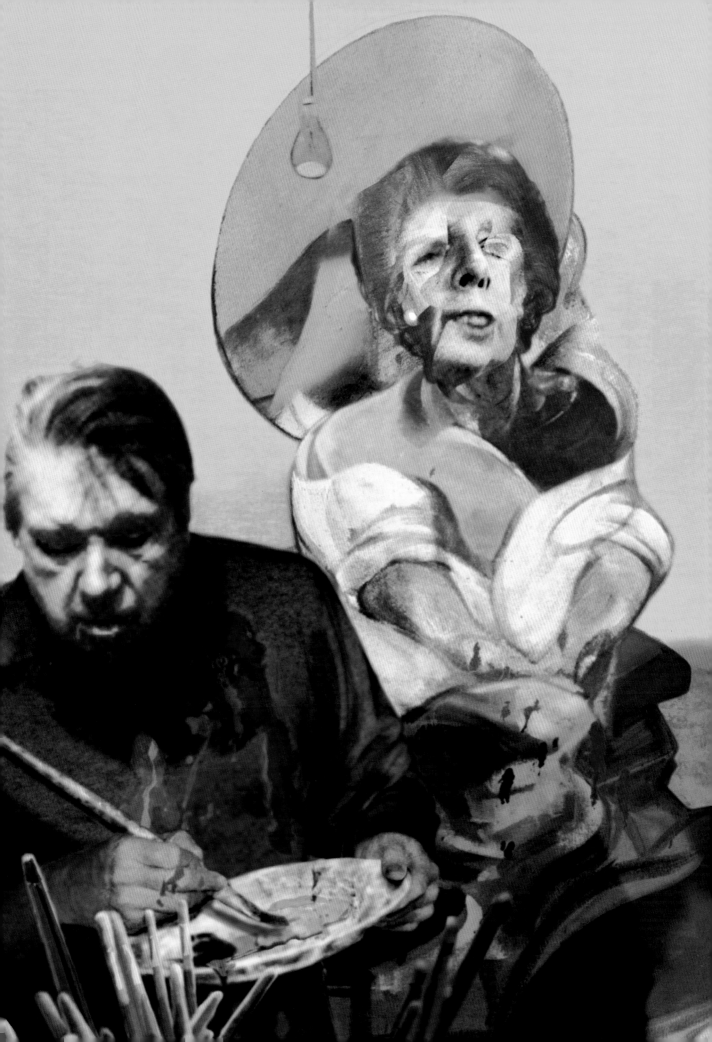

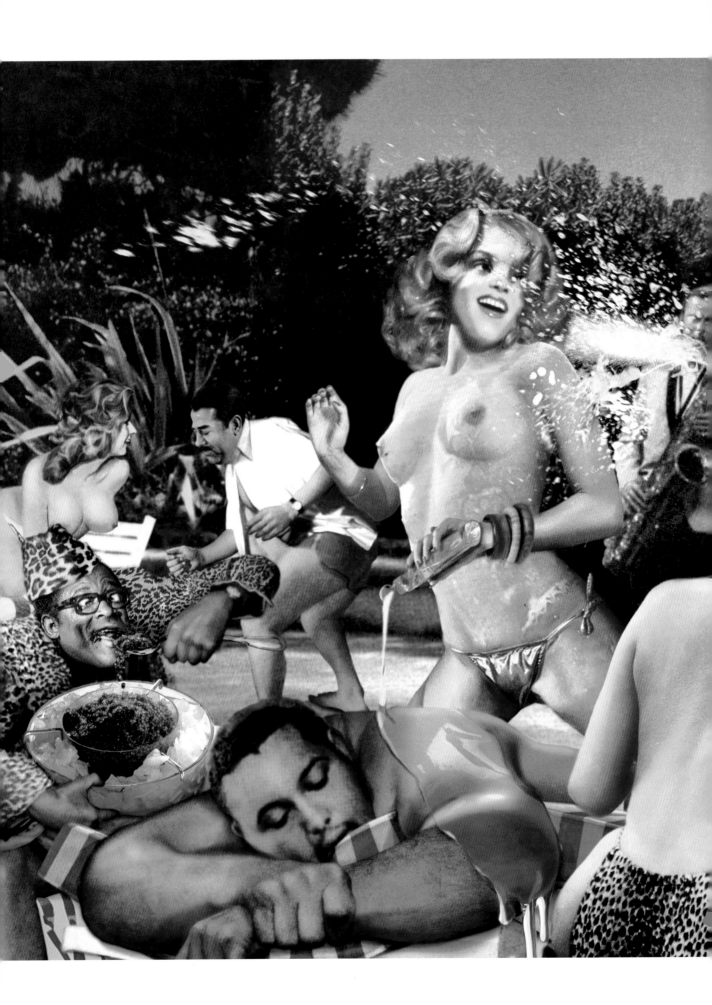

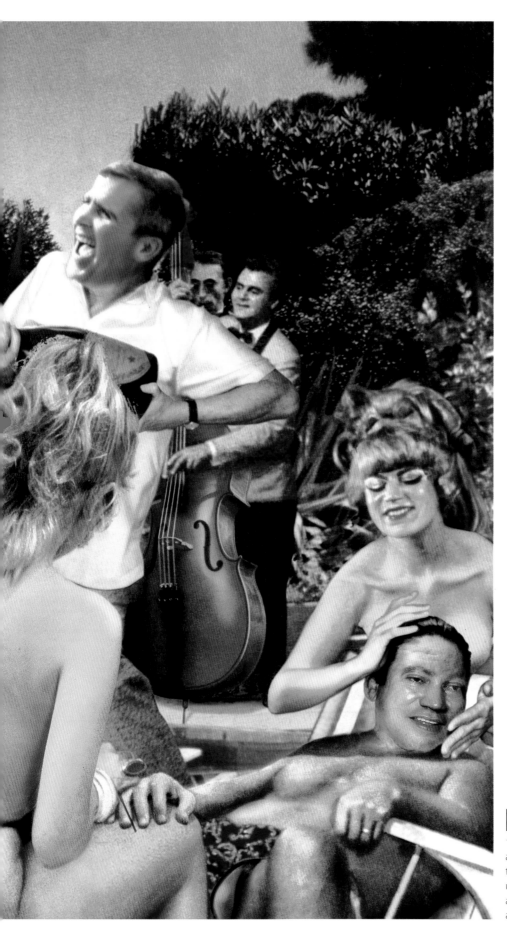

"If there's one thing I can't abide, it's ingratitude," Ollie used to say. "Instead of getting all lathered up about every little mistake, it's time the American people began to understand who our real friends are, and we showed them a little appreciation."

EVERYONE DIES IN IT

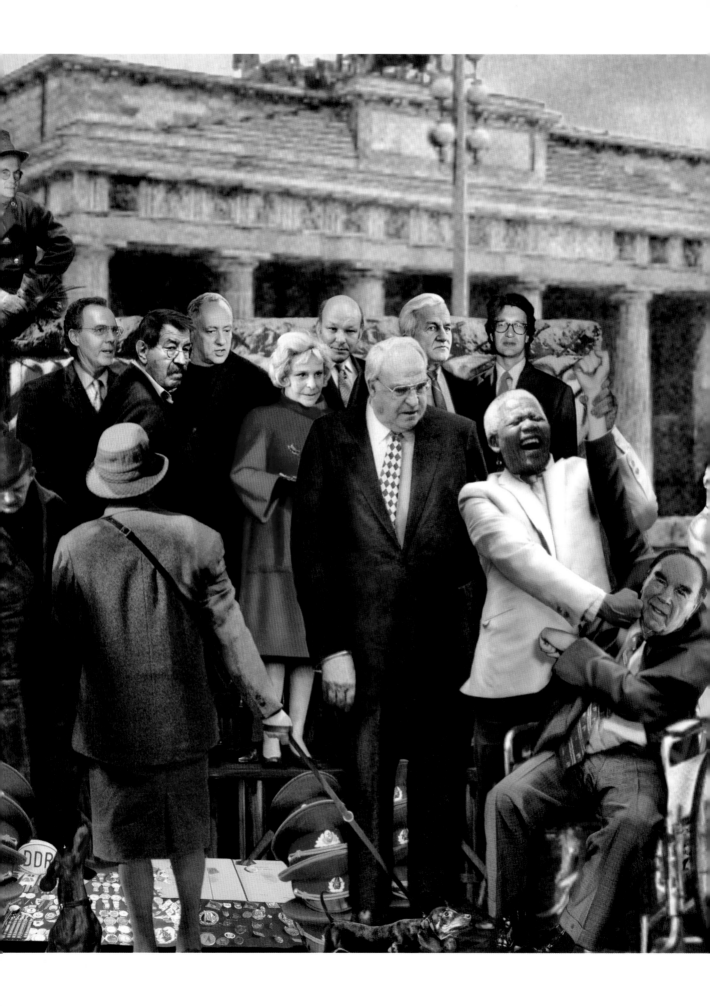

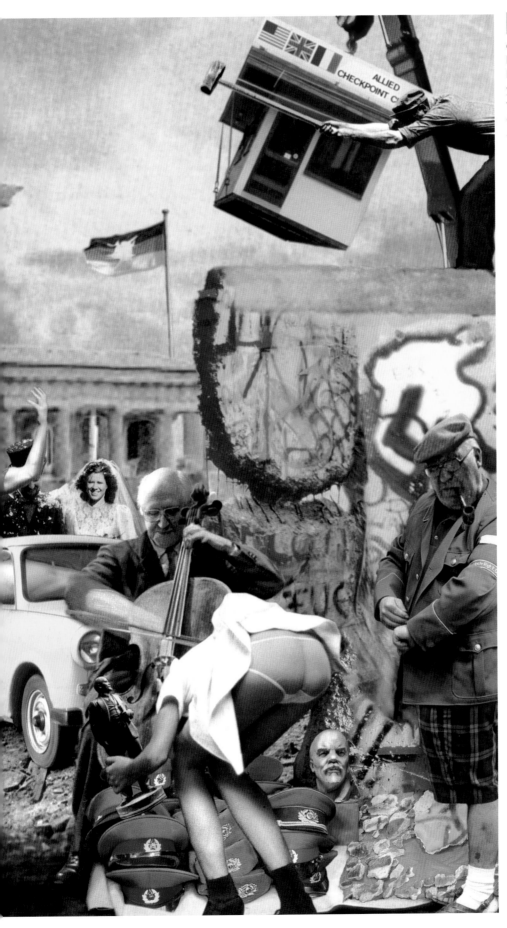

None of the organizers could identify the man in the wheelchair or imagine what business he had being there, but Mandela, who had done some boxing himself in his youth, recognized the great heavyweight right away. "How's it going, champ?" he asked, as one warrior to another. "Tell me about Joe Louis."

OVERLEAF:

She always was an impetuous girl.

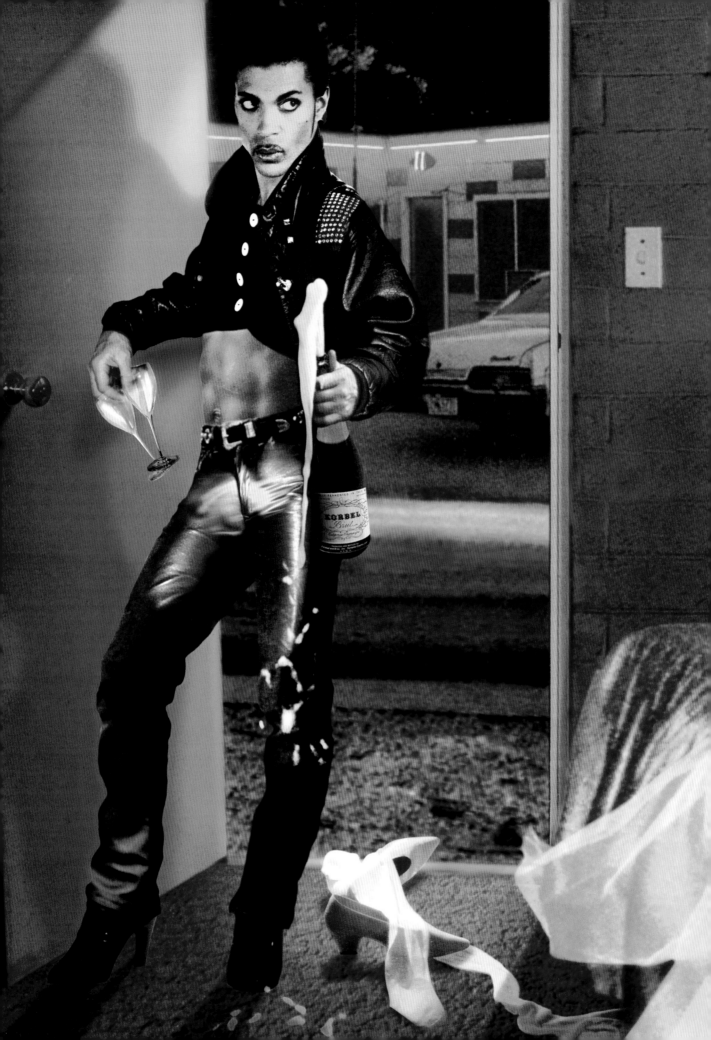

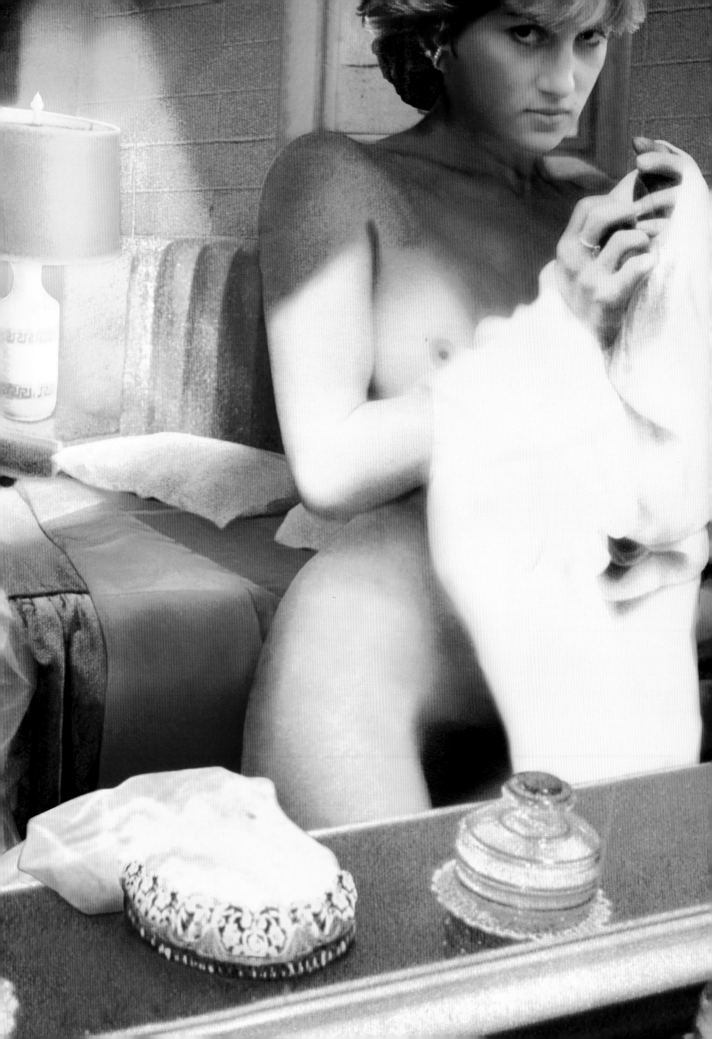

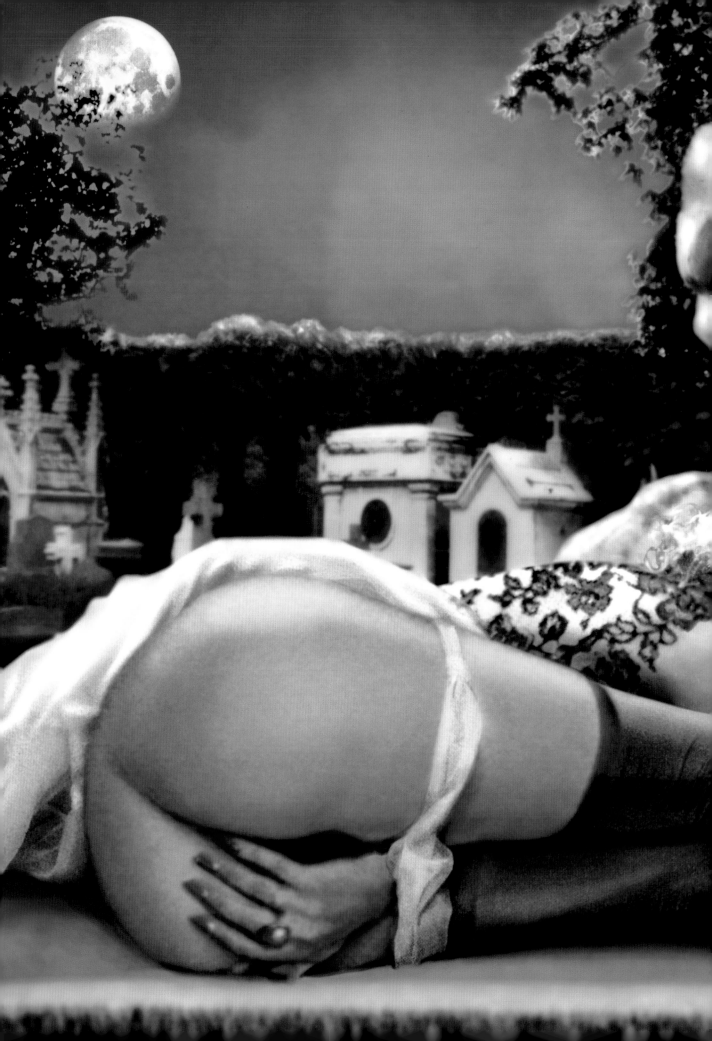

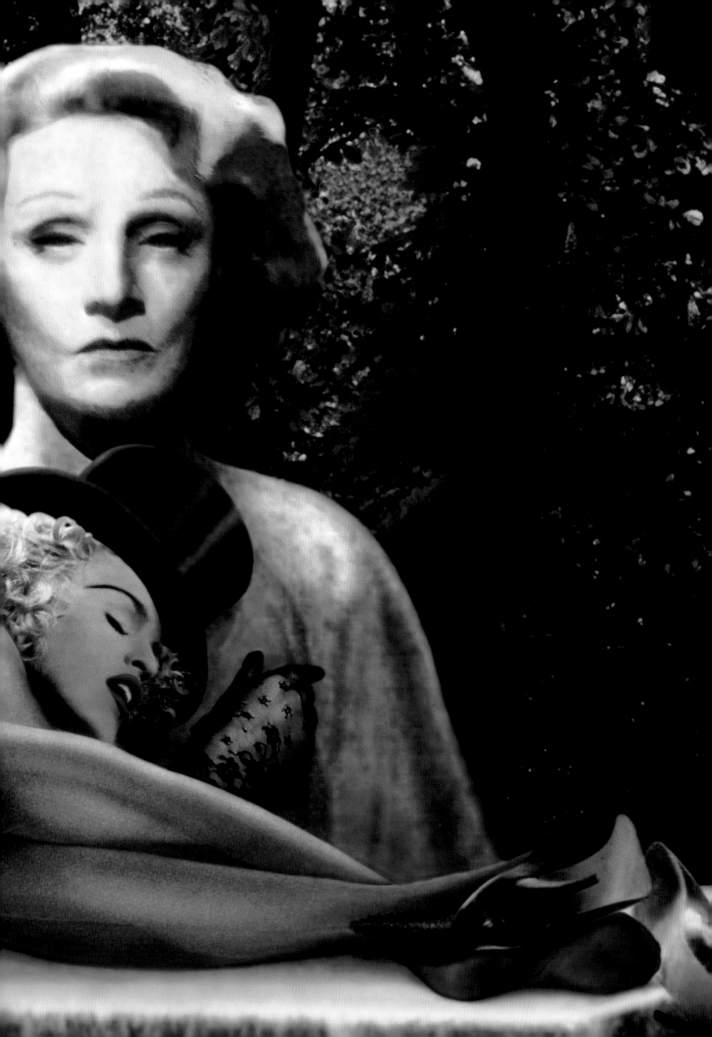

PRECEDING PAGES:

I'd give my eyeteeth to meet her," Madonna said when I mentioned that Dietrich was failing. By the time she arrived in Paris, however, it was too late. "Madame," she was told, "has acquired a new address."

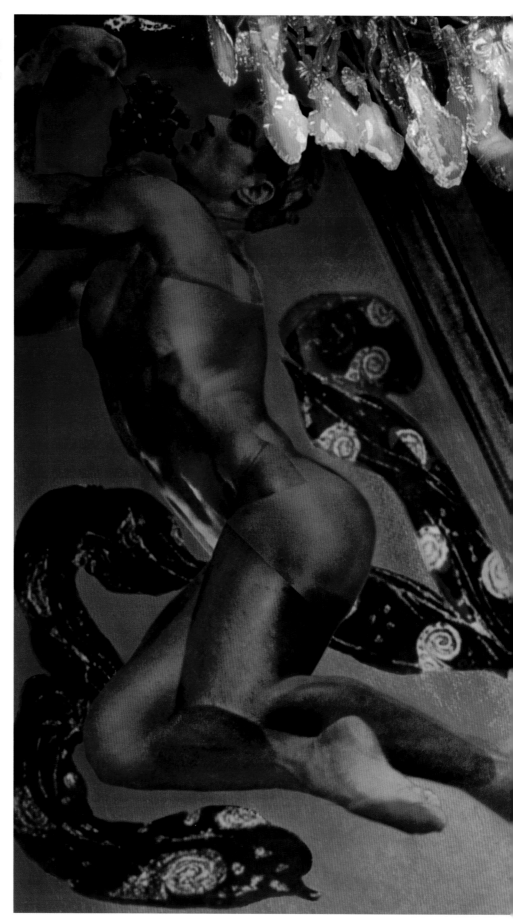

At last, when there were no more boys left to talk about, Rudolf began to recite from the Book of Revelation: "And I beheld when he had opened the sixth seal, and, lo, there was a great earthquake; and the sun became black as sackcloth of hair, and the moon became as blood . . ."

"The Bible's too freaky for me," said Robert, overturning the board. "Everyone dies in it."

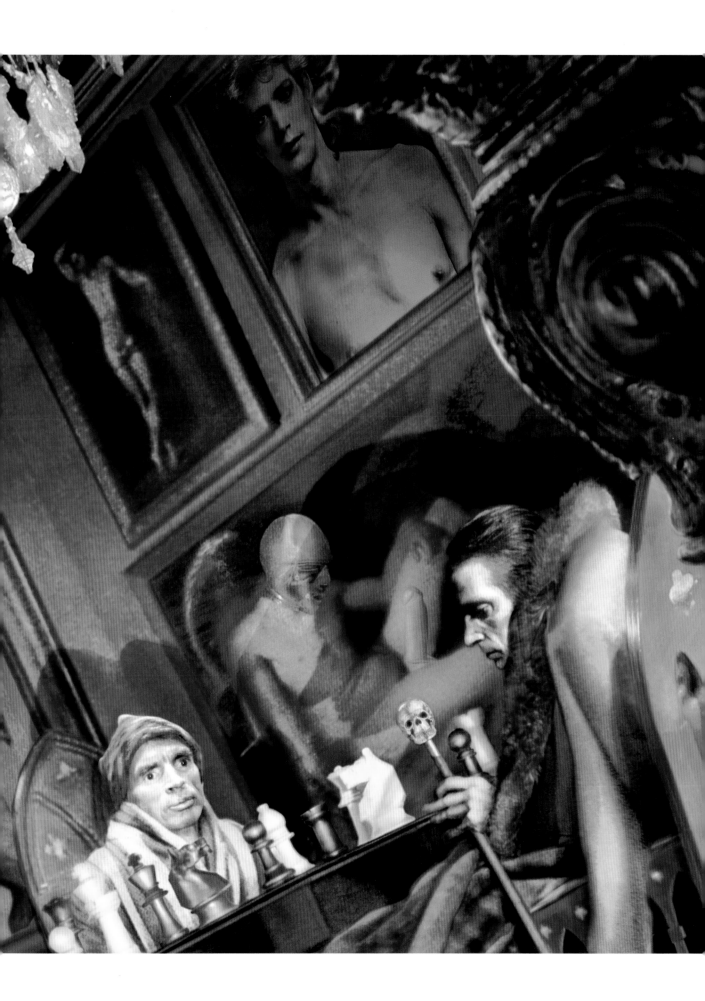

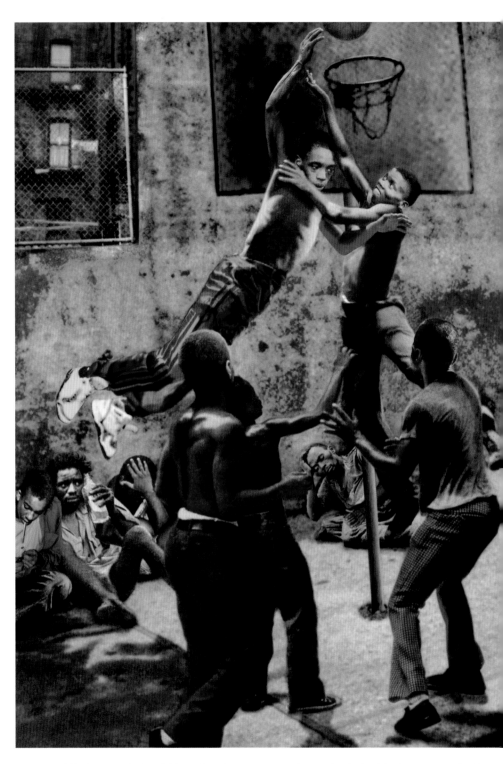

Michael liked to watch the children play. They reminded him of himself at that age, playing pickup games in the schoolyard. He had always been the hungriest, and hunger always won.

Sometimes, when he had the time to spare, he'd show the kids a few moves, a couple of shooting tips. More important, though, he'd school them in the mental game. Being like Mike, he explained,

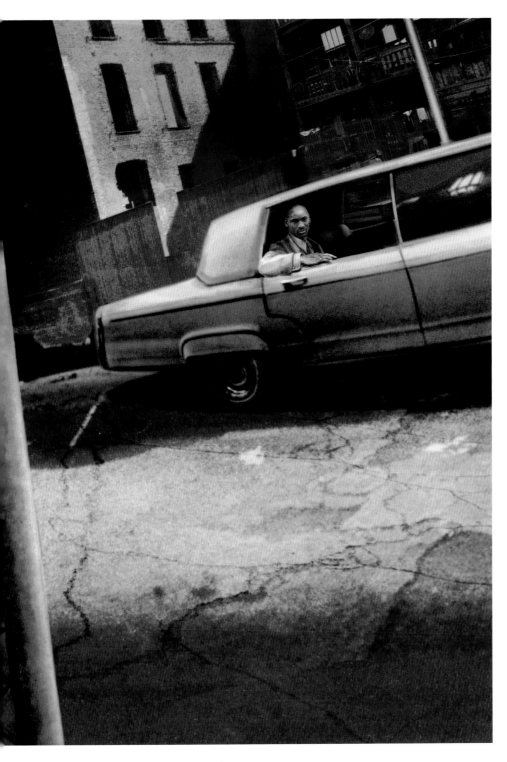

required hard work, discipline, passion and never forgetting the bottom line: "All God's children got swoosh."

OVERLEAF:

Courtney was disconcerted to find that she had company. "Are you sure you've got the right address?" she asked.

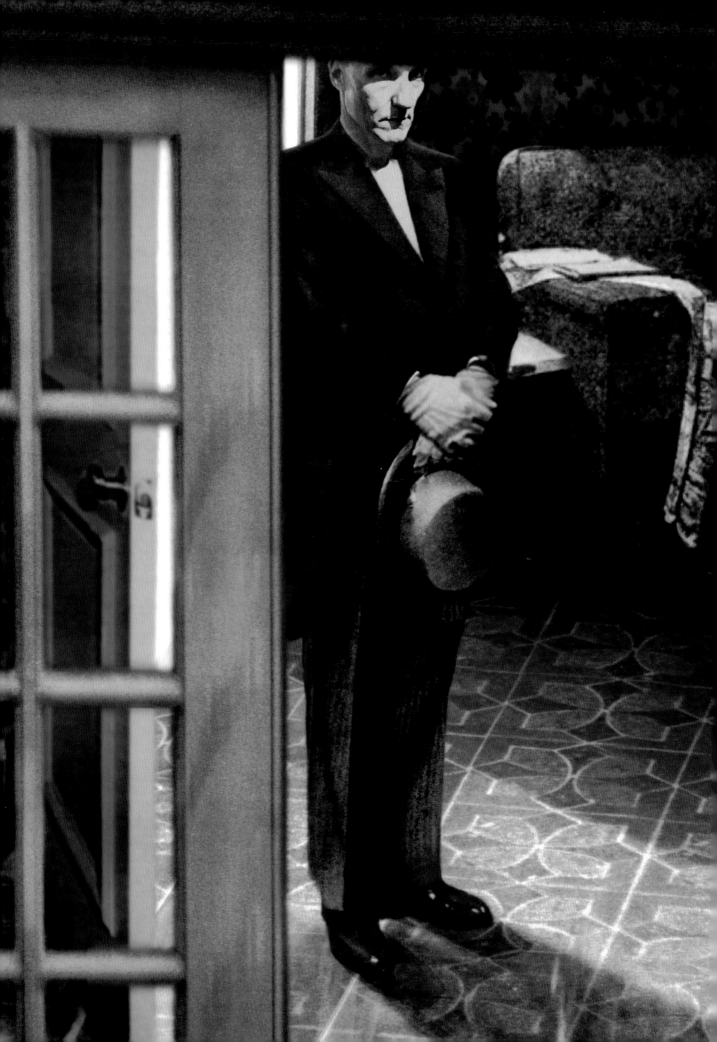

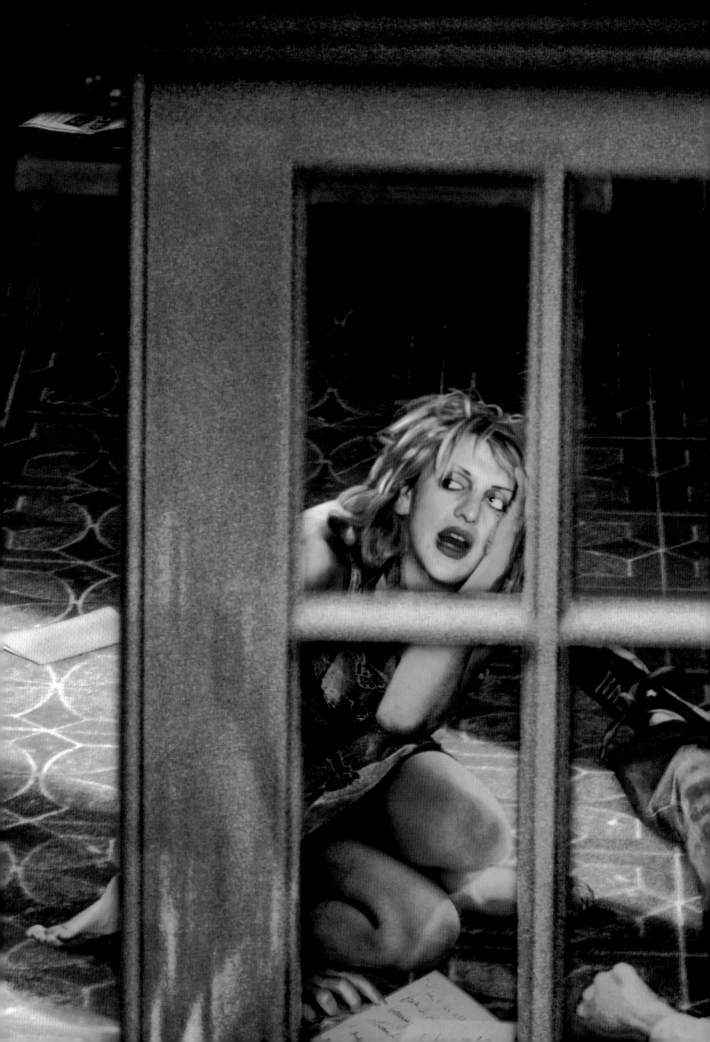

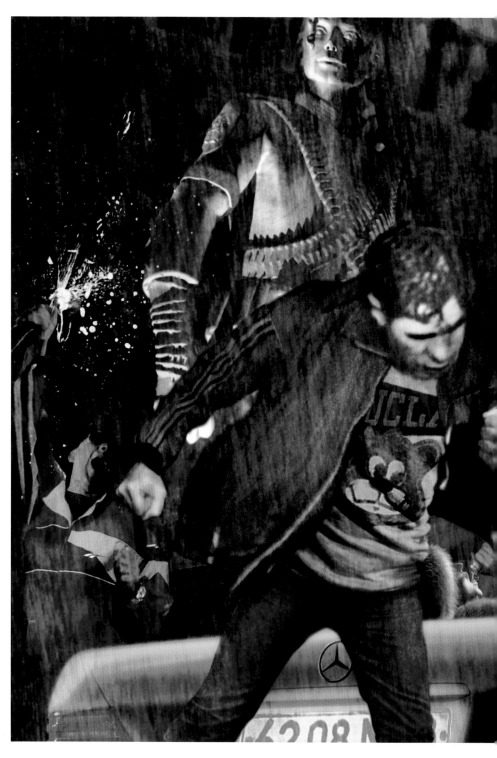

The boys were mad as wet hens. They had made Boris an offer he couldn't refuse—get them a private audience with the King of Pop, or else—but the evening had proved a fiasco. They had been kept waiting for hours in a hotel room with not a drop to drink, unless you counted Pepsi. Finally, the Gloved One sent a message that he was indisposed. Instead of a face-to-face meeting, the boys were handed a few CDs and autographed T-shirts, then sent packing like teenyboppers. Somebody would have to pay.

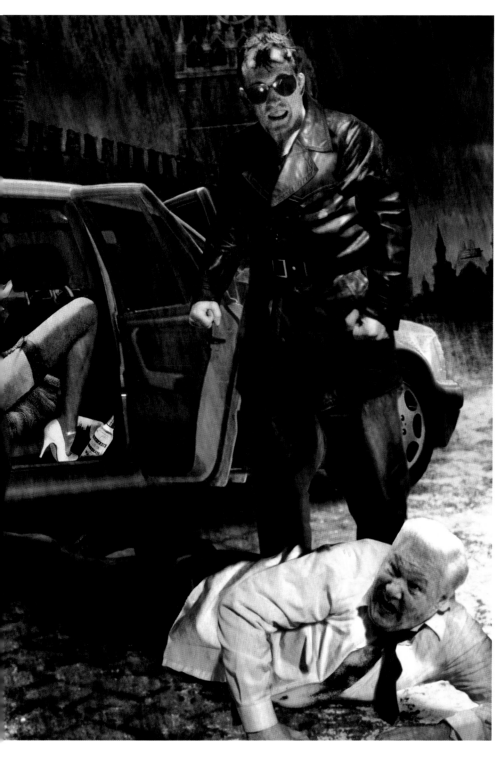

OVERLEAF:

She had been living in this condo for longer than anyone could remember. At first she had a maid to help her, but in recent years she'd looked after herself. Sometimes her neighbors would see her out shopping, a tiny woman, stooped and frail, but with a certain air. Since she always wore dark glasses and a black wig, they couldn't describe her in detail. Still, she had a nice smile; they all agreed on that. "She was a lady. You could tell."

On rare occasions, she'd ask one of the neighbors in for morning coffee, but they remembered little about the apartment. The curtains were always drawn, the lights turned low. Any old pictures or mementos must have been locked away in her bedroom. The only personal touch that anyone could recall was a postcard of the White House. "From Jack," the inscription read. "Forever."

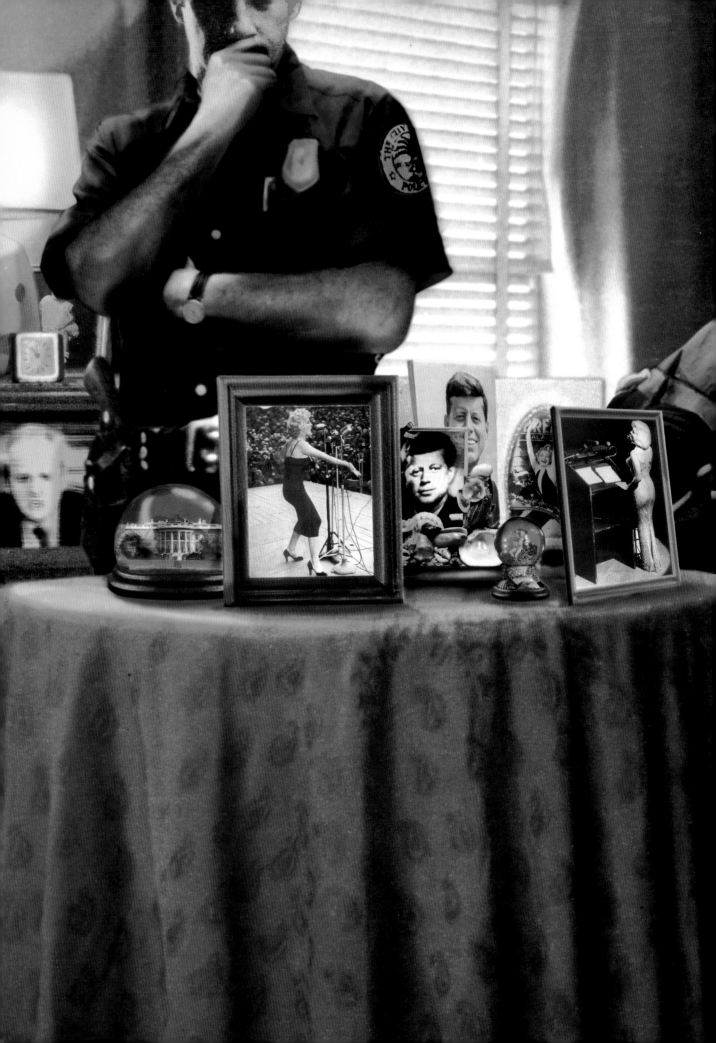

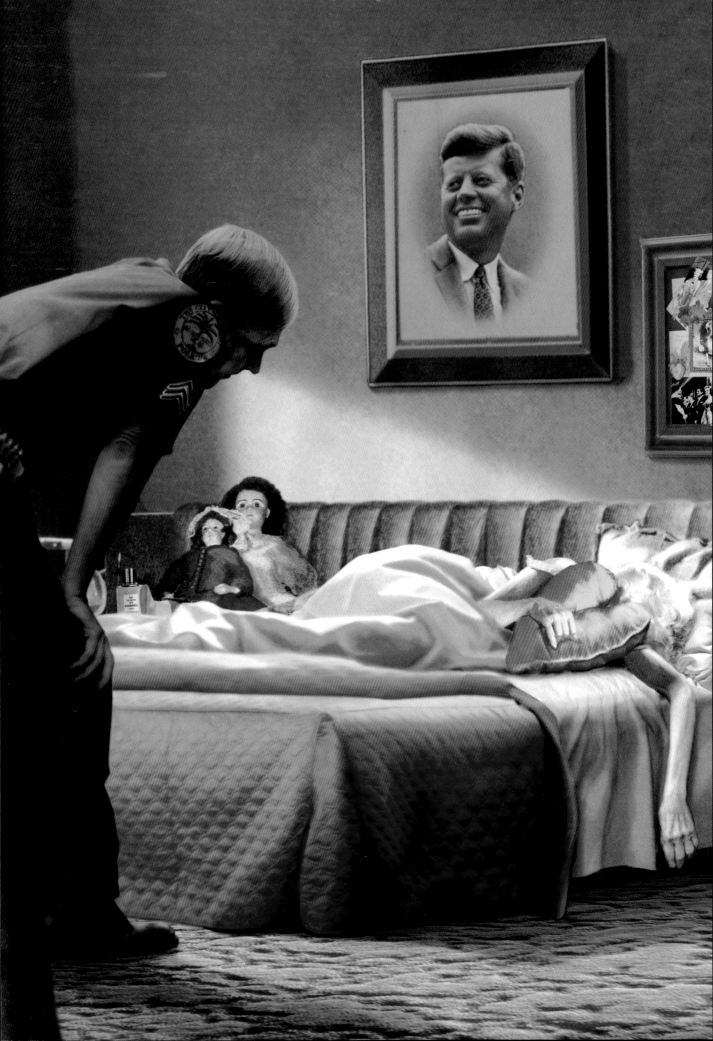

DOES HE THINK HE CAN HOLD BACK
PROGRESS?

Grigory Rasputin, Tsarina Alexandra

Joseph Stalin

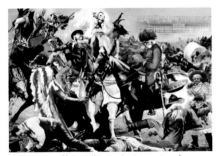

William "Buffalo Bill" Cody, Franz Josef,
Annie Oakley *(on right)*

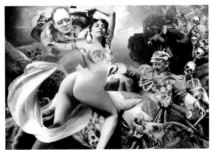

Winston Churchill, Mata Hari (Margaretha
Geertruida Zelle), Kaiser Wilhelm

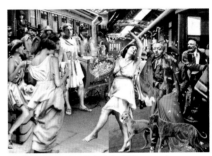

Isadora Duncan, Gabriele D'Annunzio,
Vladimir Ilich Lenin

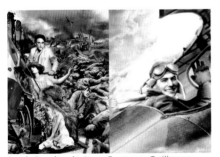

Sarah Bernhardt, Jean Cocteau, Guillaume
Apollinaire, Ernest Hemingway

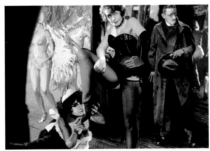

Colette, Mistinguett, James Joyce

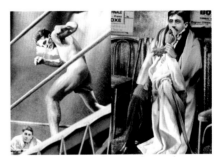

François Descamps, Georges Carpentier,
Marcel Proust

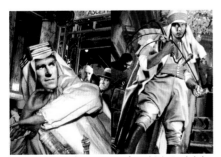

T. E. Lawrence (Lawrence of Arabia), Rudolph
Valentino; *(in background)* David Lloyd George,
Georges Clemenceau

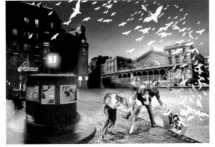

Tristan Tzara

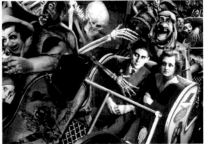

Franz Kafka, Milena Jesenská

TAKE US TO THE REGULAR JOES . . .

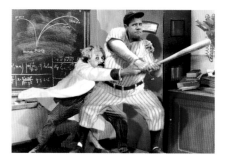

Albert Einstein, Babe Ruth

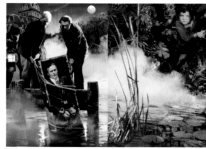

Harry Houdini, Orson Welles

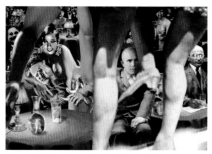

Leon Trotsky, Josephine Baker, Nikita Khrushchev, Lavrenty Beria

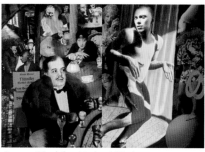

Sergey Diaghilev, Vaslav Nijinsky

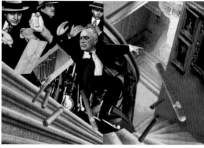

Al Capone, Vincent "Mad Dog" Coll, Franklin Delano Roosevelt, Lucky Luciano

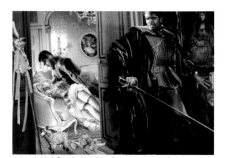

Mary Pickford, Paul Robeson, Douglas Fairbanks Sr.

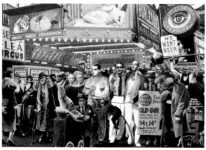

Luis Buñuel, Jack Johnson *(partly obscured)*, Federico García Lorca, Salvador Dalí

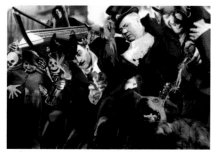

John Barrymore, W. C. Fields

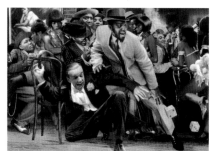

Fred Astaire, Bill "Bojangles" Robinson

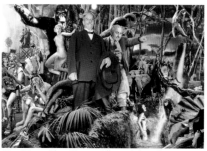

Fay Wray, King Kong, Albert Schweitzer, Cecil B. De Mille, Maureen O'Sullivan, Johnny Weissmuller

A CANAPÉ FOR ROBINSON

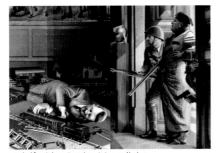

Adolf Hitler, Benito Mussolini

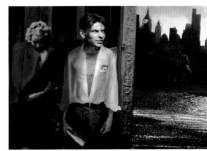

Frank Sinatra

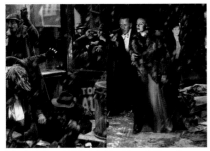

Noël Coward, Tallulah Bankhead, Dorothy Parker

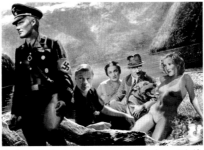

Duke of Windsor, Duchess of Windsor, Adolf Hitler, Eva Braun

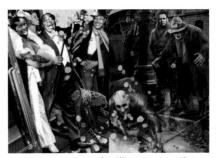

Louis Armstrong, Duke Ellington, Jean Genet

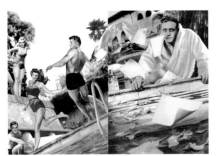

Kirk Douglas, Lana Turner, Rita Hayworth, Burt Lancaster, F. Scott Fitzgerald

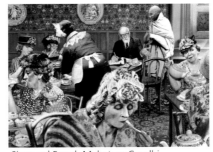

Sigmund Freud, Mahatma Gandhi

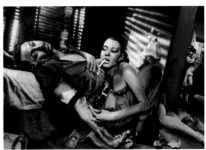

Tennessee Williams, Billie Holiday

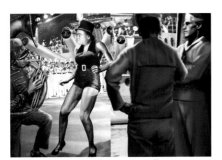

J. Edgar Hoover as Eleanor Powell

YOU OWE ME FINLAND

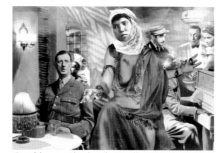

Casablanca: Charles de Gaulle, Claude Rains, Dooley Wilson ("Sam"), Humphrey Bogart, Ingrid Bergman

Gladys, Elvis, and Vernon Presley; William Faulkner

Franklin Delano Roosevelt, Joseph Stalin, and Winston Churchill at Yalta

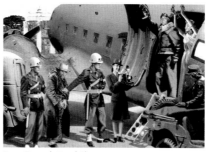

Ezra Pound, Errol Flynn

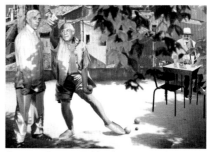

Georges Braque, Pablo Picasso, Henri Matisse

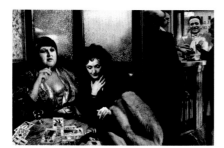

Edith Piaf, Marcel Cerdan

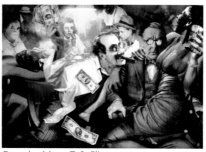

Groucho Marx, T. S. Eliot

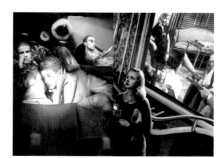

Nouvelle Vague: François Truffaut, Jean-Paul Belmondo, Jean-Luc Godard, Jeanne Moreau

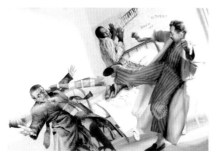

Jean-Paul Sartre, Bud Powell, Albert Camus

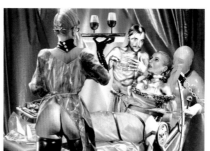

Howard Hughes, Eva Peron

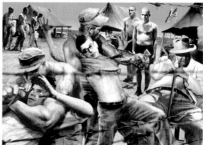

The Beats: Gregory Corso, Allen Ginsberg, Neal Cassady, Jack Kerouac, Orson Welles ("Sheriff Hank Quinlan")

AH, THE SEX THING . . .

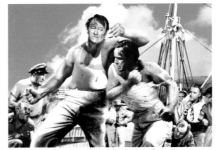

Ward Bond, Victor McLaglen, John Wayne, Marlon Brando, Karl Malden, Rod Steiger

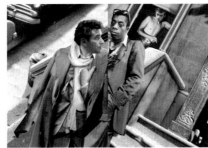

Leonard Bernstein, James Baldwin, James Dean

Lenny Bruce, Malcolm X

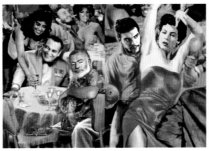

Fulgencio Batista, Fidel Castro, Ernest Hemingway, Ernesto "Che" Guevara, Ava Gardner

Winston Churchill, Brigitte Bardot

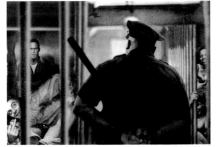

Ted, Bobby, and John Kennedy

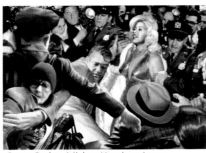

Greta Garbo, Mickey Hargitay, Jayne Mansfield

Clark Gable

Françoise Sagan, Louis-Ferdinand Céline

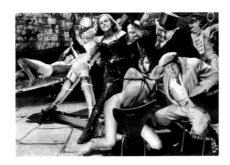

Goldfinger: Stephen Ward, Mandy Rice-Davies, Honor Blackman ("Pussy Galore"), Christine Keeler, "Odd Job," Nikita Khrushchev, "The Man in the Mask"

I CALL IT AMERICA

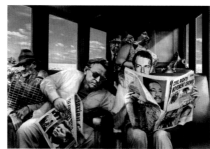

Strangers on a Train: James Earl Ray, Lee Harvey Oswald; *(in background)* Alfred Hitchcock, Mahalia Jackson

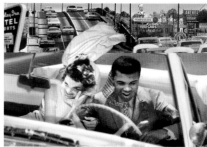

Jacqueline Kennedy, Cassius Clay

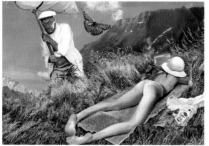

Vladimir Nabokov

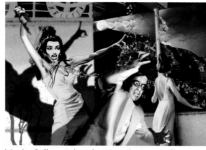

Maria Callas, Aristotle Onassis, Jacqueline Kennedy

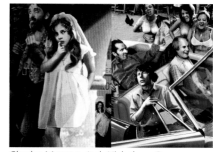

Charles Manson, Jack Nicholson, Roman Polanski, Timothy Leary

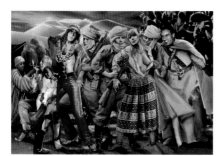

Paul Bowles, Mick Jagger, Marianne Faithfull, Muammar Qaddafi

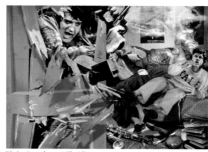

Elvis Presley, Bill Clinton

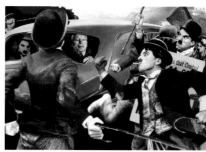

Charlie Chaplin

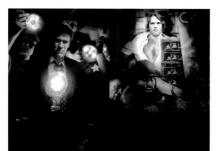

Clint Eastwood, Arnold Schwarzenegger

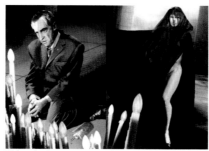

Richard Nixon, Jane Fonda

STRANGE DAYS INDEED

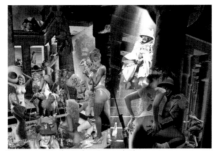

Emperor Haile Selassie and Playmates

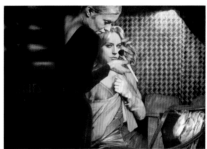

Jean Seberg, Sharon Stone

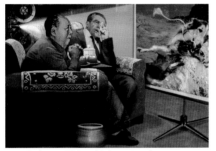

Mao Zedong, Richard Nixon, Lassie

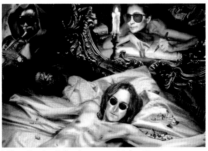

Miles Davis, John Lennon, Yoko Ono

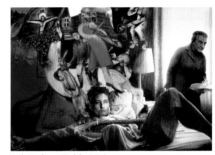

Bob Dylan, Golda Meir

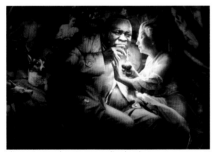

Idi Amin Dada, Queen Elizabeth II

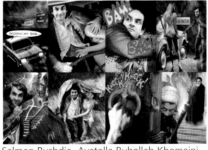

Salman Rushdie, Ayatolla Ruhollah Khomeini

Grace Kelly, Alfred Hitchcock

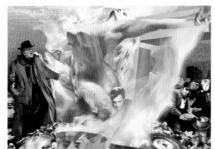

Federico Fellini, Anita Ekberg, Marcello Mastroianni, Anthony Quinn, Giulietta Masina

THE LAST TIME I HAD SUCH FUN

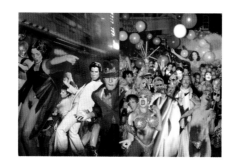

Studio 54: Grace Jones, Margaret Trudeau, Disco Sally, Liza Minnelli, John Travolta, Truman Capote, Sylvester Stallone, Steve Rubell, Elizabeth Taylor, Amanda Lear, Elton John, Yves Saint Laurent, Roy Cohn, Norman Mailer, Rudolph Valentino, Aleksandr Solzhenitsyn, Regine, Halston, Jerry Hall, Calvin Klein, Salvador Dalí, Bianca Jagger, Sterling Saint-Jacques, Andy Warhol, Karl Lagerfeld

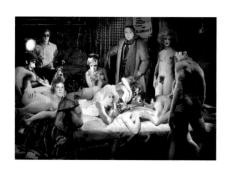

The Factory: Ondine, Andy Warhol, Brigid Polk, Gerard Malanga, Edie Sedgwick, Mario Montez, Tom Hempertz, Orson Welles, Viva, Joe Spencer, Taylor Mead, Candy Darling, Joe Dallesandro

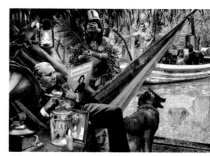

Martin Bormann, Lord Lucan

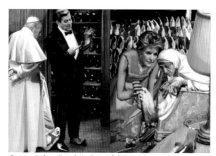

Pope John Paul II, Ronald Reagan, Nancy Reagan, Mother Teresa

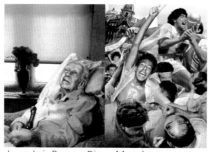

Jorge Luis Borges, Diego Maradona

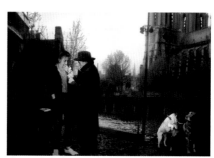

Serge Gainsbourg, François Mitterrand

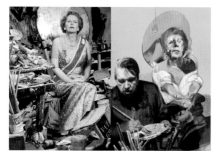

Margaret Thatcher, Francis Bacon

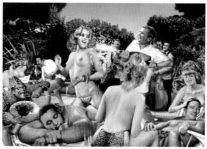

CIA: Mobutu Sese Seko, Saddam Hussein, Jean-Claude "Baby Doc" Duvalier, Oliver North, Manuel Noriega

EVERYONE DIES IN IT

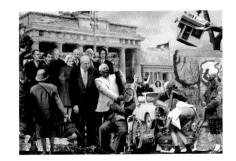

Berlin Wall: Franz Beckenbauer (soccer player), Günter Grass, Peter Zadek (theater director), Leni Riefenstahl, Walter Momper (mayor of Berlin in 1989), Helmut Kohl, Richard von Weizsäcker (president of Germany in 1989), Wim Wenders, Nelson Mandela, Max Schmeling, Mstislav Rostropovitch

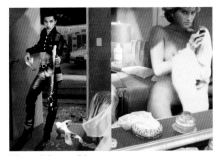

Prince, Princess Diana

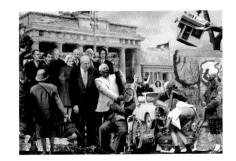

Madonna, Marlene Dietrich

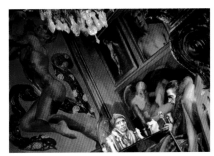

Rudolf Nureyev, Robert Mapplethorpe

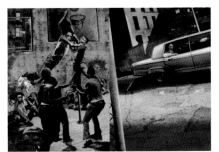

Michael Jordan

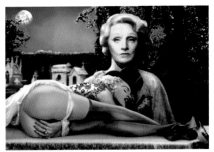

William Burroughs, Courtney Love, Kurt Cobain

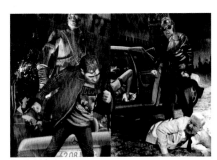

Boris Yeltsin

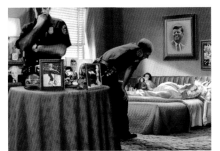

Marilyn Monroe

A NOTE ON THE TYPE

This book was set in Fairfield, the first typeface from the hand of the distinguished American artist and engraver Rudolph Ruzicka (1883–1978). In its structure Fairfield displays the sober and sane qualities of the master craftsman, whose talent has long been dedicated to clarity. It is this trait that accounts for the trim grace and vigor, the spirited design and sensitive balance, of this original typeface.

Rudolph Ruzicka was born in Bohemia and came to America in 1894. He set up his own shop, devoted to wood engraving and printing, in New York in 1913 after a varied career working as a wood engraver, in photo-engraving and banknote printing plants, and as an art director and freelance artist. He designed and illustrated many books, and was the creator of a considerable list of individual prints—wood engravings, line engravings on copper, and aquatints.

Composed by Creative Graphics,
Allentown, Pennsylvania

Color separations by Professional Graphics Inc.,
Rockford, Illinois

Printed and bound by Butler & Tanner,
Frome, England

Designed by Iris Weinstein